The Day I Am Free

 Katitzi

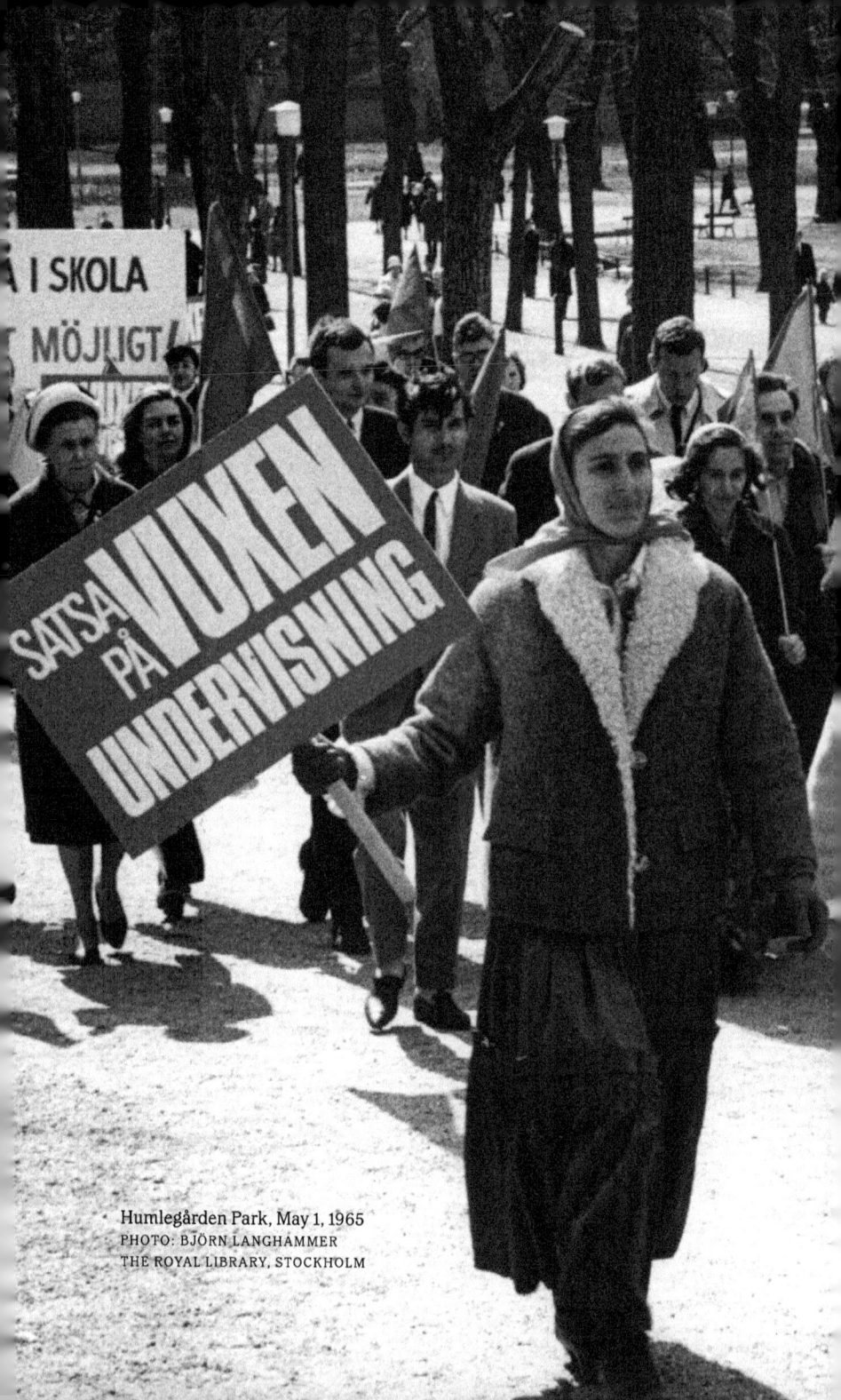

Humlegården Park, May 1, 1965
PHOTO: BJÖRN LANGHAMMER
THE ROYAL LIBRARY, STOCKHOLM

The Day I Am Free

by Lawen Mohtadi

&

Katitzi

by Katarina Taikon

Translated by
Jennifer Hayashida

Sternberg Press

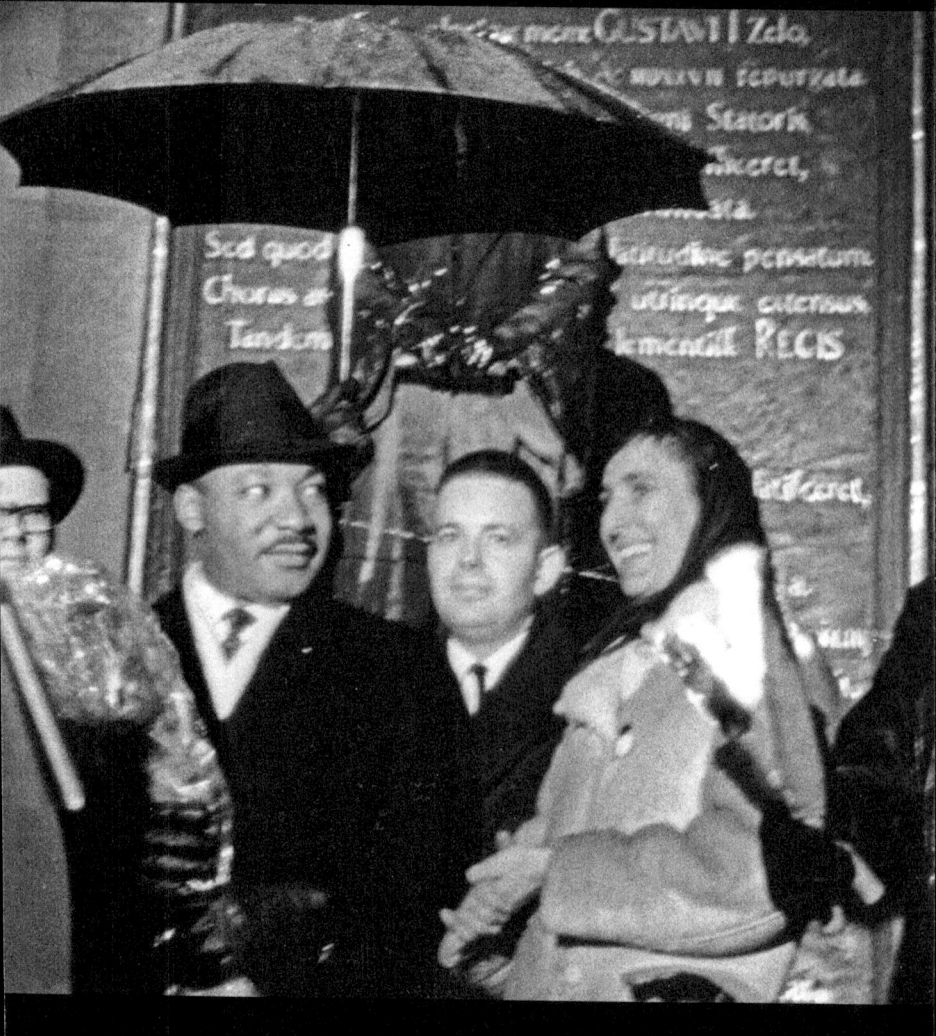

Martin Luther King Jr. and Katarina Taikon outside the Storkyrkan cathedral in Stockholm, with Paul Rimmerfors between them.
PHOTO: PER ANDERS THUNQVIST (PRIVATE COLLECTION)

Contents

The Day I Am Free 8
Lawen Mohtadi

Katitzi's Journey through Sweden 188
Maria Lind

Katitzi 214
Katarina Taikon

This volume consists of two books and an essay. The first is a 2012 biography of Swedish-Roma author and civil rights activist Katarina Taikon, written by Lawen Mohtadi. The second is one of Taikon's own books; the first part of her children's book series, *Katitzi*, from 1969. The essay deals with the figure of Katitzi, the book series, and its reception. It is written by Maria Lind to accompany an exhibition about Katitzi at Tensta Konsthall in 2012.

In *Katitzi*, Taikon writes about her struggle as part of an ethnic minority in Sweden in a fierce young girl's coming-of-age story. The thirteen-volume series is beloved by generations of readers and is today a part of the Swedish cultural heritage.

Mohtadi's biography brought renewed attention to Taikon's literary and activist work and created a cultural reckoning that named Taikon one of the most important Swedish human rights figures of the twentieth century. With the publication of this joint volume the aim is to introduce Taikon's work and legacy to readers beyond Sweden.

The Day
I Am Free

Lawen Mohtadi

Introduction

The Great Hall of the Nordic Museum is packed. It is September of 2011 and Rosa Taikon is celebrating 45 years as a silversmith with an exhibition at one of Sweden's most prominent cultural institutions. Friends from an entire lifetime are gathered, those who were her friends when it all began and those who remain today. Nieces and nephews and their families, children and grandchildren. The Minister of Culture pays tribute to Rosa Taikon and praises her artistry; in the audience are the collectors, those who have followed her work throughout the years and who now proudly wear her jewelry.

It is difficult to see Rosa Taikon up on stage, but when the murmur of the crowd dies down, her voice can be heard in the enormous building. After a few words about the silver she addresses the struggle, the one that began in 1963 and came to transform the lives of Sweden's Roma.

– The work Katarina did ... she begins.

Someone starts to applaud. Rosa Taikon tries to continue, but the applause swells and drowns out her words.

Rosa and Katarina Taikon, one a silversmith and the other an author: both have made a deep impression on the cultural landscape of Sweden. Two sisters who followed each other through life. It is impossible to talk about one sister without talking about the other.

Now the older of the two sisters—Rosa Taikon—stands here, at her opening, and as always she has difficulty speaking only about the art, her silversmithing. This 85-year-old woman is compelled to bring Katarina into the festivities taking place in the museum's magnificent hall this late autumn evening as she is feted by a who's who of Sweden. Little sister Katarina is always present,

even though she passed away many years ago, and perhaps her presence in this space is especially palpable: many of the hundreds of guests were personally acquainted with Katarina Taikon, while others developed relationships with her through her public presence in the 1960s and '70s, not least through her books. Thanks to this direct link to history, they have a living memory of Katarina Taikon. As the author of the beloved children's books about Katitzi, literature which today belongs to the Swedish canon, she has made an impression on generations of children and young adults, rivaling the popularity of Astrid Lindgren. Swedes today compare her activism to the work of Martin Luther King Jr.

But Katarina Taikon's role in a larger narrative, a story about postwar Sweden's cultural and political transformation, is not as much of a given, even though she, as the author, agitator, public intellectual, journalist, and activist that she was, can be considered one of the twentieth century's foremost advocates for human rights in Sweden. By extension, this also means that the Roma people's struggle for equality has not yet been included as a crucial link in Sweden's national history.

Katarina Taikon was born in 1932 in the small city of Örebro, today less than a three-hour drive from Stockholm. She was the child of Agda Karlsson, a young non-Roma Swedish woman from the area around Gothenburg, and Johan Taikon, who was born in France but spent most of his life in Russia and then immigrated to Sweden in the early 1900s. Katarina was born during a time when Sweden was on the cusp of developing what we today call the welfare state. As early as 1927, the Social Democratic Prime Minister Per Albin Hansson articulated a vision of this society, in this, his perhaps most well-known speech:

"The good home does not know the privileged or the neglected, neither favorites nor stepchildren ... In the good home, equality, care, cooperation, and helpfulness rule."

This belief concerning the function of society came to define

the image of modern Sweden. This is when terms such as solidarity, welfare society, *Folkhem* (the people's home), and *rekordår* (boom years) all originated and gained a remarkable foothold in our collective understanding of Sweden's history.

During the same period that the Swedish welfare society begins to take shape, another political current emerges: eugenics. With the founding of the State Institute for Racial Biology in 1922 in the university city of Uppsala, Sweden became a model for scientifically grounded racism. The institute's scientists were—during the more than three decades of its existence (in 1958 the institute was renamed the Institute for Medical Genetics)—active in mapping and disseminating information about the country's different "races." In the racial hierarchy that dominated and was generally accepted, Roma were not only cast out of the Swedish national community—they were, like Jews and the indigenous Sami, seen as a threat to the purity and sustainability of the Swedish race.

This exclusion of Roma from Swedish national identity was manifest within a range of different spheres, most clearly the law. In 1914, legislation concerning the "immigration of gypsies" is passed. The law expressly prohibits one, and only one, group from entering Sweden: Roma. The ban is in effect until 1954, which means that Roma who resided in Sweden could not travel abroad during that time, but also that Roma who had survived the Nazi death camps and sought refuge in Sweden after the war were considered illegal immigrants.

Then followed laws concerning the treatment of vagrants, sterilization legislation, censuses, investigations, and ethnic registries. In municipal regulations and practices, Roma were prohibited from residing in and/or renting housing up until the 1960s. During this time, Roma were also excluded from the educational system, something which had a direct impact on both Katarina and Rosa Taikon.

Katarina Taikon was 31 years old when she published her first book, *Zigenerska* (*Gypsy Woman*), in 1963. The book landed like a bomb in Swedish society—her timing couldn't have been better.

During the 1960s, the people's home was at its apex. Sweden took a leading role as a proponent of global equality and justice. The nation's self-perception hinged on an idea of Sweden as a place free of racism, or, as it was sometimes termed, "minority problems." The racism that a few decades earlier had been state ideology was now effectively scrubbed from public discourse. But in reality things looked very different. Roma demands for housing, education, work, and a life free from racism were met by a brick wall of resistance, contempt, and outright mockery, both from official Sweden and the general population. Despite a new ideological doctrine based on equality and prosperity for all, the discriminatory praxis of Swedish society remained alive and well.

This relationship, between dominant historical narratives and actual conditions, is the great paradox of the 1960s. It is out of this light and darkness, a polarity that runs throughout the Swedish 1900s, that Katarina Taikon emerges. She will become an unforgettable public voice, treated more like a movie star than as an activist, and she will fundamentally transform Swedish society. My book about her is an attempt to bring to life a deeply fascinating woman and add nuance to the pervasive but oftentimes oversimplified Swedish success story.

Stockholm, January 2019
Lawen Mohtadi

I.

It was a warm midsummer day when Agda Karlsson gave birth to her fourth child. The mild weather made things easier: many relatives could attest to the fact that it was both painful and dangerous to give birth in a tent during the winter.

The family had set up camp in Almby, outside the central Swedish city of Örebro. For the first weeks, Agda Karlsson and her newborn daughter were allowed to live in their own tent, separate from the rest of the family. The intention was for Agda to avoid risk of infection and to rest, away from all housework. The father, Johan Taikon, and the older siblings did not see much of the new family member during the early days. The girl, born July 29, 1932, was named Katarina Taikon. Later in life she would be told that one of the older women in the family had assisted at her birth.

The parents had met in the west coast port city of Gothenburg, at a restaurant where the two of them were employed. Agda Karlsson had recently moved to the city from her native community in Härryda, twenty kilometers east of Gothenburg; she was 21 years old. Johan Taikon traveled with his carnival through Sweden, staying only briefly at each of the various stops. He had come to Sweden from Russia at the turn of the century, and when he met Agda Karlsson he was 47 years old.

Katarina Taikon knew relatively little about her mother's background. She knew that her mother came from modest means and that she had many relatives. Perhaps they were contract farmers, she once speculated in one of her books. Agda Karlsson's parents

were crofters. The father, Karl Augustsson, was born in Härryda while the mother, Anna Johansdotter, was born in nearby Surteby. As crofters they rented a cottage and a bit of land from a farmer. There they worked hard to grow vegetables: potatoes, kale, peas. Sometimes they also kept a small herb garden.

In 1894, the railroad came to Härryda. It was remarkable that the little community had its own station when the railroad line was drawn between Gothenburg on the coast and Borås further to the east. A journey that previously took days by horse and carriage now took just over two hours. The farmers traveled to the market held at Järntorget square in Gothenburg, but travel also took place in the opposite direction. Gothenburg's well-to-do city families took the train to Härryda in order to spend a few bucolic days in the countryside. Certain families rented out their houses for an entire summer: to do this the farmers had to move into tighter living quarters in a guest house or attic, perhaps belonging to a neighbor or family member.

Härryda was a conservative and religious community. Women who had children outside wedlock could be ostracized or simply instructed to leave the village. It is also not surprising that Härryda was largely untouched by the labor movement emerging during the late 1800s. When syndicalists from the nearby industrial town Mölnlycke attempted to organize new members in Härryda, they were driven away by farmers who did not want to attract troublemakers.

It was here that Agda Karlsson started school in 1910. Notably, her report cards show particularly good grades in Christian studies, reading, and geography. In the marks for diligence and behavior she, like all the other girls in her class, received the highest points. After graduating at age 14 she may have worked as a maid or assisted with the family's croft. During that time, her father died, while her mother and siblings remained living in Härryda until 1926 when her mother also passed away. Agda left her childhood home in January 1924.

Johan Taikon and his siblings and parents immigrated to Sweden at the turn of the 20th century. His father was named Kori Caldaras and his mother Voroshana. Johan was married to a woman named Masha: they had lived in Russia during an extended period and had made a living through being musicians and giving dance performances as well as coppersmithing. The family was Kalderash Roma, who were traditionally coppersmiths.

In the 1860s Kalderash Roma migrated from Wallachia, Moldavia, Hungary, and Transylvania to Poland. Many moved on from those regions to Russia. The Roma had as early as the late 1700s begun to influence Russian culture, primarily through music. Roma choirs emerged, and performed at events under Catherine the Great, having a significant impact on Russian society and culture. During the 1800s, Roma and their lives became a commonly occurring literary motif. Tolstoy, Pushkin, and a number of other authors wrote stories involving Roma characters. Pushkin's prose poem *The Gypsies*, which he wrote while in exile in Bessarabia, where he met many Roma, became a great success when it was published in 1824 and later was produced as an opera at the Bolshoi Theatre in Moscow.

Although a significant number of Roma lived quite privileged lives in the cities, the majority of Russia's Roma population remained in the countryside, poor and nomadic. In *A History of the Gypsies of Eastern Europe and Russia*, David M. Crowe describes the difficulty of including the Russian Roma in the censuses of the late 1800s. During the 1890s there was great social and economic turmoil, where approximately 400,000 people died of starvation and cholera and the Tsar ruled through a repressive regime. That the number of Roma was especially difficult to determine during this period could indicate that many moved around more than usual, and even emigrated.

What compelled Johan Taikon and his family to emigrate to Sweden is unknown. There are very few contemporary sources and

any established details are sparse. We learn that two separate clans came from Russia via Finland to Haparanda in the north, and Johan Taikon's father, Kori Caldaras, was the namesake to one family. His last name would then have been Jantjeschtji. This family, together with seven other Roma families (all having immigrated in the late 1800s and early 1900s) laid the foundation for the group that would later be termed Swedish Roma and who a century later became one of Sweden's official minority groups.

One winter day at the Royal Library in Stockholm, I find an additional source, a document from 1923. It is a state report on vagrancy, an investigation often cited in research on Roma. Johan Taikon, along with his wife, father, and siblings, is included in that report.

In September 1922, the police in Gothenburg interviewed a number of people in a Roma encampment in the city. The police had been charged by the State Commission on Vagrancy to find out how many Roma there were and what their employment and living situation looked like. One wanted a bigger picture and understanding of the Roma and traveler population, who at that time were regarded as vagrants by the authorities. The report opens with an interview with Kori Caldaras, now with the last name Taikon.

Kori Taikon was born in Hungary and is in the report referred to as "the former musician and coppersmith." His parents were Hungarian subjects. About 22 years earlier, circa 1900, Kori had arrived in Sweden with his family. They had previously lived in Sweden only periodically, six to twelve months at a time, and at other times in Germany, France, and Finland. Since approximately a year prior to 1914, the family had lived continuously in Sweden. Kori Taikon's wife died in 1914 and he now had eleven living children, of whom eight resided in Sweden. Until around 1916, Kori had traveled with his own horses and vehicles and usually remained in one location for a week or two. The men had worked with tin-plating and repairing copper containers, and all had performed music together as a group. After settling in Sweden, they no

longer owned horses. They stayed for a set period of time in each location and obtained a permit for the carnival. Soon they would separate into smaller groups.

Thereafter follows an interview with Johan Taikon. He was born in 1877 in Gascony, France, and growing up he continuously travelled with his father, Kori. Approximately 22 years later Johan married Masha, who was born in France in 1872, 5 years his senior. Until 1914 he had traveled with his father and made a living for himself and his wife through coppersmithing. In 1914, he left for Norway where he began to manage carnivals. He then returned to Sweden and had remained there with his wife, taking the carnival to various locations throughout the country. Johan Taikon had non-Roma men as employees; the number of employees varied from four to fourteen. The couple had no living children. Johan Taikon and his wife lived in a large trailer that he brought on his travels and which was transported via railway; the other carnival crew members generally lived in tents. During the winters he planned to live in hotels or in rented homes.

Johan Taikon had spent the most recent winter in Borås, where he had managed a shooting range. That spring he had taken the carnival to different fairs, thereafter he had arrived in Gothenburg where he participated in the Children's Day festivities and was then going to return to Borås. During the following summer, that is to say in 1923, he planned to return to Gothenburg.

When Agda Karlsson left Härryda for Gothenburg in January of 1924, she moved into an apartment in the Lundby neighborhood, located in a district of the city called Hisingen, an island that forms part of Gothenburg. She worked and made a living for herself; for a while she worked at a shoe factory. In Gothenburg she was no longer surrounded by the farming community's conservative norms, and she could retreat into the anonymity of the city.

During this period, Gothenburg was a city marked by pro-

nounced class conflict. A year earlier, the city held the Gothenburg Tercentennial Jubilee Exhibition, a joint exhibition of art, crafts, and technology. The exhibition was celebratory and modern and attracted four million visitors. However, at the same time, workers in the city were demonstrating against poverty and a lack of social reforms. The elegant restaurant Lorensberg was an established entertainment venue in the city, located in the area assigned to the Jubilee Exhibition right by the recently constructed Götaplatsen, a monumental city square. This is where Agda Karlsson and Johan Taikon met late in the winter of 1924. She was employed as a waitress and he as a violinist.

*

I open the door and enter into the foyer. An unopened copy of the daily *Dagens Nyheter* lies on the bench by the coatrack. The house is quiet. Outside, the taxi that I took to get here drives away. It is May and the skies are gray and Rosa Taikon lies on the sofa in her studio, resting. She hears me and calls my name. I enter the room. As she sits up she gathers her hair into a ponytail. I didn't hear the car, she says. We sit quietly for a while, her hand on mine. She wants to keep herself warm, she says. We might as well start a fire in the iron stove already. Then we'll go upstairs and make lunch.

We are in Flor, Ytterhogdal, Sweden. Rosa Taikon has lived here since 1973. She and her then-husband spotted the house during a ride home to Stockholm. They had been to Umeå and exhibited silver: upon discovering the house they went for it right away. The building, a former school, radiates all the way to the road: a black exterior with turquoise and yellow corners.

We go up the stairs to the kitchen. The white wall-to-wall carpet that curves up the rounded stairs and spreads across the upstairs living room mutes our steps. I glance at the painting hanging by the hall window: a portrait of Rosa Taikon painted by Albin Amelin. She stands in a half-profile with one hand resting on her hip.

Rosa Taikon is the second oldest child of four siblings. She was born in July of 1926 in the furniture-producing town of Tibro, two years after her older brother Paul. When Johan Taikon met Agda Karlsson he had already lived with one wife. According to the authorities' records, she was named Katarina, which could have been her Swedish name. By others she was called Masha and that remains the only name that Rosa knows her by.

– Masha was a dancer at the Bolshoi Theatre in Russia and older than my father. She was not Roma. Grandfather had forbidden their relationship but they got married anyway. Grandfather simply had to accept it, says Rosa.

Johan and Masha Taikon could not have children, but they took in a foster child, a girl whom Johan's sister had conceived in a relationship with a non-Roma man. To Rosa's grandfather, the daughter's extramarital child was so shameful that he had told his daughter to go drown herself. She was on her way to fulfill his wishes, Rosa was told as a child, when she was stopped by Johan. He supposedly encouraged the sister to come live with his family and assist with the carnival, and when the child was born he and Masha would care for it. The child was named Stina, and she was later married in the early 1920s at the age of fifteen. In a photograph from the 1960s, Rosa, Stina, and Stina's husband sit and drink coffee in Rosa's living room.

Throughout Stina's childhood, Johan Taikon's carnival was successful; she had everything she wanted, says Rosa, and during those years the family was prosperous.

Johan Taikon was a perfectionist. He worked nearly around the clock, either taking care of the carnival and the music or with tin plating and silversmithing. Rosa recalls how he sat up at night working on a piece of silver by candlelight. Everything had to be done just so. He abhorred sloppiness and middling efforts.

When Stina was married and had left Johan and Masha Taikon, Johan's brothers started to ask if he shouldn't consider marrying

a woman with whom he could have children. Masha must have suspected that her husband would leave her for another woman, so when Johan then met Agda Karlsson and told Masha, the two of them struck an agreement: Johan could remarry and Masha stayed in the camp. In that way, Masha's economic and social future was secured.

Rosa Taikon calls Masha *mami*, "grandmother" in Romani. When Johan Taikon and Agda Karlsson were married, Agda and Masha became friends, almost like mother and daughter. Masha was then in her fifties and Agda 21.

– Mama called Masha *Dale*, mother. When we were little it was Masha who cared for us when mother and father would go out in the evening.

Agda Karlsson left her life in Gothenburg when she met Johan Taikon. She learned how to speak Romani, wore Roma clothing, and became a part of the Swedish Roma culture in the mid-1920s. In a photo from when their son Paul was not more than a year old, the new parents look happy. Agda is in a dark fur coat and a hat typical of the 1920s; Johan is in a bow tie, hat and light wool coat. Between them in Johan's lap sits Paul in a leather cap. Behind the new father and the little child stands Agda Karlsson. Her gaze is clear and open.

Paul Taikon was born at a hospital in Lund on December 17, 1924, and baptized one week later, according to the hospital's birth and baptismal records, as the son of the unmarried Agda Karlsson. There is no record of a father. One reason might have been that Agda and Johan did not want to subject themselves to others' condemnation by revealing that he was the father. It was extraordinary in the 1920s that a Swedish woman would have a relationship with a Roma man. But when the couple's second child, Rosa, is born in 1926, Johan Taikon is in the picture. In parish records for Lundby, where Agda Karlsson remained registered although she no longer resided there, Johan Taikon is identified as the father of

the children. Both children are "born outside wedlock." Johan and Agda were married only according to Roma tradition; they never registered their marriage according to Swedish law. It was common that Roma couples initially had a Roma ceremony and were legally married at a later date. One reason that Agda and Johan remained unmarried could have been that Johan never became a Swedish citizen. At the time, children automatically inherited the father's citizenship. Johan Taikon remained stateless his entire life.

When Rosa was born the authorities were familiar with the fact that Agda Karlsson and Johan Taikon lived together. In the parish records there is the following note concerning Agda: "Runs around with the gypsy Johan Taikon." Neighbors and acquaintances in Hisingen were probably familiar with these circumstances. Finally, it is noted about Agda that she was a "carnival owner." It is possible that Johan for a time had transferred the business to Agda, since it may have been easier for her to obtain the necessary municipal permits to operate the business. In January of 1930 the third child was born, the daughter Paulina, in Fritsla, approximately 40 kilometers from Agda Karlsson's hometown, Härryda. In 1932 the couple's youngest child, Katarina, was born.

The following summer Johan Taikon and Agda Karlsson lived with their children in Stockholm. They had set up camp by the old Skanstull Bridge abutment on the island of Södermalm, down by the community gardens. Paul and Rosa, who that year turned respectively nine and seven, worked at the carnival while the little ones, Paulina and Katarina, stayed with their mother. But Agda Karlsson was not in good health. In April of that year she had diarrhea and a fever that rendered her helpless. After three weeks she recovered somewhat and was up and about and working, but she soon became sick yet again. On June 12 she sought care at the Serafimer Hospital on Kungsholmen: she had a burning pain in her abdomen, and all she could ingest was broth and juice. The nurses tried to get her to eat eggs and cream—according to hos-

pital records Agda weighed 43 kilos when she was admitted—but she had no appetite at all.

Johan could only stand by and watch as Agda grew weaker and weaker. Rosa Taikon recalls that mami prayed to god in Russian. Rosa thought that if she did the same maybe Mama would get better. There is a photograph of Rosa from those days in June of 1933, taken in the family's tent. Rosa, six years old, clasps her hands in prayer for her mother. Three days after she was admitted, Agda Karlsson died, at 10:15 p.m. The cause was pulmonary tuberculosis.

– My next memory is of large stones with gold inlay and flowers all around. I have a bouquet of lilacs that I've been allowed to pick from the ladies' hedges in the community gardens. I think to myself that it's a shame Mama isn't here: she loves flowers. But why is everyone so sad? *Bibi* Voule holds my hand and weeps. The women remove their headscarves and wave them in the air and on the ground ahead of them as they walk. They shout words into the air. We are at the Skogskyrkogården cemetery and arrive at a small chapel. There, Mama lies in a box; she wears Roma clothing. I ask bibi Voule: Why is Mama lying there? I have to wake her up. Bibi Voule holds my hand tightly. Your mother is dead, Rosa, she says. Paul comes up to me, he says: Rosa, Mama is not alive, she cannot breathe. Papa has made a beautiful silver vase and cross for Mama. I ask Paul if he believes what mami says, that Mama can see us, that she is in heaven. Yes, I think so, Paul says.

Sorrow permeated the camp after Agda died. Johan Taikon took the loss of his wife very hard: older relatives recalled that he often retreated into himself. They also felt the loss; Agda had been a natural part of the family, but life must go on, which it did in large part due to female relatives' care for Paul, Rosa, Paulina, and Katarina. And thanks to mami. Masha was still a part of the family and a source of support when Agda passed away. Now Rosa and Paul were old enough to participate in the carnival's musical performances. At about the same time, in 1934, Johan had attempted

to register his two oldest children at a school in Östersund. Paul and Rosa were permitted to attend the school for a few months; their studies, however, came to an end after the school decided that it did not admit "gypsy brats."

– Papa understood that he needed to teach us something, a trade. Paul learned how to play the accordion and piano. He enjoyed imitating Louis Armstrong's voice. I wanted to play the violin; I thought it was a beautiful instrument. One day I saw Papa assemble a large drum kit and I thought: who's going to play that? You sit down right there, Rosa, Papa said. I sat on the stool and disappeared behind the drums, she recalls.

Rosa was nine years old when she became a professional musician. Paul was eleven.

A life with a dance band, concerts, and performances ensued. They played at community centers and parks across Sweden. Children were prohibited from performing in the evenings, a law that was difficult to circumvent in the larger cities.

– When we played in Uppsala until eleven o'clock at night, a police officer approached the dance floor. He looked at Papa and asked, How old is the girl? Mister Taikon knows that children are not allowed to play. Yes, I know, Papa said, but this is how we make a living. I had to leave the stage.

In the mid-1930s, Johan Taikon met a new woman. She was from Skönsmon outside Sundsvall, where the family lived for a brief period. The woman's family was scandalized. In Katarina Taikon's books about her childhood the woman is called Siv; I will use the same name here. She would become Katarina Taikon and her siblings' new mother and also the mother of three younger children. When Siv and Johan were married a new phase began for the family. To begin with, there was no longer a place for Masha in the camp. According to Rosa Taikon, it was inconceivable to Siv to live in the same camp as Johan's ex-wife, even though they had divorced more than a decade earlier. Masha moved to her foster

child Stina's camp and, for the second time, Katarina and her siblings lost a loving and caring adult.

Life for the family slowly changed during the second half of the 1930s. Johan Taikon's carnival was no longer as large and profitable. He developed asthma, which periodically made him weak. When he as a 57-year-old met Siv, he had lived his entire life in tents and, later, trailers, having constantly traveled. Johan Taikon was beginning to feel the physical consequences of his lifestyle. In April of 1937, Siv and Johan had a daughter. That summer, Johan gave up Katarina.

*

Charles and Isabella Kreuter had run carnivals their entire adult lives. In the phone book, Charles Kreuter was listed as "artist." He was born in 1887 in the east coast city of Kalmar and belonged to a circus family of Danish heritage that traveled across Sweden, Norway, Denmark, and Germany. In 1917 Charles married Isabella; friends and family called her Lola. Her maiden name was Armstrong and she was born 1890 in Leeds, England. Together they traveled with different circus companies, where Charles Kreuter performed as a clown.

In the early 1930s, they moved to Skellefteå in the north and quickly found a plot of land to lease. There was a great deal of competition in the city. The first carnival came to Skellefteå as early as 1920. It touted an electric roller coaster, a boxing machine, and a so-called Oriental theater. Thanks to iron ore discoveries in nearby Boliden, Skellefteå became a lively community with an active entertainment industry. During one period, there were 20 dance halls operating on any given night, and Charles and Isabella Kreuter participated in these developments. They invited radio celebrities such as the actor Stig Järrel and singer Karin Juel, and their carnival could offer a flying carousel, a shooting gallery, and a museum of curiosities. They even advertised "raining oranges."

The Kreuters lived at Sörböle, just south of the Skellefte river. On August 1, 1937, when they had found a permanent plot for their carnival, a "gypsy orchestra" made its debut at the Kreuters'. It was the siblings Paul and Rosa, thirteen and eleven, and their father Johan Taikon, who performed. Johan Taikon knew the Kreuters from owning a carnival for most of his life. At this point, he had lived in Sweden for nearly 40 years and had seen every corner of the country.

One evening Charles and Isabella Kreuter came down to the camp. Rosa Taikon recalls that she served tea to the adults. The Kreuters asked if they could adopt Katarina. They cared a great deal for her and Paulina. Johan Taikon, who initially had firmly refused this idea, gradually let himself be convinced. Siv also felt that it was a good idea: the winter would soon be upon them and it would be better for Katarina to live in a house. But Rosa does not think it was concern for Katarina that had actually motivated Siv. When the family had completed its run in Skellefteå, they drove Katarina to the Kreuters' home.

– There, Aunt Lola had decorated a room. There were little chairs and a little table. Everywhere there were teddy bears, balls, and soft little stuffed puppy dogs. It looked like a toy store. Then Aunt Lola fetched a doll that was nearly as big as Katarina. She adjusted something on its back and the doll started to move. Kati just stared at the doll. Then she threw herself at it. When Kati saw it she forgot all about me and Paulina, Rosa Taikon recalls, laughing. Rosa, Paulina, and Paul wept as they drove away.

At some point during this time, when she is five years old and living with Charles and Isabella Kreuter, Katarina Taikon's own memories begin to take shape: she came to a large, warm home. She had her own room and her own bed that was always dry. She had dolls and dresses and any food she wanted. The winter came and Katarina remained with the Kreuters.

There are two photographs of Katarina from her time with the

Kreuters. In one, she is wearing a dark winter coat and Sami cap that has a large pompom affixed to its top. In her lap she holds a cocker spaniel: the dog poses patiently and Katarina smiles.

In the other image, Katarina sits on the hood of a large black car. She wears a white dress, white hat, and knee socks. On her feet are sandals. She smiles, and cannot be older than six. Isabella and Charles Kreuter stand to the left of Katarina, elegant and relaxed while the sun blazes down on them. Charles Kreuter's eyes are cast under a shadow from beneath the brim of his hat. To their side stand two other adults, presumably friends of the Kreuters. The group may have gone for a drive during the gorgeous summer afternoon. If one glances at the photo one cannot avoid seeing what's unfolding just behind Katarina on the hood of the car. There stands a little white dog on its hind legs, ready to do tricks for the camera.

Maj Lundmark met Katarina Taikon in Skellefteå: she was eleven years old when Katarina moved into the Sörböle neighborhood. Maj Lundmark recalls a pretty dark-haired girl who lived with the Kreuters in the house they rented from a farmer. Nearby was a farm with some cows and in the newer, more modern, section of Sörböle were a few grocery stores and shops. Once, Maj and the neighbor girl Karin were allowed to take Katarina to the movies. They crossed the bridge to the north side, and then walked a few blocks on the main thoroughfare.

– We were so proud when we went to the movies with Katarina. She was her own person. You could tell that she wasn't like us, says Maj Lundmark, today 85 years old, when we speak on the phone.

Katarina played with the other children in the yard in front of the house. Everyone was kind to her, says Maj. She occasionally saw Charles Kreuter, but recalls Isabella Kreuter more vividly.

– Mrs. Kreuter was strict, somehow. I don't think I would curtsy for her, but she was definitely strict.

Katarina Taikon lived with Charles and Isabella Kreuter for two

years. In the summer of 1939 they delivered her to the municipality's child welfare services: the couple had wanted to adopt Katarina, but Johan Taikon refused. They had made many attempts and each time been rebuffed. Finally, they became angry. Katarina later recalled that they had been forced to wrest her away from Isabella Kreuter. On July 12, 1939, a few weeks before her seventh birthday, Katarina was taken to the orphanage in the town of Umeå.

"–KATITZI! KATITZIII ...! Why do you always have to go looking for that girl?"

Here begins the first of thirteen books in Katarina Taikon's autobiographical series *Katitzi*. Katitzi is seven years old and lives in an orphanage. Katarina's time at the orphanage maintained a prominent place in her personal narrative. The memories are vivid: she recalls each room in the building, the women who worked there, and the dynamics between the children. The orphanage became the point of origin for Katarina Taikon's life story: she had been given away. Now she was to return home.

The orphanage in Umeå was almost 140 kilometers from the Kreuter home in Skellefteå, the house that for two years was the center of Katarina's world. The orphanage appears to have been relatively small, with a couple of employees and housing about a dozen children. She was registered there as Ketty Karlsson. Katarina, *Kati* in Romani, was called Ketty by some while she was a child. But Karlsson, Agda's last name, does not appear in any other documents pertaining to Katarina Taikon. At some later point, it is evident that an additional note had been made in the registration documents: "Ketty Karlsson" is in parentheses and "Katarina Maria Taikon" had been added. On the line for the parents' names, the occupation and address were also written: Johan Taikon (gypsy) Agda Elisabet, née Karlsson (deceased).

In Katarina Taikon's rendering of the orphanage there are two adults, Miss Kvist and Miss Larsson. One good and one bad, surely exaggerated in order to illustrate both the care and the disapproval

she encountered at the orphanage. And the children: the siblings Gullan and Pelle, who had lived at an orphanage almost their entire lives and who became Katitzi's friends. Later, Rut: eager to report each prank to the teachers.

One event recounted in *Katitzi* takes place during a warm day by the lake. The children have been looking forward to swimming and quickly change in order to jump into the water. Katitzi remains standing at the water's edge. Her friends ask her why she doesn't put on her swimsuit. It's cold, she says. Pelle and Gullan don't understand what she's talking about; they jump into the cool water. When they resurface, Katitzi is sitting on the dock. Reluctantly, she tells them that she can't swim. When Rut hears this, she laughs and proceeds to push Katitzi into the water. Flapping her arms does nothing: Katitzi still sinks and Miss Kvist comes to the rescue.

After a few weeks at the orphanage, Johan Taikon came to retrieve his daughter, but Katarina did not want to go. She did not recognize the man in the car and she did not understand what the children peering out from the car windows had to do with her. Johan Taikon struck an agreement with the staff that Katarina could remain at the orphanage a little while longer. In the meantime, they could prepare her so that the reunion with her family would be less frightening.

It appears to have been at the orphanage that Katarina Taikon first became aware of the fact that others perceived her as Roma. Even with the Kreuters, she most likely experienced a kind of tension, felt others' stares, or heard comments made behind her back, but it was at the orphanage that they were first spoken aloud, against her. In *Katitzi*, that feeling is illustrated by a conversation that takes place in her absence. Rut tells the other children that she has heard the adults discuss the fact that it is time for Katitzi to go home. She has also heard them say that Katitzi is a gypsy. The children are confused; no one really knows what the word means.

For Katitzi, it is a conversation with Miss Kvist that helps her comprehend what is peculiar about her father and siblings. Miss Kvist tucks her into bed and offers her *bullar*, which are quintessential Swedish cinnamon buns, and *saft*, a juice-like drink made from fruit extract, sugar, and water. Ten days have passed since your father was here, Miss Kvist says. Katitzi nods and wants to hear more about her father. "What do you remember from before the circus people?" asks Miss Kvist. Katitzi says that the circus people told her that her mother died when she was very little. She also remembers something strange: a fire inside a large barrel, and that she was tied to the barrel. Miss Kvist thinks that the barrel was their iron stove and that Katitzi was tied to something so that she would not get too close and be burned by it. Miss Kvist tells her that everyone on earth does not live under the same conditions. Katitzi's father and siblings live many kilometers away. Siblings? Katitzi is shocked. Miss Kvist tells her that she knows a lady who lives near Katitzi's family who has told her that a girl around twelve or thirteen years old has knocked on her door asking to borrow a large tub to wash clothes. The lady has also seen several little siblings. The big girl was named Rosa and she really misses Katitzi. Katitzi marvels at what she hears, and she falls silent. Someone misses her? "They probably don't have a laundry room and are very poor," Miss Kvist continues, "but they are doing fine. You will be happy there."

These words prompt strange feelings within Katitzi. "Can my father help the fact that he has black hair and such a large beard?" she suddenly asks. "Oh no," says Miss Kvist, "many men have beards. My father also had black hair, just like yours." Miss Kvist herself was teased for having red hair. Katitzi thinks that people who tease others should be punched; some people cannot be reasoned with. She tells Miss Kvist that Rut teased her in the beginning. "Why?" asks Miss Kvist. "Because I was black. And my hair was long." Rut also teased Katitzi about the dresses she had been given by the circus people. "That was probably just because she

was jealous of your pretty dresses," says Miss Kvist. But now Miss Kvist has planned something very special: before Katitzi leaves they are going to have a party for her. And if Katitzi will lend Rut her blue dress it will make Miss Kvist very happy.

On August 15, 1939, Johan Taikon arrived at the orphanage in Umeå and brought his daughter home.

*

Katarina Taikon had been away for two years. In Sweden, concerns were growing about impending war, while Europe at large prepared for it. Katarina came home to a camp set up in Strömåker, outside Umeå. She had little understanding of what life in such a camp looked like. She was seven years old and had only vague memories of life before the Kreuters, and there she had had a large, warm house and even her own room. But there were no easy ways to acclimate Katarina to a life in camp; she simply had to step out of Papa Johan's car and become part of the family again.

Katarina was nicely dressed when she came home, Rosa recalls.

– I said to her: "I'm going down to the lake to do laundry. Don't you have a laundry room, Rosa? Kati said." And when Paulina greeted her in Romani, Kati just stared at her.

The siblings were happy to be reunited with Katarina. Paulina was a mere two years older and would become the one Katarina spent the most time with. Rosa was older and the most responsible of the siblings. At age thirteen she was the one who took care of the more significant household duties: Rosa did the laundry, washed the dishes, and cleaned. She cooked food for the adults and got bottles ready for the little ones. Sometimes she also sewed clothes. Paul followed in his father's footsteps: he had become a skilled tinner and was gifted at anything practical or technical.

The first thing that happened in her new home was that Siv

Taikon took the doll that Katarina had brought with her from the Kreuters. Siv said that she would take care of it, Rosa recounts. Katarina burst into tears. I see, so it begins again, said Paul. Katarina Taikon herself recalls that she was forced to change clothes. She was to have the same kind of clothes as her sisters, Siv instructed. But Katarina objected: she wanted to wear her own clothes, the ones she already wore and liked. Paulina quickly took her hand and ran with her into their shared tent. Paulina gave her some advice: the first was to never talk back to Siv; the second was to never whine. Then Paulina herded her little sister through the camp. She showed her around the carnival: they had a shooting range and slot machines, a carousel and a bandstand. At one booth was a ring toss and in another corner you could have your fortune told. Everything was set up in a large circle. Rosa and Paul performed with Papa: Rosa usually on the drums and Paul on the accordion. It was a lot of work, Rosa recalls. After a day of intense household work she got dressed to play music and dance at the carnival until late at night. The next day she got up early and everything started all over again. Paulina and Katarina's job was to staff a game called Make a Point: It cost 25 öre a turn. Many who came up to their little booth asked if the girls couldn't sing "You Black Gypsy," a hit song from the 1930s.

> You black gypsy, come play your song,
> tonight I want to forget everything from long ago.

For the performance they would receive a 50-öre piece. Katarina quickly learned the lyrics.

In the shooting gallery you could win a Monark bicycle or a set of china from the manufacturer Upsala-Ekeby. The first-place prize that everyone always chose was a new bicycle, according to Rosa.

– People got to shoot every night and whoever had the most points at the end of our stay won. Wow, did the boys in the village shoot. We had to make sure to be near a railway station to pick up

the delivery of boxes of china from Ekeby. Everything had to work just so.

Gradually Katarina came to understand what made each day work. In the mornings she and Paulina woke up and together went into the woods to gather pine cones and twigs for the iron stove. Some days they got up a little bit earlier than usual in order to have time to play bakery. Katarina writes of how they prepared the soft soap they had brought with them and whisked it into whipped cream and how they decorated their cake with lingonberries. They would talk extensively during these adventures: Katarina would tell her about the circus people and about the beautiful dolls she had and all the delicious food she had eaten. They bickered and fought and quickly became friends again. If there was something that Katarina did not understand she would ask Paulina to explain. It might be a word in Romani or something someone had said that Katarina thought sounded very strange; she was still too young to understand irony.

Katarina was a hard worker, says Rosa. After they had gathered wood in the forest they each fetched water in a big bucket. Meanwhile, Rosa prepared bottles for the three little siblings, and sandwiches and black coffee for the others. If it was a laundry day, Rosa would ask her younger sisters to go to the nearby farmer and ask to borrow a washtub. Katarina and Paulina admired their older sister: she could do anything and she was phenomenal on the drums. Rosa was big: she did not play games like Katarina and Pauline liked to do.

Sometimes Katarina and Paulina were given bigger responsibilities. When the family lived in Vännäs they were sent by train to Umeå in order to sell copper bowls that their father had plated. They walked, Katarina writes in her debut *Gypsy Woman*, from door to door in the city and if one of the ladies asked if the neighbor lady had bought one you had to answer yes, otherwise you risked missing a sale. But after a few days, Katarina and Paulina grew tired of walking around selling bowls. They took a break

from work and went to the movies. The film, *Now, Voyager*, with Bette Davis, was so captivating that the break became longer than they had planned. They saw the film every night for a week, twice a night. Bette Davis played a young woman whose life was completely eclipsed by a tyrannical mother. Katarina and Paulina surely filled in the scenes and plot with their own imagination; they did not understand English nor could they read the subtitles. When the money stopped arriving by mail, Johan Taikon sent big sister Rosa to find Katarina and Paulina. It was not a happy father who welcomed the sisters when they returned home.

In addition to playing music, Paul Taikon worked with the carnival and tin-plating. After breakfast, he began to prepare for the evening's carnival and if there were bakeries, restaurants, or farms nearby he could plate their copper goods. Like Rosa, Paul had big responsibilities as a teenager. He was a people person and was courteous and helpful. Rosa recounts an occasion when they had set up camp for a longer period of time. Every day they saw an old woman in the forest gathering pine cones and twigs, which she placed in a large sack on her back. Paul would run up to her and help her carry the sack home. The younger siblings felt safe with Paul.

For Johan Taikon, the days mostly looked the same. He managed the carnival, did tin-plating and worked with his silversmithing in the evenings, when he could get some peace and quiet. Johan preferred to travel alone, away from his extended family. He knew that traveling together in a large group, there could always be someone who behaved badly, which was not something he wanted to risk. When they would leave land they had rented from a farmer, he was fastidious about cleaning up; there could not be a bottle cap on the ground. Rosa and her siblings swept the flattened grass left behind by their tents. A big part of Johan's time was also devoted to planning the family's journeys. Most often they could be in one place for three weeks, then the municipal authorities would drive

them away. It was important for Johan Taikon to have a good relationship with the local district superintendent, otherwise they may not be allowed to return.

Sometimes they would receive a letter from the district superintendent, notifying them that they would have to leave the municipality within a few days. Paul was upset by the fact that his father would so readily agree to leave. Paul wanted to live somewhere, settle down, perhaps get a job outside the camp. He was also concerned about the fact that the younger siblings did not get to attend school. But Johan Taikon believed that it would only make things worse to resist the police, who did not listen to reason. One time, they were driven away on even shorter notice. Katarina recalls that the superintendent was so determined to have them gone that they assisted the family with moving their things. But the cars stopped at the outskirts of the village. It was night, the family's belongings were unloaded. The drivers explained that they had done their job and left Johan and Siv and the seven children at the side of the road while rain poured down.

Another time, Katarina writes in *Gypsy Woman*, they had rented land from a farmer's wife. After a few weeks, her sons arrived at the farm. There, they learned that their mother had permitted Roma people to stay on the land, and they went down to the camp and drove the family away. Katarina and Paulina were frightened, and they began to cry when the men grew loud. Johan, Siv, and the children were given a few hours to pack up. When Katarina and Paulina went to return a washtub that they had borrowed from the woman, she came out and spoke with them. She said that if it was up to her they would never have to move, and she hoped that they would not be upset with her. Then she gave them a basket full of fruit and freshly baked bread.

For Siv Taikon, life with Johan was not easy. If she had grown somewhat accustomed to the constant moving and perhaps even

life in a trailer, she could never come to terms with the insults, hostility, and harassment her family was subject to. It was upsetting for a non-Roma woman who, when she met her husband, had no idea what it meant to live as a Roma person in Sweden, that strangers would come to the camp and throw rocks at them. What was most difficult for her to understand was why she was attacked: she was Swedish and white. But in Rosa Taikon's opinion this is not strange: for people who were racist it was even worse that Siv was blonde. How could she live with a gypsy, people would say to her. Siv Taikon most often retreated from the day-to-day work and socializing, complaining of migraines.

How did Johan Taikon explain the stares his children endured? People gawked at them: they stared, sometimes on the sly, sometimes unabashedly. "They look because they don't recognize you," he might say. It was a father's way of protecting his children from reality.

When Katarina and Paulina Taikon in the early 1940s crossed a school playground in Linköping, and all the children paused in their games and pointed at them, the sisters tried their best not to care. They would finally get to start school, something they had wanted to do for years.

Katarina Taikon describes the visit to the principal's office as a protracted and silent wait where her father's erect posture gradually grew more deflated as the minutes passed. Finally, they were allowed to meet with the principal. He explained that he would very much like to admit the girls to the school, but that unfortunately it was not possible. The other parents would pull their children out of the school if Katarina and Paulina were admitted. Johan Taikon could not hide his disappointment. He replied that he was very dissatisfied with the conversation, took his daughters by the hand and left. Katarina and Paulina were also dissatisfied. Katarina was surprised: she did not quite understand what had just happened. Paulina was greatly hurt; she walked in silence. When Katarina

wanted to talk to her about the principal's strange answer and asked if Paulina had heard what he had said, Paulina snapped. "Of course I heard what the principal said: Do you think I'm deaf?"

After a day or two, a female teacher came to the camp. She knew what had happened with the principal and offered to teach Katarina and Paulina herself. The first time the sisters sat in a classroom was in Linköping in 1942. For an hour a day, they were permitted to secretly come to the school when all the other children had gone home.

*

The shortage of goods during the war and the need for ration cards strained the Taikon family's finances. Johan Taikon did not receive a ration card since he was not a Swedish citizen. If a loaf of bread cost one Swedish crown he had to pay twice as much without a card. The family's finances were stretched so thin that Johan applied for welfare assistance during four months in the early 1940s. During this time, Rosa was married off to her cousin Stevo, the son of her uncle Savka Taikon. She was fifteen years old. There was no love between them, says Rosa. She believes that she was married off to a cousin because her father felt comfortable with the fact that he was a relative.

– Among these old men, the Kalderash, you didn't marry your girls off to just anyone. They saw themselves as a little bit above other Roma and with a stronger social position. But the marriage didn't last. There was a *kris*, a kind of trial, and the ruling that came down was that Papa should return the dowry payment. Papa paid and I was divorced, but I had to continue wearing a headscarf since I was a "used" woman. Being away from the family was not fun: when I returned home, Katarina and Paulina threw themselves around my neck. They wanted to tell me about everything that had happened while I was away. That night, Kati lay on my one arm and Paulina on the other. It was the best feeling I've ever had.

Katarina Taikon writes about the period when Rosa was away and she herself was around ten years old. Paul was worried: no one was taking care of Katitzi. "Why are you such a mess?" he asked one day when her hair was tangled and her face dirty. Katitzi, who had been cared for by Rosa every day since she had returned from the orphanage, replied, "Why and why and why. You ask about so much! Imagine if I asked you so many questions. I look like this because my mother got married and left me behind."

Another change that took place when Rosa was away was that Siv Taikon's abuse of Katarina and Paulina grew more severe. Siv had continuously ordered them around and treated them cruelly; she did not like that Katarina was so outspoken. She might pass Katarina and without warning pull her hair or pinch her, and when Rosa returned home she witnessed slaps across the face. Katarina grew afraid of playing games and speaking freely, since to think aloud could lead to threats and beatings. Katarina began to retreat into her own fantasy world: she met a prince with golden blond hair and velvet clothing. He was the most beautiful person she had ever seen. She dreamed that she got to participate in the public radio program *Barnens Brevlåda* (The children's mailbox). Another time she was a famous Russian singer whom the audience showered with red roses. In *Katitzi* she tells her little dog and companion: "Swing, I'd like to be big, but still stay little."

Katarina and Paulina helped each other avoid Siv's wrath. Sometimes, when Paulina knew that a particularly severe punishment awaited Katarina, she had to beg Siv to not strike so hard.

In 1943, when the family lived in Södertälje, south of Stockholm—they had been permitted to set up camp adjacent to a golf course owned by a man named Sam, Rosa Taikon recalls—Katarina ran away to her old mami. Masha was at that point nearly seventy years old and lived in a retirement home in Uppsala, a few hours away. Katarina Taikon describes her as a fine lady wearing all black and a straw hat, someone who ignored the staff and had her whiskey

every evening. Masha welcomed Katarina with open arms. She bathed her and gently deloused her. Katarina got to hear stories about Saint Petersburg and about the journeys around Sweden before she was born. The portrait of Masha in *Katitzi* is filled with devotion. Katitzi teases Masha about her Swedish pronunciation. Masha says "mickit." You should say "mycket," Katitzi corrects her. When Masha then sees Katitzi's bruised body she is so outraged that she calls Johan Taikon. It would be better if child protective services took Katitzi than for her to stay with the family, Masha says.

It is impossible to know whether or not this conversation actually took place. The escape to Masha and the tenderness and love between the two of them should most likely be regarded as a means for the adult Katarina Taikon to address her father's responsibility for the violence embedded in the family's history.

Paulina began to grow sick of life with Siv and Johan Taikon. In *Katitzi* there is a scene where Paulina does laundry in a large washtub. It is a day like any other and the event is unremarkable. Siv is angry: she shoves Paulina against the tub so that the water splashes, and then slaps her across the face. Only, this time Paulina strikes her back. It may be that Katarina Taikon did not witness this particular event, but that it is a way to illustrate Paulina's active resistance to the many attempts to suppress her. What actually happened is that Paulina ran away to her aunt Voule Taikon's camp in Sköndal, south of Stockholm.

The atmosphere at home grew so unpleasant that Paul and Rosa took matters into their own hands. They took Katarina and set up their own camp in Rotebro, 20 kilometers north of Stockholm. Rosa negotiated with the district superintendent so that they were allowed to stay for a longer stretch of time. Rosa told fortunes and Paul, who mostly did tin-plating at that point, obtained a permit to run a shooting range.

One incident that Rosa Taikon immediately mentions when we discuss Rotebro is that Paul was assaulted. Some local men

came down to the camp and wanted to try out the shooting range. Things quickly grew tense. One of the men shot Paul in the hand while he was changing the target: when Paul asked what they were doing, they pushed him to the ground and began to beat and kick him. Rosa acted quickly. She grabbed a rifle and used the butt to strike one of the men in the head. She was terrified, she says. Katarina, no older than twelve, hid behind a car. When the district superintendent arrived at the scene it was in complete chaos, and he had to fire into the air in order for anyone to listen to him.

Normally Rosa and Paul, as well as the younger siblings, were good at warding off violence. They encountered many intoxicated and obnoxious people and were good judges of people's character. They knew when they could ask someone for help and when to step back. Rosa tells stories of farmers who showed kindness when she had a hankering for *sockerkaka*, a kind of Swedish pound cake. She would buy milk, butter, flour, and a few loose eggs. Then she went over to the farmer's wife and baked the cake in her oven. A warm sockerkaka just out of the oven is still one of my most favorite things, she says.

Besides the assault, the time together in Rotebro afforded the siblings some peace. Katarina Taikon was different when she was alone with her brother and sister. She asked adults questions, wondered what they meant when they spoke and why they did what they did. She grew animated when there wasn't the constant threat of violence, and all of them had some breathing room. At the same time, Paul and Rosa were aware that their life of freedom could not go on forever. Some cousins thought they should join them in Sköndal. Bibi Voule already lived there with her husband, Johan Dimitri Taikon, and with their children and grandchildren. Johan and Siv Taikon had also joined that camp.

*

To attempt to recall one's childhood is demanding. Images, sounds, faces, and feelings are buried within us, within the mind's

reach in some ways, yet still so distant. Rosa Taikon has a sharp memory. She recalls details about a life seventy years ago—place names, events, encounters—which for the most part align with my own research. But the interviews with Rosa are not simply about extracting information. Hours spent in the red easy chairs in her studio are difficult work for her. We sit across from each other with a pitcher of water on the table, and Rosa retreats into the past. Sometimes when several images appear at once she is forced to close her eyes and collect herself so that none of them will vanish. At other times, deep sorrow engulfs her. Most often, this sorrow pours out. It fills the room and we can talk about it, but sometimes it also frightens her, taking hold of her in a gut-wrenching way. How much can I demand of Rosa, I often ask myself. How deeply can I ask her to remember when it comes to how she and her family have been treated? Can I ask her what it feels like when people throw rocks at your siblings? Rosa often returns to how her pain turns to rage when she speaks in schools and other spaces. It's something she tries to suppress. People do not take in your message if you're angry: I have to better control my anger, she says when she is in a self-reflective mood.

During the hours with Rosa it also became clear how various members of your family recall things differently, in part because we actually experience different things. Rosa was, for example, married off when Katarina ran away to Masha while the older woman was living at the senior home; she has no memory of that event. But also, in part, because the same events mean different things to different family members.

The camp in Sköndal was located by a bare hillock at the southern end of the Skogskyrkogården cemetery. Thirty or so people lived there in 1944. At this time, Roma people in Sweden traveled less and less. Copper goods had begun to be replaced by aluminum. In addition, tin was scarce during the war, which made it even more difficult to do tin-plating. For many, the rationing of gasoline also

meant that it became nearly impossible to run carnivals. Roma people's previous occupations, and thereby their modes of survival, quickly changed very drastically.

Little Sköndal became the first permanent camp in Stockholm, and the trailers and tents butted up against each other. Arriving to Sköndal was exciting for Katarina Taikon: it was vibrant and lively and there was her big sister Paulina, whom everyone now called Lena; Katarina had missed her. Katarina also had two friends, her second cousins Mauritz and Marianne Taikon. They helped each other do various chores and when there was time left over they played together. Judging from the descriptions in *Katitzi*, life in Little Sköndal seems to have been overall relatively easy.

For Rosa Taikon, however, life in the camp was far from fun. She recounts that the atmosphere was muted because one of the cousins was ill with tuberculosis. Roma people were extremely wary of contagious diseases: it was something one did not discuss, but everyone was well aware of. Fear of contagion was founded on experiences that equated illness with death. Rosa and her relatives could not socialize the way they once had. The mood in the camp was tense. During a few weeks Johan Taikon moved Katarina and her younger siblings to the Nyboda orphanage, where they stayed until the cousin had recovered.

That spring something took place that dovetailed with then-eighteen-year-old Rosa Taikon's longing for freedom. She met a woman named Elisabeth Larsson.

– One day I'm washing clothes in a zinc tub when I hear a woman say: Can we come in and see what it looks like? She stepped into the tent and said, my, how nice it is. I replied that it wasn't particularly nice, but it was clean. She asked where we fetched our water from and I said we get water from some people who live in a house near the camp. The woman said: You're welcome to come to my house to do laundry. I was thrilled. Paul drove me and all our laundry to her house in Stureby, Rosa says.

Thus, Rosa and Elisabeth Larsson initiated a friendship that lasted for many years. Elisabeth was an optimistic and active woman, according to Rosa. She owned three successful yarn stores in Stockholm. Later, Rosa would start working in one of the shops, located on Östermalm square. There, the ladies who sold vegetables in the square would buy Swedish wool yarn for their socks. Rosa treated them in the same manner as she did the ladies who bought silk yarn, and Elisabeth appreciated Rosa's way of greeting customers. But what happened immediately after Elisabeth visited the camp was that she offered Rosa employment as a maid. It was time for Rosa to step out into the world: she was moving away from home—for good this time—and she was ready.

This event figured heavily not only in Rosa's life. Katarina Taikon depicts Rosa's move in *Katitzi*: one day Katitzi catches Rosa getting off the bus before her regular stop in order to change clothes in the forest before she goes home to the camp. Rosa hid her Roma clothes in a bag behind a rock. When Katitzi catches sight of Rosa wearing a hat with flowers and a veil, she laughs out loud. Rosa is not amused. She explains that it is modern and that she likes being modern. But Katitzi soon grows serious. Rosa tells her that she is going to move, leave them. Rosa wants to explain to Katitzi.

– Katitzi, do you understand? I have to leave you now, say that you understand, it's very important to me that you understand. You might think that I'm letting you down, but I'll never do that, because you'll be my little girl forever, do you understand that?

Rosa had tears in her eyes. Katitzi looked at her and understood that she had to help by being strong.

– Don't be ridiculous, Rosa, I have so much to do now, I don't have time to hang around with you all the time. You have to try to take care of yourself, since you always want my help and I really don't have time.

To help with the family's income, Katarina started to sell Christmas cards. She bought them at the department store Åhlen & Holm at the intersection of Götgatan and Ringvägen in the working-class neighborhood of Södermalm in Stockholm. One Swedish crown for one hundred cards, which she proceeded to sell for ten öre each. She walked across the city, all the way to the fashionable Nybroplan, and during her walks she met many people. Katarina was observant and inquisitive and had become skilled at reading people in a range of situations. After selling a hundred cards she had made ten Swedish crowns.

Rosa's move also meant that Katarina became the oldest sibling in the home. Paulina had moved in with a friend who lived in an apartment in Stockholm, and Paul had met a woman named Barbro and lived mostly with her. Domestic work fell on Katarina's shoulders. She no longer had time to play and socialize with Mauritz and Marianne. Katarina would soon turn thirteen and her days were filled with laundry, cooking, and child care. At home she was beaten by a deeply unhappy Siv Taikon, who struck her hard, right across the face. Katarina was alone and isolated: as a result, she was happy when she got to go to summer school.

Johan Dimitri Taikon was married to Katarina's paternal aunt, Voule. He was well-known among Swedish Roma and belonged to the same generation as Katarina's father, born at the end of the 1870s. The two of them were often mistaken for each other. Very early on, Johan Dimitri Taikon believed that the Roma children needed access to education. Among Roma in Sweden he was most likely the one with the most frequent contact with Swedish state administrators: he liked to call himself the "gypsy chief" and stepped up and served—perhaps a bit formally and theatrically in the eyes of other Roma—as the spokesperson for Swedish Roma. But he also appears to have had a different attitude toward Swedish authorities and institutions. For most Roma in Sweden, encounters with the district superintendent, social welfare agen-

cies, and other authorities was a necessary evil: you were dependent on them and did your best to maintain pleasant but short-lived interactions. Johan Dimitri Taikon, on the other hand, did not try to steer clear of the authorities' attention. In the 1940s he became an informant for the curator of the state-run Nordic Museum, the anthropologist Carl-Herman Tillhagen. Tillhagen eventually became one of the twentieth century's most influential "gypsy experts."

As early as 1933, Johan Dimitri Taikon wrote a letter to the Swedish National Agency for Education requesting access to education for Roma children. Swedish politicians did not respond. The agency believed that the differences between Roma and other children were too profound for them to attend the same schools: "Especially from a psychological but also a disciplinary vantage point, difficulties would most likely arise for children, educators, and administrators for these very reasons." But in March 1943, Johan Dimitri Taikon made another attempt, together with the evangelical "gypsy missionary" Otto Sundberg. This time the state granted them 1,500 Swedish crowns to start something called the experimental school, the first structured education for Swedish Roma. Of the approximately 500 Roma in Sweden at the time, 5 percent could read and write. The funds were allocated to the municipality and the curriculum was initially developed by a handful of people, including Otto Sundberg, who was motivated by a Christian humanitarian philosophy. Later, the project came to be formally managed by the Swedish Gypsy Missionary Foundation.

Education at the experimental school, which unfolded over the course of one month, took place in a little masonite house, the interior of which was decorated with floral textiles; the roof consisted of a tarp stretched out in an arc above the classroom. One of the students was Aljosha Dimiter, Johan Dimitri and Voule Taikon's son and Katarina Taikon's cousin. Working with the writer Gunilla Lundgren, Aljosha Dimiter later authored his autobiography. The book *From Coppersmith to Nurse: Aljosha, the Son of a Gypsy Chief*

was published in 1998 and depicts both the camp in Sköndal and the experimental school.

The first teacher was named Karin Hartman. She was young, and normally worked at the *folkhögskola*, essentially an institution for popular adult education, in Birkagården, and she was a member of the Salvation Army. Karin Hartman did not know what to expect when she bicycled to her new position in Little Sköndal. People had warned her against bringing anything that could be stolen. The first person to greet her was Johan Dimitri Taikon. He wanted to make clear to her that he expected structure and discipline, no matter how small and temporary the school. Students in the class ranged from six to sixty years old. Among them were Mauritz and Marianna, Katarina's second cousins and friends. When journalists and photographers gathered outside their classroom windows the students sometimes felt like the animals at the Skansen zoo. It was remarkable that these children were in a classroom, according to the journalists: to them, it was a phenomenon full of contradictions.

In August 1943, the daily newspaper *Dagens Nyheter* reported on the graduation in the camp: "Warm and wide, Mama Taikon filled the tent opening, sucking on her pipe with great satisfaction while her progeny sat down for their graduation. Some of the little ones fled into the forest, but eventually settled in with their school caps pressed down on blue-black locks and melodic gypsy Swedish streaming out of their mouths."

In the summer of 1945, Katarina Taikon became one of the students. The discarded school desks that the City of Stockholm had donated were placed out in the school yard. She was to learn how to read, write, and count. But it was difficult to focus: lessons were interrupted by children who started crying and needed to breastfeed, and adults who wanted to drink tea. The sun beat down on them. It became hot and the children would rather go swimming than learn to count. Katarina liked her teacher, but she did not learn much.

That summer, many men carrying black briefcases visited Little Sköndal. They had long conversations with the elders in the camp. One of them was Sven Andersson: he became a "gypsy adviser" and was to see to it that any willing Roma would be permitted to move into apartments. The war was over and the Swedish authorities were starting to shift.

2.

The year 1923 saw the release of a government report that was sixteen years in the making. The subject was how the state should manage what one termed vagrants. In 1907, the government charged the Ministry of Health and Social Affairs with reviewing and developing new legislation concerning social welfare and vagrancy: it was within this legal framework that Roma were addressed. The report also gathered information concerning the size of the Roma population in the country. The state's relationship to Roma as a group is historically characterized by a desire for them to conform to a social system that sought to have the population be permanently settled and steadily employed.

The first Swedish documents concerning Roma date from 1512 and can be found in the City of Stockholm's *tänkeböcker*, city court records, which mention a group that arrived to the city that same year and who were housed in a shelter. The Roma were initially called "tinkerers," a term denoting itinerant tin-smiths which also included other kinds of "travelers." In early legislation concerning Roma and travelers, it was stated that they should be detained and sometimes deported for unsanctioned trade; priests were directed to not baptize or bury people from these groups.

In her dissertation "The Gypsy Question: Intervention and Romanticism" (2002), the scholar Norma Montesino Parra places legislation against Roma and travelers in relation to attempts to create a centralized state: the population was to be controlled. In 1624 a proposal was drafted wherein state-sponsored social wel-

fare distinguished between sanctioned begging—legal for those who were unable to work—and what came to be called vagrancy. People who were not settled threatened the new social order. Among those singled out were Greek beggars; others were "tinkerers" accused of theft, fortune-telling, and witchcraft. In a subsequent ordinance from 1637, the laws became markedly more severe. Roma men were to be hanged and women and children deported. Norma Montesino Parra is careful to point out that these laws emerged during a time when other groups also were subject to repressive politics. For example, foreigners suspected of espionage, prisoners of war, people of the wrong faith, and poor people accused of crimes. At the same time, attempts to remove and even execute Roma and travelers are exceptionally obvious. In one legislative proposal, it was suggested that they be sent to New Sweden, a Swedish colony in Delaware.

The laws that followed in the 1700s were intended to employ the population and put an end to traveling. They can be understood against a backdrop of economic and social organization dependent on access to a permanent labor force. With the consolidation of the nation state during the 1800s, additional legislation was introduced in an effort to regulate the immigration of poor people.

At the conclusion of the 1900s, a number of transformative events took place that impacted the lives of Roma and which came to determine the relationship between the Swedish state and Roma as a minority. For the first time in Sweden, one began to distinguish between Roma and travelers in an effort to make vagrancy legislation more precise. Travelers were the "native" vagrants whereas Roma were "foreigners." They were regarded as disparate groups with different histories and lifestyles: travelers were considered a "mixed" ethnic group that was more settled than the Roma, while Roma were seen as a "pure race" with clear boundaries concerning who did and did not belong to the group.

At the same time, a large-scale debate arose over immigration. Parliamentarians and the media painted a picture of Sweden, with

at the time unregulated immigration, as threatened by mass immigration by poor and dangerous foreigners. Russians, Poles, Jews, and Roma were presented as a threat against the nation's security and as detrimental to the purity of the Swedish population. When this rancorous immigration debate resulted in the first piece of immigration legislation in 1914, *one* group was excluded on strictly ethnic grounds: the Roma. This did not simply mean that Roma from other countries were prohibited from traveling to Sweden; it also meant that those Roma who resided in Sweden could not travel abroad: they were more or less confined to living in Sweden until 1954, when the law was repealed.

Eight families, including Katarina Taikon's ancestors, immigrated at the turn of the century, thus founding a new Swedish minority. During the 1900s, these families became the community in question when one discussed Roma in Sweden. Approximately one hundred years later, Roma were to be granted official status as one of Sweden's five minority groups. These three events—the distinction between Roma and travelers, legislation excluding Roma, and the immigration of the Roma families—which took place over the course of twenty years, have garnered little attention from historians and other scholars.

This situation cannot be allowed to continue. The children will become delinquent. The state must liberate the population afflicted by this social ill. This was the political position of the investigators behind SOU 1923:2, the so-called vagrancy report. It is this document that contains the Gothenburg police interviews referencing Johan Taikon and his family, an extremely matter-of-fact document compared to how the state investigators appear to have regarded Roma and travelers. The investigation contains a series of statements and notes with a completely different tone. One parish priest by the name of Hedvall has included a letter where he suggests that the children of Roma and travelers should be taken into custody and placed in "rescue homes and work camps," and that

the government should foot the bill since the smaller municipalities do not want to acknowledge the homeless. In 1921, the parliamentarian Oscar Osberg wrote a motion mentioned in this report: he demanded an expedited investigation "concerning the most appropriate way to liberate society from gypsies and other tinkerers." The second chamber's ad hoc committee responded to Oscar Osberg. It finds the motion "credible" since measures "against these socially inferior elements" are necessary. At the same time, one points out that Sweden already has legislation intended to protect against the aforementioned social elements, such as the immigration legislation of 1914 which expressly prohibited Roma from immigrating and also allowed for greater leeway in terms of deporting Roma who are not Swedish citizens. The committee considers those laws sufficient. Throughout the investigation it is seen as obvious that the police, public prosecutors, and clergy have negative opinions about Roma and travelers: "The gypsy plague is an emergency, the tinkerer plague is chronic."

The fundamental problem with vagrancy stems from two interrelated issues, according to the state investigators: an itinerant lifestyle and therefore no stable employment. But the investigators are at the same time aware of the fact that they have a problem. Many of the targeted groups are not "destitute": they could in other words not simply be arrested or subject to arbitrary legal action. They made a living through horse trading or the sale of scrap metals, and sold various items sought after in rural areas. They did tin plating and repaired pots and pans, and they played music, sang, danced, and managed carnivals. There were also of course class differences between Roma and travelers: there were families without means or assets, but it was a fact that many of them ran successful businesses. Therefore, the state was forced to invent new arguments in order to still be able to label Roma and travelers vagrants. This is what the reasoning looked like: "Tinkerers and gypsies, despite right to property ownership and bulging coffers, are not protected by the law, since the earnings from these prop-

erties or capital is not livelihood, but is procured through begging, fraudulent behavior, etc." That Roma and travelers had means, and that they continued to work—in spite of income from ownership and sale of property—was now used against them.

What is to be done about the travelers and Roma? wondered the investigators. The travelers constitute a threat. The native population fears them: they do not dare to refuse their goods or deny them food, shelter, or animal feed. To report them to the police is far too dangerous, and if the police are called, the "disturbers of the peace" have already vanished. What makes it difficult to apply the law concerning vagrancy to travelers, from the authorities' perspective, is that any intervention affects not only an individual but an entire family. If the father is arrested, the mother and children must also be arrested, otherwise it has no impact. In that case, the municipalities must take their responsibility.

The investigators go on to discuss a popular question at the time, that is, the nature of the Swedish race. Certainly the travelers' "inclusion in the Swedish race" resulted in a "negative impact on our race," but not much is to be done: "Since it in most cases involves Swedish citizens, deportation cannot take place." One states that it is not possible "through any other direct or indirect interventions to eradicate them." Certainly one can resort to sterilization against a select number of travelers "who have committed serious crimes or suffer from mental illness, etc.," but really the only option is to, "with or without the gypsies' consent, incorporate them into the social order."

Concerning Roma, the question is not as simple insofar as they, like travelers, should be assimilated into society. The dominant conception concerning Roma is that they constitute a distinct ethnic group. The prospects of Roma becoming settled are slim: there are "far too few linkages between the gypsies' nomadic lifestyle and the Swedish population's circumstances." With that option eliminated the investigators present their solution: "As the gyp-

sies' incorporation into the social order appears impossible, the only solution is to in one way or another compel the gypsies to leave the country." There are, however, obstacles. Most Roma are Swedish subjects, or at least it cannot be proven that they are citizens of any other nation. Therefore, "their disappearance from the country cannot be achieved in any other way than for rigid limitations to be placed on their mobility, to the point where it becomes in their best interest to leave the country and emigrate to a country that offers them more favorable conditions." In this way also the "gypsy question" would in the long run come to be solved.

The investigators present a number of suggested measures, including the implementation of permits for horse trade and then not granting any such permits to Roma and travelers. Roma should report any musical performances and carnival activity to the police so that such activities can be supervised and regulated. Roma who are not Swedish subjects should apply for special permits to carry out the aforementioned activities. Since the work of Roma in the eyes of the investigators only serves to attract gullible people and to trick them out of their money, thereby allowing Roma to continue their "idle and disorderly lifestyle," it is good if their activities can "either be entirely prohibited or that permits are only granted in exceptional cases."

Thus, during the first half of the 1920s, the state's own investigators went to great pains to be rid of Sweden's Roma population. But their perspective did not exist in a vacuum: fiercely racist winds blew in Sweden in the early 1900s. In his 1964 dissertation "Sweden for Swedes: Immigration Policy, Regulation of Foreigners and Right to Asylum 1900–1932," Tomas Hammar sheds light on the context for this new racism. It was not only the fear of dangerous immigrants, such as the revolutionary and social democratic Russian Jews who fled after the 1905 revolution, which fueled the racism. Anti-Semitism and hostility toward immigration developed a eugenic dimension as well, where the goal was to safeguard the

purity of the Swedish race. Ideas about the nature of the Swedish people originated in ideas from the second half of the 1800s, when leading historians and anthropologists developed a thesis concerning a distinctly Swedish character. The nation's isolated location was regarded as having created a people who were not as intermingled and contaminated as other European ethnic groups. In *The Pure Country: On the Art of Inventing Ancestors* (2006), Maja Hagerman writes about the typical ideology of the time, also supported by leading intellectuals:

> Sweden was the nation populated by an "aristocracy" within the human race, a pure and original segment of a sharply delineated Germanic collective of Aryan origins; this idea would live on into the 1900s and also figure into the subtext for the production of folkhemmet [the expansion of the Swedish welfare state project] itself. It was the only nation where Aryans had been able to live on, shielded from the rest of the world, nestled into the coziness of farms and cottages without being subject to the awful consequences of racial mixing.

Photo exhibitions of different "human types" were organized, where the white Aryan people were extolled in relation to Finns, the native Sami, Walloons, Jews, and Roma. Beauty pageants in blondness were organized. Sami were subject to scientific obsessions with physiognomy and skull shape, hair color, and facial shape. Famous intellectuals who supported eugenics included the explorer Sven Hedin, feminist Ellen Key, and artist Anders Zorn. In 1921, the State Institute for Racial Biology opened in Uppsala, the first of its kind in the world; Institute Chief was the physician and Nazi Herman Lundborg. With broad support from Swedish Parliament, Lundborg conducted large-scale studies concerning eugenics during the 1920s. A decade later the glamor and prestige of the institute began to diminish, since Lundborg was not a good collaborator and had become difficult to manage. At the same

time, writes Maja Hagerman, it became "increasingly obvious that the Nazis were colonizing the entire race question and developments in Germany cast a shadow across the project." In 1936, the statistician Gunnar Dahlberg assumed the role of Institute Chief. He mapped out a new direction for the institute's efforts: it would no longer work to protect the Swedish race from other races, but would turn its attention to threats to be found within the nation, against what was termed inferior social elements. Sweden saw its first sterilization legislation, after the social democratic government's proposal was passed by Parliament in 1935. People could without their consent be sterilized due to "mental illness, mental deficiency or other disorders of the soul." As the journalist Maciej Zaremba has shown, those terms could mean practically anything: everything from "poverty, outsiderness, lack of social participation, willfulness, unproductiveness, defiance of the authorities, in short an unwillingness or inability to be incorporated into the increasingly disciplined construction of society," to women who were considered "sexually unreliable." Of the 63,000 individuals sterilized in Sweden, over 90 percent were women.

Parallel to the state's investigation into vagrancy, the interwar period view of Roma was articulated elsewhere. In 1929 proletarian writer Ivar Lo-Johansson authored the 1929 travelogue *Gypsies: A Summer of Wandering with the Homeless People*. The first part of the book describes meetings with Roma in Hungary; in the second part, he is on the road in southern Sweden in pursuit of Swedish Roma. The book, published the year before Lo-Johansson had his big breakthrough with depictions of crofter conditions in Sweden, is a peculiar combination of fascination and contempt.

The point of departure for the commentary is that Lo-Johansson set himself the task of solving "the riddle of the Roma." He is curious about them, at times sympathetic, but then suddenly something happens that triggers his derision. It can be that his interview subjects, who, one senses, are reluctantly pulled into his project,

set a limit for how close he can get. When he asks a young woman where she is born and she replies, "Sweden," he interprets it as a sign that geography is inconsequential to her. The women he meets either become objects of his sexual desire or are dismissed as ugly. For Lo-Johansson, the Roma are such mystical beings that he cannot comprehend how other non-Roma do not feel the same way.

On one occasion he visits Roma living by Ring Lake in Skåne County:

> One day I followed one of the brothers to a tailor in a nearby community, where he was going to be measured for a suit—gray, with seams on the outside of the pants, in the latest style. I looked at the tailor, who did not even see that he had a gypsy before him but who surely felt professional pride in the opportunity to sew clothes for such a magnificent creature. The tailor talked about the weather, showed samples, kept going on and on:
> – Yes, that will be nice. Yes, I think the weather is clearing up, his customer replied.
> He moved with such ease in our white world. When the tailor made note of the name he seemed for a moment to listen to the foreign tone, but then he wrote it into his black note book. For many days I chuckled at the curious meeting with the tailor.

Twenty-five years later, Lo-Johansson reprinted a second edition of *Gypsies*, which included new texts. At that point, it was the 1950s and a completely different time; now his view of the Roma has changed. But to a young Katarina Taikon, who made her authorial debut in the early 1960s, Lo-Johansson's updated attitude is insufficient. She will subject him to public scrutiny and criticism.

On May 31, 1943, events took place that remain largely unknown to us today, when, at a predetermined time in the early morning,

police across the country entered Roma camps and conducted "the gypsy inventory." The National Board of Health and Welfare seeks to find out how many Roma there are, where they live, and what their familial structures look like. Roma who reside in houses are also to be registered, as are those who are incarcerated or in hospitals or orphanages. Each individual is to complete a form where they state their name, social security number, religion, and whether their parents are Roma or not. People of "mixed race" are also to be accounted for.

In their directives to the police, the National Board of Health and Welfare advises that it is good to inform the people in question that the intention is not malevolent: they are not to be subject to any measures; the registration is simply intended to allow the authorities to develop an understanding of Roma living conditions. But it is difficult to take this intervention lightly. In the midst of World War II, when thousands upon thousands of Roma are being sent to Nazi death camps across Europe, Roma in Sweden are being visited by uniformed police and forced to identify their own and their parents' ethnic backgrounds and a number of other personal and intimate details: we can only imagine the psychological impact of this so-called inventory. There are no studies or interviews with Roma about what took place on May 31, 1943, and how it affected their lives, nor is there any research concerning the political context for the authorities' registry.

In all, the police obtained 453 forms that day. The National Board of Health and Welfare estimates that this number comprised 90 percent of the Roma in Sweden. The provinces and municipalities the registered reside in are illustrated in detail. I reviewed the tables: Is it possible to find Katarina Taikon and her family behind these numbers? In the spring of 1943, they most likely traveled alone. At the same time, they also settled permanently in the Stockholm region. Can they be the ones described as a family of nine in Södertälje? The table informs us that the family consists

of four adults and five children. The adults could have been Johan and Siv Taikon as well as Paul, 19 years old, and Rosa, 17. The five children under 15 would fit Paulina, Katarina, and the three little siblings. Or, if one disaggregates the number nine based on gender, six women: Siv, Rosa, Paulina, Katarina, and the two younger sisters; and the three men: Johan, Paul, and the youngest brother. No other numbers in the tables would fit them.

*

The sun sparkles on the surface of Årsta Lake. Beneath my shoes, gravel crunches against asphalt while the birds above jump from tree to tree. In the community gardens at Tanto Grove, spring is about to burst into life. Here, beneath the abutments of the Årsta Bridge, lay an old managerial mansion which during the war was used by the military. It was large and deserted and some called it a ghost castle. Everyone who had lived in Lilla Sköndal moved here: Katarina Taikon and her family as well as Aunt Voule and Johan Dimitri Taikon with their children and grandchildren, in all 40 people. The house was surrounded by allotments of community gardens in the back, and in the front courtyard that slopes toward the water's edge, which had previously been a garden, one had made room for the trailers. The courtyard also became a workshop for tinning and a junkyard. On the other side of the abutment, where the crescent-shaped buildings from the 1960s stand today, sits the Tanto Sugar Factory. Everyone who recalls the building also remembers the rats. Large, gray rats that would give you the creeps.

It was not a happy group that moved into the house in Tanto Grove on Södermalm. The war had taken its toll on the adults. Not knowing how long it would last and if the Germans would come to occupy Sweden as well, what happened to the Roma and the Jews in Europe's camps: those questions were ever-present in Katarina Taikon's family. The absence of ration cards had deci-

mated the family's finances. In addition to his rheumatism, Johan Taikon also had trouble with his stomach. Katarina often saw him grimace in pain. Johan Taikon was by the war's end an ill and depleted man.

Paul and Barbro Taikon had also moved to Tanto. They lived in a green trailer in the courtyard; Siv did not permit Katarina to visit them. In Katarina's stories about life in Tanto, Johan Taikon is not particularly thrilled about Paul's wife either. When Barbro hung her underwear up to dry she was yelled at by Paul's relatives. They shouted to Johan: tell your daughter-in-law that she shouldn't hang her underwear right in our faces! Barbro fought back: I will hang them wherever I wish; I'll hang them in the kitchen if I want to! This was about as bad as it could get, to place something belonging to the body's lower half, the unclean realm, in the kitchen, a place meant to be kept spotless. Johan Taikon kept quiet. He no longer had the energy to argue. Katarina was ill at ease. How could their relatives speak that way to her father? Shout at him from across the courtyard as if he was a boy. In *Katitzi* she describes how the ill will between the families had spread to the children. The cousins ceased speaking to Paul. Katitzi's best friends, Mauritz and Marianne, could no longer play with her. But there were many of them in Tanto and they all lived in close proximity; avoidance was not an option.

Siv and Johan Taikon and the four children had two bedrooms and a small kitchen in the building. The three youngest children slept with their parents in one room; the other room was Katarina's. The wallpaper was brown and curled at the edges, and the walls were thin: she could hear almost everything that Siv and Johan said in the other room. Katarina had begun to have problems with an ear infection; pus ran out of her ear and sometimes it was so clogged that she could not hear. When Siv struck Katarina and hit her ear she nearly gasped for breath.

Many have said that Katarina Taikon embellished the image of

her father, that he was not the noble and just man she wanted him to be. But if one examines the portrait of Johan Taikon that emerges in the *Katitzi* series, a deeply flawed man appears. There are numerous instances when others witnessed the treatment of Katitzi while Johan Taikon turned a blind eye. Once, when both Siv and Johan are away for the day, Katitzi and Marianne become friends again. Marianne offers to help Katitzi carry water into the house. At first, Katitzi is too proud, but then accepts her help, and once inside they embrace and complain about the adults' fighting. It feels good to hug Marianne, to see the kindness in her face. When Marianne discovers large wounds on Katitzi's back she is shocked and begins to cry. It hurts me, Katitzi, she says, and fetches salve and a new blouse for her. She wonders why Katitzi didn't ask for help when the beating took place, and what does her father say? Katizi replies that he was away when it happened.

No matter how understanding and warm he was, and no matter how much he shielded his children from public contempt and racism, Johan Taikon is not forgiven. On this point Katarina Taikon is firm. The father gave his tacit approval to the physical and psychological abuse of his and Agda's youngest child.

*

When fall came that year it was finally time for Katarina Taikon to go to school. The short walk through Tanto Grove's community gardens up toward Ringvägen, a large street that runs the perimeter of Södermalm, takes you directly into a beautiful 1890s brick building, the Maria School. In October of 1945, Katarina began fourth grade there. The same day her little sister and five second cousins, among them Mauritz and Marianne, started school as well. Enrollment documents identified them as living in the Tanto Sugar Factory.

Katarina Taikon had always longed for school. She wanted to learn how to read and write; she wanted to have friends and

homework and a school to go to every day, where she had a place that meant that she mattered. In all her books she has written about her disappointment over a nearly nonexistent education. In the *Katitzi* books she describes how she finally gets to get up in the morning and rush to school.

The first day in school Katitzi sits lost in thought. She gazes at her classmates: they have such beautiful and comfortable-looking clothes. One person has a soft, red sweater; someone else has a blue dress with a sailor's collar. Everyone has socks and shoes suited for the weather. Katitzi looks down at her thin clothes and summer sandals and is embarrassed.

Of the 29 children in the class, most of them came from less prosperous homes, but one could still spot class differences. Some wore patched clothes in gray tones; others wore soft sweaters in beautiful clear colors. One person had pretty white skates, others borrowed the kind that you tie directly onto your boots. A few of the children could not contribute to the class piggy bank. Katitzi was one of them.

During the winter months, the children skated at the athletic fields at Zinkensdamm and cross-country skied in Tanto Grove. In the spring they went to the National Museum of History to learn about the Iron Age and to the Skansen open-air museum and zoo to see animals and plants. Katarina studied Christianity, geography and math and most likely improved her very basic skills in reading and writing. She must have developed enormously during that year, absorbing the new knowledge like a sponge. But why is there something sad and worried in her descriptions from her time at the Maria public school?

Even though Katitzi hurried in the mornings it happened that she arrived late to school. She had a number of chores to finish before she was allowed to leave the house. Her teacher constantly had to remind her how important it was to arrive on time and that she had to do her homework.

One of Katitzi's friends was named Bojan. Bojan read the homework aloud and Katitzi memorized it enough to be able to follow during class discussions. But a problem arose whenever she was supposed to identify cities on a map: she always got it wrong. Miss Carlström did not understand how Katitzi could understand the homework, yet was still unable to identify Malmö, Luleå, and Gothenburg—some of the largest cities in the country—on the map.

That Katarina Taikon was unable to read and write was something that Miss Carlström (her actual name) did not initially understand. But that Katarina had summer shoes and no socks was something the teacher quickly noticed. In her enrollment paperwork is a note stating that Katarina was given a pair of pants, a cotton dress, socks, and shoes.

One event in *Katitzi* illustrates the concern which casts a shadow over the period in Tanto and says something about a thirteen-year-old girl's anger at not being understood by the world. One day in class, the boy who sits next to Katitzi raises his hand. He says that he wants to move to another seat; Katitzi smells bad. Katitzi stiffens. It's my ear, she says and remembers that she forgot to stuff a cotton ball into the infected ear before she left home. Miss Carlström comes up and looks at the ear. It smells very bad, and Katitzi has to go to the school nurse. Katitzi makes her way to the nurse's small office at the school. The nurse seems kind. She reassures Katitzi over and over again: It won't hurt. The doctor is only going to clean her infected ear. Then, everything happens very quickly: Katitzi does not have time to react. Suddenly the school nurse has Katitzi's head in a tight grip while the doctor sticks a metal needle into her ear. Katitzi thinks her head is about to explode from the pain. She is terrified and furious and screams at them that they promised that it wouldn't hurt. Why did they lie? If only she had been told the truth she could have prepared for the pain.

It is as an adult that Katarina Taikon recalls this memory. There were the long winter months and the impending spring that felt

like almost all of Södermalm was going to melt away. She remembers the old woman and man who lived in the stone building next door and how the frail old couple played cards and split a beer when they wanted to have a good time. The pastry shop by Hornstull and the bath house that was part of the Sugar Factory also comes up. Katarina Taikon remembers what it was like to leave home and make new friends, but also what it was like to feel lonely, to not have an adult on your side.

During her one year in a Swedish school Katarina Taikon was often subject to physical abuse. Some older boys tore her blouse apart and pulled off her skirt while they beat and kicked her. She did not tell anyone.

*

In the spring of 1945, two young women arrived in Sweden on the white buses, an initiative of the Swedish Red Cross and Danish government to rescue inmates from the Nazi concentration camps; initially intended to aid Scandinavian inmates, the white buses also came to transport thousands of non-Scandinavians. Hanna and Sofia Brezinska were 14 when they stepped off the boat in the harbor of the southern city of Malmö. One should actually call them girls, but they did not have a childhood. The cousins Hanna and Sofia Brezinska are, as far as we know, the only Roma who survived the concentration camps and were granted asylum in Sweden. When they arrived in Sweden, the two cousins hid the fact that they were Roma; they let people believe that they were Jewish, which was good, because in Sweden Roma were prohibited from entering the country. Hanna and Sofia Brezinska, who had survived the Nazi death camps, were in other words illegal immigrants.

Their stories are documented in two separate books. Gunilla Lundgren has written about Sofia Brezinska, later Taikon, in *Sofia Z-4515* (2006). Sofia Taikon's story is told in a graphic novel, which

grew out of a close collaboration between Gunilla Lundgren, the illustrator Amanda Eriksson, and Sofia Taikon and her family. The interviews with Sofia took three years to complete. In another remarkable book, *My Mother Prisoner Z-4517* (1996), Hanna Brezinska, later Dimitri, tells her daughter, Berith Kalander, about her life. Both Sofia Taikon and Hanna Dimitri passed away before the books about them were published.

Sofia was eight years old when World War II began. She lived in Poland with her mother and father and her three siblings. On March 18, 1943, Sofia and her family, after a time in the ghetto, were taken to Auschwitz II-Birkenau. They were placed in the so-called gypsy camp. Their bodies were completely shaved and they wore prison uniforms. Sofia harvested potatoes. The chronic hunger in the camp had everyone talking about food, thinking about food, and dreaming about food. Soon her father grew so weak that he could no longer stand; he was taken away and never returned. The other prisoners in the camp understood what was in the smoke that emerged from the chimneys. Sofia did not want to believe it was true.

The gypsy camp at Auschwitz included a barracks for orphaned children. Sofia was an eyewitness to the story of the little Roma boy whose macabre life is documented in history books. The boy was cared for by a Doctor Mengele who worked at Auschwitz. Sofia recalls that the boy wore a beautiful suit and that Doctor Mengele and the boy took walks around the camp in the evenings. The doctor liked to show off the boy, who sometimes was allowed to dance for the other prisoners. One evening, Doctor Mengele was walking by himself, as pleased as ever. Sofia's fellow prisoners said that he had placed the boy in the gas chamber himself.

In 1944, Sofia was transferred to Ravensbrück. She had then escaped the murder of all Roma at Auschwitz, which took place on August 2–3 that same year. At Ravensbrück, Sofia worked in a factory. She was thirteen years old and did not think she could endure

anymore, but the other women urged her to continue, otherwise she would be taken to the infirmary; that was where the Nazis conducted experiments on women, many of whom were sterilized. In the spring of 1945, the guards deserted the camp at Ravensbrück. Sofia and the others were free to go, but Sofia had no more energy. She wanted to die. During the long hike to the nearest community, just when Sofia was ready to lie down and not get back up, a Jewish woman pulled her up. After that, Sofia was too weak and ill to understand what happened. By May 2, 1945, she was in Malmö.

In Sweden, Sofia was able to rest and regain her energy. She ate food, a great deal of food; she had forgotten what it felt like to be full. But one day the police came and said that Sofia was to be returned to Poland. Awaiting news about where in Poland she was to go, she was moved between different refugee centers. Finally, she ended up in Vingåker. There, she became good friends with Karola, who had also been in Auschwitz. In Vingåker, Sofia let the Swedes believe that she, like Karola, was Jewish. It was better that way, she felt. When Sofia was sad, Karola said that she could be her sister. Karola wanted Sofia to come with her to Stockholm. There, a Jewish organization would assist them and the following year they could move to Jerusalem. But Sofia could not come with her; she needed to search for her family and try to discover if any of them were still alive. Sofia remained in Vingåker and found work at a restaurant. One day two Roma women came to the restaurant: they had heard about Sofia and wanted her to come with them to Stockholm and become a part of their family.

Sofia arrived at the house in Tanto Grove where she married one of Katarina Taikon's cousins. Sofia Taikon is called Zoni in the *Katitzi* books. Zoni is tense and nervous and shows Katitzi the tattooed numbers on her arm. An important point that Katarina Taikon makes in her books is for Zoni to say that the murderers in the concentration camps were regular people. They looked like any Swede who has just eaten their pea soup, Zoni says. That was

perhaps what was most frightening, she continues. The same observation recurs in Gunilla Lundgren's *Sofia Z-4515*.

The story about Zoni—Sofia Taikon—was published in 1976 in the book *Katitzi Z-1234*, 30 years after the conclusion of World War II. The extermination of Roma was at that time never remarked upon. During the Nuremberg trials, when prominent Nazis were sentenced for their crimes, the genocide of Roma was not addressed during the deliberations. Not a single person was called forth as a witness, Donald Kenrick and Grattan Puxon observe in the seminal *The Destiny of Europe's Gypsies*, published in 1972 as the first English language volume about Roma and the Holocaust.

Roma had been murdered in the camps and during the transports. They had been shot to death by Nazis and Polish and Ukrainian fascists in the Soviet countryside, and they had been used in unthinkably horrific medical experiments. In Croatia they were subject to such atrocities by the Ustashe militia that Holocaust researchers have no language to describe it. Between one half to one million Roma were exterminated during the war: their experiences became a great root of sorrow and shame throughout European Roma communities. The Norwegian journalist Jahn Otto Johansen writes in his 1989 book *The Gypsies' Holocaust*: "When the gypsies sought compensation after the war, they were met with derision. Subsequent legislation introduced the possibility of compensation in individual cases, but in practice it was very difficult for gypsies to achieve their goals. As recently as the 1970s, West German parliamentary spokesperson Gerold Tandler characterized the gypsies' demands for war reparations as 'unreasonable' and 'insulting.'"

Where Sofia Taikon's book briefly examines life after the war, Hanna Dimitri describes in detail the traces of her time in the concentration camps. Hanna was eight years old when she arrived at Auschwitz. At that point her parents and three older siblings had already been shot to death by the Germans; remaining were

Hanna, and her little sister Anita. Hanna survived five concentration and labor camps, of which one was Majdanek. She saw her own sister be escorted to the gas chamber, was branded by one of the camp's guards with an iron brand meant for cows, and witnessed a man with the SS spear a newborn infant with a bayonet. She worked throughout her entire time in captivity. When Hanna arrived in Sweden in 1945, she was a deeply damaged 14-year-old. She eventually married Georg; in 1949 they had their first child, named Anita after the little sister killed in the concentration camp. When Anita was born Hanna's fear grew that men from the SS would visit them. At night, she could hear their steps outside the tent. They whispered about how they would first murder the child, then Hanna. "At those moments I took my child and ran into the forest. There I sat and hid with her beneath some large, dense fir tree." It would be Georg who had to go find them. In the tent, he would sit and caress Hanna's head until she fell asleep.

Hanna and Georg moved to Malmberget where Georg got steady work in the local iron ore mine. At first they lived in a Volkswagen bus. They looked for an apartment for themselves and their children, but were turned away everywhere. One day a few social workers came to take Hanna and Georg's three children into their custody and place them in foster homes. Hanna's world fell apart. All the anxiety and terror she had attempted to suppress erupted and she screamed and refused to let go of her children. Georg threatened the social workers with violence if they came any closer to the children. After that, they were given an apartment.

Hanna Dimitri struggled her entire life with her experiences from the war, and this trauma was inevitably passed on to her children. "I had to be in a calm setting. If I was angry about something I would have a breakdown. The only thing that could calm me down at those times was my husband. I myself don't understand how he managed it, since I wasn't reachable at those times. When I had a nervous breakdown, he would say to the children to go into another

room. Then he would close the door behind us and by talking to me and holding me he could get me calm again ... The children knew from a very young age how to behave so that their mother would not get sick ... When TV would show documentaries about World War II and the genocides that took place, I always sent my family out of the TV room. I didn't want them to see what I had experienced. I wanted to sit by myself, remember, and cry."

*

When Siv married Johan Taikon in the mid-1930s she was excommunicated from the Pentecostal church that her family had belonged to. For the deeply religious Siv, this exclusion was awful. She had been baptized in Sundsvall in 1932 and had participated in church meetings and services her entire life; her worldview was deeply religious. There was good and bad, grace and sin. When she struck out against the children it was often because they were close to the devil. But some time during the fall of 1945 she must have been forgiven, because in February of 1946 she and Johan Taikon were accepted as members of the Pentecostal Filadelfia church in Stockholm.

– I drank, I smoked maybe fifty or sixty cigarettes a day. I didn't sleep at night. And then I met the Pentecostals.

This is what Johan Taikon stated to the journalist from the tabloid *Aftonbladet* in early March of 1946. The journalist visited the family in Tanto Grove and observed that there were many children in the house. In one picture Katarina Taikon, 13 years old, sits and listens to the radio with two of her younger siblings. When the journalist sees Siv Taikon he is surprised by Mrs. Taikon's light hair and Nordic appearance. Johan Taikon, described as "a very famous gypsy," says that something in him has been awakened. He is at peace with himself.

– That I've been saved is a miracle. Like all gypsies I've lived a strange life. I've wandered from country to country. I'm originally

Hungarian, if you can even say that a wandering child has a nationality.

Johan Taikon says that most Roma are Catholic, and that all one has to do is read the Bible to understand that the truth is there. Siv chimes in in agreement. During the interview the journalist describes him as calm, but towards the end Johan Taikon grows animated.

– I only have one goal, and that's to go to the Lord.

Johan and Siv also wanted Katarina to be saved. They brought her with them to the Filadelfia church in Stockholm. In *Katitzi* we witness an evening when the church is packed. A speaker giving a sermon stands at the podium. The audience shouts, "Praise be to the Lord, Hallelujah!" Many are speaking in tongues and throwing themselves on the floor. Katitzi is disturbed: she does not understand what is happening and begins to cry and tremble. Suddenly she sees how her father, whom the preacher calls Chief Taikon, stands and begins to speak. He says that he has been sinful and cruel, has smoked and gotten drunk. The audience rejoices. On the tram ride home he shouts to his fellow passengers that they need to be saved. Katitzi is embarrassed.

*

Katarina Taikon is to begin the fifth grade in the fall semester of 1946. At least that is what the school believes; she is still listed in their enrollment documents. But Katarina does not return. In November of that year she is married off.

That fall she works as a busser in one of the Konsum food cooperative's cafeterias for workers. She liked it there: she met new people and was appreciated by the other women for her work. With her first paycheck she bought bananas that she then offered to her colleagues. But Katarina left after a short while. She was accused of stealing money and when it was revealed who was behind the theft and the manager did not apologize to Katarina, she quit.

One day, a large group gathered at the house in Tanto in order to discuss a wedding. Katarina Taikon has written many times that she had no idea it was time for her to get married. Johan Taikon did not speak with her about it, nor did she know the identity of her husband-to-be. During the gathering in Tanto, Katarina was to dance and sing to her in-laws. They were satisfied, she writes. She was a good dancer and could in that way contribute to the income of her new family. Normally the man's parents paid the woman's family—when Katarina was married off it could have involved approximately 1,500 Swedish crowns — but Johan Taikon did not want any money. He just wanted Katarina to grow up, for her to leave Tanto and begin a new chapter in life.

It was doomed to end disastrously. Katarina Taikon was fourteen years and four months old when one November day she was forced into marriage with a man six years her senior. The wedding dinner was held at the Metropol restaurant on Sveavägen. For some reason, the newspaper *Stockholms-Tidningen* was there and took a picture. Katarina Taikon stands next to her new husband: he looks at her while she stares out of the image. On her head she wears a wedding veil. After the dinner with champagne and a buffet with turkey as the main course, the celebration continued at Tantogatan 26.

Why did Johan Taikon arrange a marriage for Katarina? Had he not learned anything from how his older children's marriages, all entered into through coercion, had ended? Paul, Rosa, and Paulina had been married off young and divorced young.

At the end of 1946, Johan felt worse and worse. He had earlier been admitted to a nursing home by Hornstull, but could not stand the stench and filth and demanded to be released. His abdominal pains were caused by cancer: that his energy was failing him and that he was unable to work only increased the sense of unhappiness in Tanto. He felt restricted. At the same time the mood in the family was infected, almost unbearable. "Father felt that I lived under very unhappy circumstances—which ones he

meant doesn't even matter—and explained that I would be better off as a married woman in another camp," Katarina writes.

No matter how strange it felt to suddenly be married to someone she did not know and begin a new life as a married woman, the thought did occur that perhaps this could lead to something better. "Maybe this was the liberation I'd waited for," she writes. Katarina Taikon moved to a camp that consisted of no more than one tent, in Åkersberga outside Stockholm. Her in-laws had promised her a new, modern camper with all kinds of comforts. She was disappointed. In addition, the tent was shared with her in-laws and the man's two younger siblings. Katarina was repelled by the thought of having sex in the same tent as the man's family, and she wrote openly about this as an adult. In order to achieve anything resembling privacy she hung a sheet between herself and them.

With the new family, Katarina was expected to contribute to their income. She went to the farms and told fortunes. But the family also encouraged her to beg, which she refused: that was something she had been raised to never do, no matter how poor they were.

In truth, Katarina got along well with her in-laws, especially her mother-in-law, who is repeatedly described as a stately and powerful woman; she just was not accustomed to a life of isolation and poverty. In addition, however, the relationship with her husband was terrible: they were different and wanted completely disparate things. Or, rather: Katarina probably did not know what she wanted, but everything was wrong. After a short period, she miscarried and was admitted to the hospital. The doctors suspected that she was married and asked her about it, but she denied it; she feared that it would have consequences for her father.

Finally, the day came when Katarina ran away from her child marriage. She made her way to Gothenburg, most likely because she was aware that a married woman's escape would not be viewed kindly by other Roma. She also wanted to find her mother's relatives. But she did not remain in Gothenburg for long. There she

met relatives of her husband who quickly saw to it that she was returned to Stockholm. And to Johan Taikon.

I try to imagine what took place in the house in Tanto during those days when spring was in full bloom and Katarina would soon turn 15. What happened when she showed up with a police officer who escorted her all the way to the large wooden house? Was Johan Taikon angry, or was he simply tired? Something was said which meant that Katarina could no longer remain there. What was most likely clear was that Johan Taikon and the in-laws intended to return her to the marriage. So she ran away once again. This time she escaped to the Tanto Grove forest.

While her father, Siv, and little siblings lay asleep in the small apartment, Katarina Taikon lay on cardboard boxes in the woods a few hundred meters away. The only people to come to her assistance were a pair of homeless alcoholic men in the Tanto Grove. They said that she should make her way to the Child Custody Board on Vasagatan. Katarina visited their offices on multiple occasions, and was turned away each and every time. She was told that what happens among your kind you have to take care of yourselves. After much begging and pleading, the Child Custody Board in Stockholm sent her to the City Mission in the city's Old Town. This move changed Katarina Taikon's life forever. Shortly after, Johan Taikon died.

3.

The home for girls run by the humanitarian organization Stockholm City Mission was located on the top floor of the building at Köpmansgatan 15 in Stockholm's Old Town neighborhood. Most of the residents were teenage girls who for one reason or another could not remain at home with their parents: one was pregnant; another had parents who were addicts; someone else went against the gender norms of the 1940s. The home for girls became their refuge.

At the time, the City Mission already owned a large number of properties by the Stortorget square. To this day, the square's southeastern corner is dominated by the City Mission's activities: the building features a spacious outdoor café, in the summer it is typically crowded with people eating lunch or having a cup of coffee while gazing at the crowds and tour guides' flags bobbing in the air. Adjacent to the café is the City Mission bakery, where even in the 1940s the scent of cinnamon buns greeted you when you entered the building. If you gaze upward from the square you can see the administrative offices one story up. Desks, binders, and printers today stand in grand, creaking rooms from the 1600s, with ceilings many meters high. What cannot be seen from the exterior is the church for the poor. Although the extravagant Storkyrkan cathedral is located a mere minute's walk from the square, there is another church located within the City Mission building. Behind a modest door off the building's labyrinthine halls and stairways, a fantastic room unexpectedly opens up, practically

unfolding before one's eyes: an ascetic miniature church space with benches, an organ, even bleachers. This is where the poor and outcast turn, as much then as they do now.

Katarina Taikon did not understand her good fortune when the City Mission's director Hildur Forsman opened the gate for her. Dressed in a torn and dirty dress, her hair in knots down her back, Katarina was about to walk away; she did not think she could manage yet another rejection. But Hildur Forsman did not hesitate: Katarina became one of the girls at the home five stories up. She describes Miss Forsman, as the girls called her, as a small, round woman with beautiful curly hair and a warm gaze. Miss Forsman had a soft spot for food and sweets; she had integrity and her peers regarded her as a powerful woman. When Miss Forsman entered one of the shops on the commercial street Västerlånggatan, all attention inevitably turned to her. Everyone in Old Town knew who Hildur Forsman was.

To begin with, Katarina Taikon needed a hot bath and new clothes. On the first floor of the building on Köpmangatan was something called the division for women. Widows, pensioners, single mothers, and other impoverished Stockholmers came here for assistance. Some needed clothing for their children, a warmer coat for the winter, or a pair of shoes. Others received financial assistance for food and medication. Sometimes when the City Mission's coffers were empty the staff turned to their own wallets. Katarina Taikon describes how she gazed into the division for women, where people sat waiting their turn. "Just peek: I don't want them to feel stared at," Miss Forsman says in *Katitzi*.

When Katarina was first outfitted—her hair was cut, she was given new clothes and shoes, even a little leather handbag—she was almost unable to recognize herself. She has written repeatedly about how at that moment she decided to not tell anyone that she was Roma; it would only lead to problems. It was better to say that she was from France or Russia.

Miss Forsman obtained work for Katarina as an assistant at a clothing store located on Mäster Samuelsgatan in Stockholm's downtown shopping district. Each morning she walked to her job in the city. She enjoyed her new routines: she made friends and learned new skills; she ran errands and assisted with dressing the mannequins when clothes were to be displayed, and she made her own money. Part of her wages went toward food and lodging at the City Mission, and each time Hildur Forsman put away ten crowns or so for Katarina's savings. The rest was Katarina's to spend as she wished. After work she went home to her room; she was rarely out at night. Katarina eventually moved into the best room at the girls' home: it was tucked away on the second floor and was simply furnished with a bed, a small desk, and a bookcase. There she could sit in one of the window bays and gaze out at the sky and the glossy black rooftops. When it was supper time, she would join the others downstairs in the main room. There, they sometimes socialized by the fireplace and played games or read and chatted. The girls' home also had its own kitchen with windows facing the courtyard.

Everything remains there today. A private company now operates out of the rooms previously associated with the girls' home. The kitchen and main room are located at one end and in the other was Hildur Forsman's office. The two halves are connected by a long, narrow corridor from which one can enter a few smaller rooms. All the way to the left, by the room which was once Miss Forsman's office, decorated with book cases and a large Persian rug, is the stairwell that led to Katarina's room.

*

Johan Taikon died on August 28, 1947, during a journey in Värmland where he did tin-plating work for the hotels in Karlstad and Kristinehamn. Johan, Siv, and the three little children had left.

Paul did not want his father to travel: he understood that Johan was weak and seriously ill. But Papa was happy to be going out into the world, says Rosa Taikon. Shortly thereafter a telegram arrived from Siv: Papa is dead. Come right away. Paul and Rosa traveled to Kristinehamn. When they arrived at the tent they saw a half-built trailer in the little camp: the thin wood boards intended to become walls stuck up out of the trailer's floor. Johan Taikon had started to build a completely new trailer in the days before he passed away. Surrounding the tent were the copper bowls he had been working on. Siv told them that the night before she had been stuffing the down bolsters while Johan sat on a stool across from her; suddenly he fell forward.

Siv Taikon wanted to oversee her husband's funeral on her own.

– Lewi Pethrus's[1] son came to help us transport Papa home to Stockholm. A week later his funeral was held at the Filadelfia church. They placed him on *lit de parade* up on the stage in the church, which was filled with people, says Rosa Taikon.

She recalls that her uncle, *kako* Joshka, wondered why they had placed his brother out for public viewing. "Do *gadjé* get paid when their dear ones die?" he said when the collection bag circulated that night. Rosa and her siblings were embarrassed.

Johan Taikon's funeral was reported in the Christian publication *Dagen* (The day). In all, four men spoke—all non-Roma—of whom Lewi Pethrus was one. In unison, the congregation sang *Löftena kunna ej svika* (All that our savior hath spoken), "the deceased's favorite song," from the Pentecostal psalm book Victory Songs.

Katitzi finds out about her father's death from Hildur Forsman. She does not cry, but Miss Forsman holds her in a tight embrace. When Katitzi arrives at the cemetery Haga Norra, north of the city, she is greeted by Rosa and Paulina, dressed in black and with

[1]. Petrus Lewi Pethrus (1884–1974), leader within the Swedish Pentecostal Church.

veils covering their faces. They are heartbroken. They say that they wish their father had understood why they had to leave him and the camp. Rosa was at the time married to a non-Roma man named Allan, and they lived in an apartment on Kocksgatan on Södermalm. Paulina had also left the camp; she wanted to make a life better suited to who she was.

Katitzi's sisters mourn the fact that their father did not have time to forgive them before he died. You're being stupid, Katitzi says. "Papa knew that you had to leave them. Papa was the wisest and he understood and forgave us all." Katitizi also mourns her father, but she seems more prepared to say farewell than her sisters. What has a deeper impact on her is the fact that she is reunited with her siblings.

During the months at the City Mission, Katarina had been cut off from the family, since she felt that the others regarded her as being at fault in the failed marriage. She should not run away, and doing so would not solve anything. Either you get a proper divorce or you resign yourself to the situation. Katarina had done neither. Therefore, she had in principle been disowned for several months. So, when Rosa embraced her at the cemetery and called Katarina her little girl, Katitzi could no longer restrain herself: she simply cried out with grief, "not from longing for her father but from the longing she had felt for Rosa, but had not wanted to speak of with anyone."

*

Arne Sucksdoff was at the time one of the most prominent figures within Swedish documentary filmmaking. In 1947, he was the first Swede to receive an Academy Award for a sixty-minute portrait of Stockholm, *Symphony of a City*. The following year he wanted to make a film about a Roma camp. During his research he had heard about Katarina Taikon. When he called her at the girls' home she did not know who he was, but thought that "it sounded promising and then when we met, I was immediately on board." The short

film *Departure* was shot at Tanto and shows a Roma camp preparing to decamp in order to continue a journey. Scenes of dancing and music are interwoven with people packing and children playing. The lead role of the young dancer is played by Katarina. Juxtaposed with the image of a flower growing, her dancing becomes faster and more intense. At the same time, a young man, played by Paul Taikon, works away trying to revive a dead car engine. As the flower blooms, Paul manages to start the car. Everyone is happy and, cheering, they depart. Besides Katarina and Paul, Rosa, along with a hundred or so other Roma, also participated in the film. *Departure* premiered on New Year's Eve 1948 to accompany Ingmar Bergman's *Thirst*.

The making of *Departure* also meant that it was no longer possible to avoid the issue of Katarina's marriage. It was decided that a trial, *kris*, should be held. Katarina Taikon has many times written about her fear of having to be returned to her husband. She knew that he and his family could make claims on her and that she according to Roma tradition was formally considered a married woman. The kris was held at Tanto. Luckily, she brought Paul and Rosa, she writes, even if they were not permitted to speak.

The in-laws wanted Katarina to return to them. They felt that she had not been a good daughter-in-law: she had been unwilling to contribute to their income and as a wife she had also "retreated from her matrimonial duties," as Katarina Taikon herself describes it. But they were willing to forgive her if she returned. Katarina's case was argued by one of her uncles. He maintained that Katarina, through her fortune-telling, had in fact contributed to the family's income and that she had cleaned the in-laws' tent each and every day. Concerning "matrimonial duties," Katarina writes in her defense that her father had "strictly prohibited any such thing until I had turned fifteen years of age." I doubt, however, that an adult Katarina Taikon truly believed that the father's condition would stand, since the fundamental purpose of marriage is to transform sex into a sanctioned act. But one of the most im-

portant points during the kris, made by Katarina's uncle, was the fact that Johan Taikon had not taken any money in exchange for Katarina. As a result, the in-laws could not demand any money in exchange for her divorce. In Katarina's own retelling of the divorce, it appears that Johan Taikon assumed she would not remain in the marriage and therefore did not claim any dowry. In other words, he somehow knew that it would not last.

The kris approved the divorce. Katarina Taikon was free: free even to remarry another Roma person. It meant that they felt she still had worth as a woman and a potential wife. After the kris they held a reconciliation party, but Katarina did not participate; she was too dazed by the proceedings. Instead, she and Arne Sucksdorff went to the pastry shop Ogo on Kungsgatan and ate pastries.

*

In light of the ubiquity of negative perceptions of Roma in the 1940s, relatively few films were made with Roma people as the central subject. Far more common were films where the topic was travelers, or "tinkerers," as they were often called. In the 1940s and '50s, a series of films were produced that contained deeply negative portrayals of travelers. Films such as *In the Darkest Corners of Småland* and *The People in Simlångs Valley* contributed to bolstering stereotypes of travelers as criminal, lazy, and possessed by menacing urges. Physically, "tinkerers" are portrayed as dark-haired and barefooted, with gold rings dangling from their earlobes. The men carry knives stuck in their belts. The women are portrayed in distinct contrast to female ideals of the time: they are sexually uninhibited, corrupting men with their seductive ways and thereby threatening the very social order that depended on a restrained sexuality between man and woman within the confines of marriage. But that "tinkerer women" could lure ordinary Swedish men to do something so dreadful also has deeper meaning, according to the journalist and author Christian Catomeris in his book *The*

Dreadful Inheritance (2004). During a time when "race mixing" was seen as a threat to society, the films' moral message became that it was important for good citizens to resist such dangers. "Tinkerer films" wanted the audience to experience a kind of unity in the face of an external enemy that took the shape of such "impure" races. Ultimately, Catomeris continues, racist conceptions of travelers had devastating consequences for the Swedish state's sterilization policies. He cites an application for sterilization made by a physician in 1941: "As the patient appears attractive to the opposite sex, is sexually unreliable with a criminal background and from a tinkerer family, I believe that sterilization is to be advised."

In the US scholar Rochelle Wright's *The Visible Wall: Jews and Other Ethnic Outsiders in Swedish Film* (1998), she explains the existence of "tinkerers" within Swedish film through the emergence of a new genre, the pastoral melodrama. It was one of several genres that appeared during the early decades of *folkhemmet*, the state-driven socioeconomic transformation to a more robust welfare state model. But while the films of the 1930s were oriented toward urbanization and comedy, a wave of nostalgia concerning the old agrarian society swept the nation in the 1940s, wherein industrious Swedish farmers and their work ethic and sense of tradition were idealized.

The reason that Roma were so rarely featured in films, according to Wright, is that they appeared to be an impenetrable group. They spoke another language and did not generally mix with the population at large, while travelers primarily spoke Swedish and were more familiar to the mainstream. In the 1960s, traveler characters became noticeably more rare in film. According to Wright, this shift can be attributed not to the fact that Swedish racism against travelers or Roma decreased, but that the genre of the pastoral melodrama faded away.

In addition to Arne Sucksdorff's *Departure*, there was one additional film that featured Roma characters: the 1949 filmatiza-

tion of the Swedish Romanticist Viktor Rydberg's novel from the 1800s, *Singoalla*. Once again, a large number of Roma participated, including Katarina, Paulina, Rosa, and Paul Taikon. Parts of the shoot took place in a large field in Gustavsberg, west of Stockholm, where a castle was built along with other sets. *Singoalla* takes place during the Middle Ages and centers around the tragic love story between the knight Erland Månesköld and the Roma girl Singoalla. The story is distinctly marked by both the romanticized and terrifying conceptions of Roma people during the 1800s. It is a fable more than it is historical fiction; for example, it takes place in Sweden during the 1300s even though all research indicates that Roma settled in Sweden during the 1500s. As a film, *Singoalla* was a major production: it was shot in three languages—Swedish, French, and English—and it was at that point the most expensive Swedish film ever produced. The cast consisted of Sweden's most prominent actors: Singoalla was played by the white Swedish actress Viveca Lindfors, who was having her Hollywood breakthrough at the time, and the knight Erland by Alf Kjellin, who a few years earlier had his big break with the film *Frenzy*. The more senior and beloved actor Edvin Adolphsson played Singoalla's father while the equally popular Naima Wifstrand portrayed an old Roma woman. Critics considered the film an embarrassing fiasco, even going so far as to describe it as trash, but it was a mainstream success. Rosa Taikon today feels that having so many established and beloved actors participate contributed to making the film appear credible in its representation of Roma. At the time, they were pleased to have paid roles as extras in a big-budget film, but they were horrified when they saw the film at the premiere: the "Roma" steal silver valuables from a monastery and get married through a blood ritual.

–If we had known what kind of nonsense we were in for, we wouldn't have done a thing in that film. At the premiere, Kati and I sat next to Sara Bull, Kati's former mother-in-law. When the film ended she loudly complained: "What will they think of us now?" Loud and clear, so that everyone heard, says Rosa.

In one of her books, Katarina Taikon called the film pathetic. In conjunction with the premiere, she was admonished by someone from the production company, Terra Film, for publicly stating that the representation of Roma did not jibe with reality.

At this point, Katarina had moved from the City Mission. She was deeply grateful for the support provided by Hildur Forsman and had developed confidence in herself. Her arranged marriage had also finally come to an end: it was time to move on. Through the productions of *Departure* and *Singoalla* she had made new friends: actors, directors, writers, and artists had become part of her social circle and she had started to frequent Stockholm's cafés and nightclubs. She and Rosa rented a room with Rosa's former employer who owned the yarn stores, Elisabeth Larsson, who now lived in an apartment on Östermalm. Both of them took more roles as film extras and made a living through various temporary positions. Rosa's jobs included working at the Marabou chocolate factory in Sundbyberg and as a photo assistant in Hägersten, all near Stockholm. At the same time, they decided to (along with Paul) revive the summer carnival business. Paulina was the only one who did not join them: she had a job she did not want to leave, nor was she tempted by the old life.

One summer the siblings traveled to Hedemora, and another to Norway. Katarina Taikon relished the camaraderie with her siblings and their profits were decent.

In 1952 Katarina and Rosa performed in the play *The House in Montevideo* at the Folkan theater, located on the square at Östermalmstorg. They had been recommended for the parts by the prominent actor and director Edvin Adolphson.

One Monday evening when the theater was closed, the actress Inger Juel threw a party for the cast. Rosa told a story about the room that she and Katarina now rented from an older woman. Rosa, who had kept the last name from her previous marriage,

had introduced herself as Rosa Widegren. And this is my sister, she said and pointed to Katarina. You two look a little bit dark, the woman said, so Rosa casually explained that their father was from France. The woman's house was covered with rules written on little notes, and one night she entered their room unannounced to ensure that they were not entertaining male guests. One of the young actors said: "Good god, you shouldn't put up with a prude like that. You can come live with me." And so Katarina and Rosa Taikon moved in with the actor Per Oscarsson in his large villa in Ulriksdal, on the outskirts of Stockholm. It was the first time in their entire lives that they lived in a place for a longer period of time. Katarina decided to grow potatoes.

Another film that Katarina Taikon participated in that captures the strange and contradictory spirit of the time was *Marianne* from 1953. The film follows a young high school student who is tired of studying and instead prefers to go dancing rather than sit at home listening to the radio with her parents. Marianne's mother, who works the night shift in order to support her children and sick husband, is not happy that Marianne is out all night with misanthropic characters. At the basement club The Atom in Stockholm's Old Town, in reality the jazz club the Gazell Club, there are young people who are a part of Stockholm's growing youth culture: they play jazz, smoke cigarettes and experiment with drugs. A girl looking for pills asks a young man: "Do you have one drug pill?" Another man with a long beard tries to convince a young woman that yoga is the only way to enlightenment.

Marianne grows fed up with her mother's prohibitions and her parents' humdrum life. She drops out of school and moves in with Birger, an older man who hangs out at The Atom and who exudes sex and violence, with a nearly failed career as a photographer behind him. After four months together, when they have been "almost married," Marianne is abandoned. Birger becomes furious that she "clings" to him and so travels abroad; he has never

believed Marianne's pronouncements about wanting to be free. Marianne weeps a little bit, but is soon back in school and, to her parents' relief, graduates successfully.

Marianne captures many of the trends, questions, and moods of the time: jazz, mysticism, homosexuality, counterculture, drugs. The film arrived at a time when Swedish society, folkhemmet, was undergoing tremendous welfare reforms: socialized medicine, three weeks' vacation, modernized housing and K–12 education for all, as well as technical innovations such as refrigerators, televisions and cars that enhanced people's ways of life. The standard of living was improved for many groups in society and there was a general sense of optimism regarding the future. At the same time the muted geopolitical threat of the Cold War balance of power had a palpable impact on the social climate. After the US nuclear bombings of Hiroshima and Nagasaki, a nuclear war was no longer simply hypothetical. "Unlike the '20s," writes Henrik Berggren in *Beautiful Days Ahead*, his biography of Swedish Social Democratic Prime Minister Olof Palme (1927–1986), "when an idea lived on for at least a decade that a global war like the one just waged was so horrific that it could never be repeated, [in the '50s] a third world war quickly became a highly conceivable possibility." The aggressive, external threat that existed alongside an internal, apparently bright and optimistic cultural mood created a kind of dissonance within popular culture.

But it was not only militarism and a possible third world war that governed the era. Many of the young writers, poets, and artists who made up the Swedish counterculture in the early 1950s were critical of folkhemmet itself, in particular its conformist ideals. The literary critic Paul Tenngart writes in *Romanticism in the Welfare State* (2010) about the literary group Metamorfos where, among others, the writer Birgitta Stenberg and the poets Paul Andersson and Lasse Söderberg were members. They participated in an underground movement where one broke away from the prescribed rules concerning what a normal life should

look like. Metamorfos organized readings at The Tunnel, a restaurant on Vasagatan in Stockholm, and published books through an eponymous publishing house. The members often hung out at basement pubs in Old Town and socialized with artists, intellectuals, and others who sought to challenge social norms.

Sweden was an orderly and rule-bound society where being different or having a more eccentric personality was frowned upon. In their work, the artists and writers in the Metamorfos group attempted to shift the social consensus, writes Tenngart.

Only a few years before *Marianne* premiered in theaters, youth riots shook the streets of Stockholm in the summer of 1951. During those warm summer nights, thousands of young people gathered in the small downtown Berzelii Park and destroyed cars and shop windows. The media described the disturbances as "mob riots" and struggled to comprehend the desire to confront the police and create chaos. Paul Tenngart offers two explanations for the nightly upheavals. In part, they can be traced to an absence of substantive problems among youth of the day: they were so pampered by state-sanctioned welfare and stability that they became bored. In addition, a new cultural category emerged in the 1950s: the teenager, or *tonåring*. That Swedish and other languages at the time demanded a new word to describe this emergent identity sheds light on a process wherein the riots in Berzelii Park can be understood as part of a more general tendency to erect alternatives to "the wholesome, pure, prosperous and decent work of building the Swedish folkhemmet." There was now a kind of youth inextricably linked to the postwar period's open borders: the young women and men who traveled to Paris to see the world, write, and test their boundaries. The trips to Paris were blamed for the new interest in drugs and homosexuality, which was seen as corrupting the youth.

Katarina Taikon also sought new ways forward in the early 1950s, opportunities for new possibilities and friends; sometimes they

appeared in unexpected places. During one of the summers when she, Rosa, and Paul managed their carnival, two young men arrived at the little camp on the island of Väddö in the Stockholm archipelago. They were illustrators and wondered if they could draw something on the facade of the carnival. One of the illustrators was Björn Hedlund; he would later be the one to illustrate the *Katitzi* books. The other was Lars Hallberg, and he became Katarina's boyfriend. Both illustrators were friends with many of the artists and writers around the Metamorfos group. Hallberg was close friends with the poet Paul Andersson, and Rosa Taikon recalls that this is how they all became friends. They went to the restaurant Prinsen—a hub for the city's writers, poets, and artists—and often the restaurant would purchase the illustrators' and artists' work in lieu of them having to pay the check. Lars Hallberg died in an automobile accident at the age of 26, but his work hangs in Prinsen to this day.

Lars Hallberg is not mentioned in Katarina Taikon's own story about her life. With the exception of the actor and director Hampe Faustman, mentioned in one of Katarina's final *Katitzi* books from the 1970s, none of the boyfriends from the '50s have left any traces in her autobiographical writing. Overall, her life during this period is not something she often spoke about publicly. In her debut, *Gypsy Woman*, she accounts for her theater and film experience in a few pages and concludes laconically, "I don't think there is any reason to examine my experiences during the 1950s in any closer detail." The somewhat evasive and cavalier attitude is understandable. Katarina Taikon became an adult during the 1950s: she made her own decisions, developed her own friendships, and had brief and extended love affairs. In 1963, when she began to write and do political work in earnest, she did not want to situate herself in proximity to the previous decade's film and theater world. Based on her own childhood and adolescence, she wanted to discuss conditions for Roma in Sweden and what she intended to do to change them.

*

"The gypsy population's situation is an illustration of the kind of racial discrimination which, despite any arguments to the contrary, exists in contemporary Sweden." With those words, the parliamentarian Gerda Nilsson puts forward the motion that forces the Social Democratic government to take action in the "gypsy question." In 1954, a parliamentary committee was charged with examining Roma living conditions. Since the mid-1940s, modest efforts had been made to confront the increasingly difficult situation for Roma in Sweden. The Christian organization Swedish Gypsy Mission had organized the summer school at the camp in Little Sköndal, attended by Katarina Taikon and her second cousins; the social worker Sven Andersson assisted a handful of families in Stockholm in obtaining housing; and in 1951 the public health physician John Takman conducted a medical evaluation of Roma in Stockholm. His investigation came about after the police in Stockholm delivered a report to the National Board of Health and Welfare concerning the growing Roma population in the city. That board in turn forwarded the report to the Child Custody Board, where John Takman was affiliated. The police in Stockholm felt that the Roma were not suited for urban living, and certainly not in a large city; their camps constituted a threat to the public's peace, order, and safety. Therefore, the police requested permission to evict the Roma camps and prohibit land from being leased to Roma in the future. Takman, who later became an activist in the Roma struggle, took the report in a direction other than what the police had hoped for. He wanted to conduct additional and more thorough medical evaluations of Roma in Stockholm, whom he suspected suffered from considerably poorer health than the population in general. At the same time, Takman stressed—as did others who sought to bring attention to the Roma situation—that the state bore the final responsibility for any necessary changes.

Reading the gypsy report from 1954 evokes a peculiar feeling. It strikes me that I am for the first time reading official documents about Roma which also attempt to take their vantage points into account. That Roma illiteracy was problematic for society since it resulted in a lost labor force could very well have become an argument for placing Roma in schools; instead, the investigators point out that the lack of reading and writing skills created personal hurdles for the individual in selecting an education, employment, and making other critical life choices. It created a forced isolation. When the investigators discuss the now mobile summer school, in particular its inefficiency, they can still see that it had a certain value. The education that the students obtained "has surely improved their sense of worth and self-confidence." That Roma people could have opinions, thoughts, and feelings around their own living situation, that the racism directed at them could inflict psychological and emotional harm, is a revolutionary perspective for those in power to articulate in relation to Sweden's Roma population. Thirty years earlier, the goal was to make life so unbearable for Roma that they on their own would feel that it was best to leave the country. Now the state admitted that they were treated badly by authorities as well as individuals: harassed, discriminated against in the workplace, refused entry to stores and restaurants, and driven away by local municipalities.

Even the widespread romanticism around Roma life was called into question by the investigators. The romanticism was parodic, they assert, and Roma existence must have been a constant struggle to survive; to the extent that any romanticism has been apparent, "it has primarily been a performance to elicit a generous attitude from others."

The investigation was directed by Gösta Netzén, editor in chief of *Work*, a weekly newspaper published by a Scandinavian working-class trade confederation. Netzén would later go on to become Social Democratic Minister of Agriculture. Carl-Herman Tillhagen,

from the National Nordic Museum, assisted him in the investigation, which focused on two areas: education and housing.

Instituting educational group homes, that is to say a kind of boarding schools, was rejected. Roma children will receive the best education by having access to mainstream elementary schools, according to the investigators. They should be placed in special classes, as was the norm with refugee children and children with learning difficulties, and the state should foot the bill. At the same time, the investigators express some concern that the various school districts will in good faith provide an education for the Roma children. At the time, one-third of all school-age Roma children could read and write.

Housing was a more pressing question, according to the investigators. In order for the children to be able to attend school they would require permanent housing. In the mid-1950s, Roma, when it came to housing, could be divided into three groups: those who were settled but wanted better housing than the ramshackle buildings that had been allotted; those who had not yet settled but who wanted housing; and the nomadic who wanted to continue traveling. The latter group was quite small. In general, the interviews reveal that Roma wanted to move into proper apartments and houses. Due to the urban housing shortage, the investigators suggested that any Roma who wanted to could live in the prefabricated wood cottages that the National Labor Market Board had provided for postwar immigrant workers. They were each comprised of 48 square meters (516 square feet) and consisted of three bedrooms, a kitchen, and a washroom. The cost of one home, including transportation and construction, was 15,600 Swedish crowns. Since children were to live in the houses, the investigators felt, with true bureaucratic ardor and care, that "the building's exterior and interior walls should be lined with 6mm wood boards."

But it was not only the challenge of getting a foot in the door of the tightening housing market—the urban housing shortage

was severe in the 1950s—that stood in the way of Roma securing housing. The larger obstacle was municipal recalcitrance. During the entire 1900s, the municipalities had fought against Roma obtaining housing, and the state investigators were aware that this was not something local politicians planned to budge on. "There are examples of municipalities," they write, "which, when gypsies have sought to purchase a property in order to settle, they [the municipalities] themselves have intervened, purchased the property, and delivered the property to other citizens." It is the municipalities' obligation to participate in improving housing conditions for Roma, to the same extent as if it concerned other municipal residents, write the investigators. "This seemingly obvious point is one that the investigators find particular reason to underscore."

Another interesting point that becomes apparent is the investigators' ability to remain flexible. They did not propose a universal solution for all Roma: they were aware of the fact that class and cultural differences existed within the Roma population. In their reasoning and proposals, they show a sensitivity to the large-scale changes many Roma underwent during the upheavals of the 1950s. This is otherwise not something the investigation is known for: its scholarly significance is typically that it constitutes the starting point for the state's assimilation policies towards Roma. Some go so far as to say that the government, through assimilation, sought to exterminate the Roma as a people. The discussion concerning whether or not social rights and integration meant that the Roma culture would be lost was established during this time. It was a question that Katarina Taikon also would come to address.

Obviously the investigators had their limits, some more glaring than others, such as the notion that the Roma did not have an overview of, or were unable to act in response to, their situation. Their ability to act and analyze on their own was considered inferior. Against that backdrop the investigation proposed that a "gypsy consultant" be appointed. The need for a consultant to assist

Roma with the authorities, schools, and management companies has been requested by Roma to the investigators themselves, they write. The investigators stepped in and obtained apartments, refinanced loans at lower interest rates (many Roma had pawned their belongings at interest rates as high as 36 percent), and put many Roma in contact with social welfare authorities. The general socioeconomic situation had clearly grown worse over the past decade; many had become poor because their professional skills had become obsolete. This poverty, paired with the social exclusion that Roma had already been facing, were the primary problems.

*

The advantage of the adult education program at Birkagårdens folkhögskola was that you could attend the school and still live at home, a necessity if you had children. The school was located all the way out in Birkastan, at the corner of Karlbergsvägen and Norra Stationsgatan on the northeastern edge of Stockholm. It was founded in the 1910s in order to create a meeting point for people who did not have easy access to education and self-improvement. Birkastan was a neighborhood dominated by workers, many of them immigrants. In the fall of 1958, Katarina Taikon entered Birkagårdens folkhögskola. At that point she was the mother of two children: Angelica, soon five, and Michael, one year old; the children had two different fathers. Angelica's father was the actor Ove Tjernberg, who participated in a number of plays and films from the '50s onward. Michael's father was the artist and Stockholm portraitist Svenolov Ehrén, who illustrated book covers and produced lithographies and stamps. The fact that her children, ultimately three of them, all had different fathers was something that Katarina Taikon always saw as relatively uncomplicated. They were friends and ran in the same social circles.

– I try to see the class, but I can't recall their friends. Rosa and Katarina stand out in my memory.

Stina Hammar, Katarina and Rosa Taikon's teacher at Birkagården, recalls her former students. We sit together in her and Tomas Hammar's living room in their Stockholm apartment located in the Tanto neighborhood of Södermalm, the same location where the sugar factory used to be situated and where tall buildings from the '60s still stand. A hundred meters from here is where Katarina Taikon lived as a teenager.

– Here they were, having come from nothing, getting an education and then changing the world. When Katarina goes to work it's as if a wind blows through Swedish society, says Stina Hammar.

Tomas Hammar's sister, Kerstin Seth, lives a few floors up in the same building. She was married to Lennart Seth, the principal at Birkagården during the time when Katarina and Rosa Taikon started in the fall semester of 1958. Lennart Seth was happy to accept them as students at the school. Both Katarina and Rosa were at the time self-conscious about their nearly nonexistent education. They had almost no background in what others took for granted. Kerstin Seth has put out tea and cinnamon buns for us.

– I was born at Birkagården. My father, Gillis Hammar, was a teacher and later on the principal there. Birkagården was located in a corner building and from our apartment on the top floor we had a view over Karlberg and the suburb of Solna.

The first thing Kerstin Seth recalls about Katarina Taikon is that she directed a play produced at the school—perhaps Gogol's *The Inspector General*. Then she says: "The friendship with Rosa."

– They would come driving very fast in the mornings, Rosa, Katarina, and their men; they all started there at the same time. At nine o'clock, they'd jump out of their cars.

The time at Birkagården was important to Katarina Taikon; in fact, it was critical, by her own account. She enjoyed close contact with the teachers, whose homes they could frequent "as if they were family." She had her scattered education placed in a con-

text and considerably improved her reading and writing skills. She found Swedish and geography to be the most enjoyable, and the classes in art history with Lennart Seth were practically "holidays." She also appreciated Gillis Hammar's lively and engaging history classes. That Katarina enjoyed Birkagården to such an extent was probably also due to the school's history, a sense of its past which infused the place. During the war, a mere fifteen years earlier, Birkagården organized Swedish classes for refugees from Nazi Germany. At five o'clock each afternoon, the refugees came to Birkagården. Tomas Hammar and Kerstin Seth's mother, who taught German, inverted the curriculum and taught Swedish to German speakers. Most of the students were older and arrived before Sweden in the fall of 1938 closed its borders to Jewish refugees. Tomas Hammar recounts that his father described himself as a fighting democrat. He had previously taught them that Nazism, Fascism, and Communism were totalitarian movements that rendered democracy and human rights impossible.

Stina Hammar describes Katarina and Rosa Taikon's acquisition of knowledge in the following way: a lot was new. At the same time, they approached this new information as if they always had it.

– Once we were reading Harry Martinson's *The Nettles Bloom*. In the book, the boy Martin is ordered to trim feed for the cattle: it is very difficult work. Just as he was finished and was about to go home, a calf came and dirtied what he had done. So he stabbed the calf to death. Then he blamed the gypsies who traveled past. Stina Hammar recalls that when they discussed it in class, Rosa and Katarina said: "Look, they've always blamed us!"

– They also had a sense of humor and perspective. One night when we had people over and everyone was leaving, Rosa said: "You had better check that the silver's still here."

Tomas and Stina Hammar recall that Rosa Taikon already wanted to be an artist and to work with silver. Katarina's plans for the future are more difficult to recall. Rosa was more outspoken in class and perhaps her thinking around silversmithing and the

future had matured; after all, she was six years older than Katarina. But what they both clearly exuded was that they were Roma and that this identity did not stand in opposition to anything they might consider doing in life, even if those were things that no one else had done before.

*

When Björn Langhammer and Katarina Taikon met, Björn's friends were initially concerned. He had gone out one night several days earlier and had not returned home. They knew that he had visited someone on Timmermansgatan: they went there and rang the doorbell.

– He was beaming with love when he opened the door. Björn had gone there with a friend who was an artist and a friend of Katarina's.

So recalls Berit Langhammer, who was married to Richard Langhammer, Björn's brother. She remembers that there was magnetism between them from the very first moment. Björn himself recounts the story of how he and Katarina met this way: after half an hour we had decided that we would get married. Katarina interjected: *I* had decided. She locked the door so that he couldn't get out, so Björn escaped by climbing out the window. After half an hour he came back. "You can't lock me in," he said. They became life partners, and always enjoyed talking about how they had met.

At the time of their meeting, Björn Langhammer lived in an apartment on Österlånggatan in the Old Town neighborhood of Stockholm. He worked as a janitor and usher on evenings and weekends at the short film theater London in the Klara neighborhood. At London you could see newsreels, Woody Woodpecker, and shorts with Charlie Chaplin. One of Björn's closest friends at the time was Mårten Andersson: Björn, Mårten, and Richard Langhammer lived in a drafty apartment in Old Town. Mårten also worked as a ticket taker at the London theater.

– After one night's work you had a little bit of money and could go out and eat a nice dinner. I met Björn and Ricke just as starköl, the new strong beer, arrived.² It was an exciting time.

Mårten Andersson, who by the mid-1950s had moved from the small town Värnamo to Stockholm to study at the university, met Björn Langhammer out on the town. They frequented the same cafés: one of the most popular was The Snake's Maids by the Stortorget square in Old Town, where many poets and other young bohemians hung out. Berit Langhammer was thirteen years old when she started going out in Old Town and the Klara neighborhood. She felt safe there, and some of the older people took her under their wing, so she could often get a ride home at night. Richard started experimenting with drugs at a young age. He and Björn were raised in the poorer part of Vasastan, coined "Siberia." Their father was from Germany and worked as a photographer, while their mother was ill for long periods of time. Björn Langhammer was harrassed and called a "fucking German" as a child during World War II: he thought it was unpleasant but also strange, since the same children who called him a "fucking German" also shouted anti-Semitic jeers at the Jewish children.

During a period of time when they were little, the children lived in a sanatorium to be treated for tuberculosis. Berit Langhammer recounts a story about an instance when Richard came home to visit: he had to sit outside and eat dinner alone while the rest of the family remained indoors.

Richard was in a state of shock after his mother's death. Amphetamine entered his life in the form of a medical prescription; at the time, it was not illegal. Truck drivers, physicians, and other night workers frequently took drugs containing amphetamine.

2. Sales of beer containing more than 3.6 percent alcohol, termed *starköl*, or strong beer, were prohibited between 1922 to 1955, during the so-called *starkölsförbudet*, or strong beer prohibition.

When Richard understood what it was, he started to take larger doses; no one knew yet what kind of effects amphetamine had or that it was addictive. Björn Langhammer was more controlled than his brother, says Mårten Andersson, and was not as wild.

In 1958, Björn Langhammer moved in with Katarina Taikon and her children, Angelica and Michael. She lived in a studio apartment on Timmermansgatan: it was a little larger than 215 square feet and had a kitchenette but not much else. The social worker Sven Andersson had helped her obtain the lease. In the fall, Björn and Katarina started at Birkagårdens folkhögskola, and Katarina's life changed. Her intense socializing with friends and acquaintances died down, and there were fewer nights of card games and late-night conversations. Her relationship with Björn and her daily academic work from nine to three made her life more predictable, and perhaps more stable. The studio on Timmermansgatan became too small for the four of them. They found a two-bedroom apartment in Bagarmossen, a recently developed suburb south of Stockholm. It was large and bright with a bathroom, and you could easily take the subway to the city.

After two years at Birkagården, Katarina enrolled in a one-year program at Påhlman's Business Institute. There, she studied accounting, commerce, calculating, and other business-related subjects. The decision to pursue this path is not entirely surprising: Katarina had been good at math at Birkagården and may very well have been nudged in that direction by a social worker who felt that a "practical" education would secure her future. At the same time, it is a bit comical that she dedicated a year of hard work to subjects she was not particularly interested in. In an interview with Katarina and Rosa Taikon on the Family Life page of the daily newspaper *Dagens Nyheter*—"Taikon sisters at Konstfack and business school"—Katarina is enthusiastic about two things: the worlds that open up through literature, and to advocate for the Roma. About her studies at Påhlman's, she remarks:

– I'm not exactly the brightest light in the class. Not even really a flickering flame, but I'm persistent and the teachers are understanding.

She persisted, but when she graduated in May 1961, she did not purchase the special Påhlman class ring.

After three years of school, Katarina Taikon entered professional life via the Vips American Ice Cream Bar, where she became the manager of Stockholm's most modern ice cream parlor. It was located downtown on Birger Jarlsgatan, adjacent to what is today the Zita independent movie theater, and was owned by the Swedish YMCA. Katarina leased the ice cream parlor: the small space contained a bar counter and a few chairs, an office behind the register, and a storage space in the basement. The large window to the busy street let in plenty of light. A motley group frequented Vips: *raggare*, American vintage car fanatics; foreign students; actors and artists. Sometimes Katarina's relatives came in for a cup of coffee. Berit Langhammer often helped out at Vips: she and Katarina lived near each other and shared many everyday responsibilities. In 1961, Katarina had her third child, Niki, and one year later Berit had her daughter Ia, so they frequently helped each other care for the children. Berit remembers Katarina as a loyal friend: once when an acquaintance at Vips asked Katarina if Richard was really involved with someone like Berit, Katarina became angry and said that no one could talk about her like that. Sometimes when they were exhausted after a long day's work in the ice cream parlor, the two of them went to the Sturebadet bathhouse to relax.

4.

In March 1963, TV viewers across Sweden learned of the conditions that many Roma in Stockholm were living under when Karl-Axel Sjöblom and Roland Hjelte's half-hour program "Vagabond eller vanlig människa?" (Vagabond or ordinary person?), aired on Sweden's only TV channel. In the opening scene, the camera slowly pans across the camp in Ekstubben: snow falls and the wind whistles. Campers and tents stand alongside each other. A girl fetches water from a pump.

This was one of the city's three camps for Roma, all of them in wooded groves in the southern suburbs. The camps came about around 1956 when Stockholm's policy makers gathered the families that had not yet obtained apartments on their own, still the vast majority. Many Roma families were at that point facing a critical juncture: they had ceased traveling while they at the same time were prohibited from moving into housing. The intention was, officially, for the camps to be temporary, but they became permanent settlements. The city installed electrical lighting and a water pump, and provided the camps with garbage cans and outdoor toilets.

Oskar Columbus, a man in his mid-sixties, is interviewed. In the background, a young woman prepares coffee on the sheet metal stove. Oskar Columbus states that he is up all night keeping the fire burning in the stove; otherwise they wouldn't make it. Some nights the temperature in the tents reaches freezing.

– When everyone else has received conveniences, we shouldn't live like this, out in the woods, he says.

Olga Demeter is a woman in her sixties. Her husband has been ill for a long time and is currently in the hospital.

– He was bedridden here. I can't really remember if it was for ten or fourteen days. Then my children said: Mama, this can't last. What should I do, children? I said.

She starts to cry.

– We have to try to get Papa somewhere, they said. Yes, children, if you can do that I'll be so grateful. So my children got together and took us to the hotel, and my husband and I and my little son lived there from eleven to twelve days.

– That costs money, the reporter says.

– Yes, it does. Thanks to my children's kindness and helpfulness, we were able to live there. They didn't eat: they helped us. Then we came home. But then we had to go to the hospital with Papa. He wasn't well. But what was good was that the doctors were very good. He got shots and all the medicine he needed. Now he's doing very well. I stayed with him at the hospital for a whole week, me and my little son. Thanks to those kind and sweet doctors. He's improving, he has bottles in both his arms, that's what's helping. But if I took him home, no, that wouldn't work. It won't work, my dear brothers.

The previous night, a young woman was at the hospital with her infant. When they left, it was an emergency: the baby had croup. But it was difficult to drive the car out of the camp because it had snowed so much. The woman says that she has lived in the camp for seven or eight years. She appears to be around 20. The reporter asks if she has ever lived in an apartment. No, she says. Do you want to live in an apartment? Yes, I do. Very much. The woman is never named.

In the second camp of the three in Stockholm, in Skarpnäck, Eskil Taikon has built a cabin with the aid of a loan from his brother-in-law. His daughter died as a newborn: at that point, his father- and brother-in-law asked if there was anything they could do for him

and his family. Eskil Taikon responded that they could give him a loan so that he could build a little house. He could do the carpentry work, but needed to buy materials. It's unlikely we'll get an apartment, he says; for several years they've told us we're on the waitlist, but nothing happens.

In the last camp, Hammarbytäppan, an older couple that has refused senior housing in the suburb of Farsta is interviewed. Someone had died in the apartment, so it was considered unsuitable for living; traditionally, Roma have always abandoned sites where someone has died. Generally, anything concerning death, even as a topic of conversation, was loaded. When the reporter asks the old couple what's so terrible about death and adds, "We're all going to die one day," they become visibly ill at ease.

After visiting people in the snow-covered camps, the reporters return to the city and open the gates to Stockholm's courtyards. Scheelegatan, Folkungagatan, Kappelgränd: run-down, small apartments, often without central heating and with outdoor bathrooms. Of late, Roma people had moved into apartments at these addresses. A family of seven, with small children, lives in an apartment on Brännkyrkagatan, it consists of one bedroom with a kitchen. They fetch water from a tap in the building's hallway and do not have a toilet. The family arrived from Finland a few years ago. The father recounts, in a soft-spoken and calm voice:

– At first, they wanted to take our children from us, but we refused that since we thought it was absolutely awful and we wouldn't have been able to bear it. We thought another solution would be better. For five weeks we didn't have any housing. It was very trying.

– Then you got this. It's not exactly a modern home.

– No, it isn't, but we're very happy. It's better than doing without.

– But they're going to demolish the building?

– Yes, they're tearing it down this summer.

– You don't know if you'll get anything after that.

– No, it's unclear. But I hope we will.

– Otherwise you're out on the street again.

– Otherwise we're out on the street again. But we don't dare think about that because I don't think we could bear it. The day we got word that we had received this apartment, my wife sat at the bus station with all the children while I went to the authorities to find out what was happening. She sat there the entire afternoon.

– To stay warm?

– Yes.

If *Vagabond or Ordinary Person?* had ended here, then these stories alone would have been sufficient to bring attention to the Roma situation: the program was unique in its manner of portraying Roma and letting them narrate their circumstances. But that the journalists also managed to get one of Stockholm's most prominent politicians to make a remarkable statement contributed to the program's impact.

A number of administrators and politicians within the municipal bureaucracy are interviewed. The gypsy consultant Nils Wall says that the whole thing is difficult and that obtaining apartments unfortunately is very slow. The chairman of the Child Custody Board, Karl-Erik Granath, feels that in this case it is best to let parents and children live together; he states that taking children into custody is not an option, even though they obviously suffer, but to procure housing is not within the purview of the Child Custody Board. The Chairman of the Poverty Board, Helge Dahlström, sees two reasons that Roma do not receive housing: the general housing shortage and that "the gypsies aren't, how should I put it, suited to that kind of lifestyle." When the question finally reaches the most prominent and accountable politician responsible, the City Commissioner for Housing, Walfrid Frank, his response is as follows:

– There are so many challenging housing problems. When it comes to the gypsies and their housing it is, however, something

they're accustomed to. They have lived this way for many years and so they have a certain ability to adjust. Not to justify the way they live.

Just as Walfrid Frank utters that final sentence, that it is not a justification, it dawns on him that his statement will become just that. They are used to it. They do not need housing.

During the spring, the public's attention remained on the Roma situation, or the "gypsy question," as it was now called. In April the editor in chief Evert Kumm stated that a folkhögskola, an adult education program, for Roma should be founded. Katarina Taikon, at that point working on her first book, agreed, but also felt that separate schools for different groups was not a suitable long-term plan.

The physician John Takman also entered into the discussion, since he could not understand why everything took such a long time. The state had since 1960 assumed responsibility for the municipalities' budgets: they no longer had any excuses. He also meant that the sociopolitical awakening was too little, too late: if the Roma as early as the 1930s, when the economic foundation of their existence started to crumble, had been accepted into society, the transition from a traveling life to a settled one would not have involved so many difficulties. Takman sought a more engaged civil society: women's groups, renters' associations, and unions should aid in making it easier for Roma to be accepted in their neighborhoods. At the same time, it started to become known that Katarina Taikon was going to publish a book in the fall. The tabloid *Expressen* writes a small piece about "a girl with ambitions" who would soon come out with a book. That summer she sent her manuscript to a publisher.

*

No one could have predicted that it would be a municipal administrator who would help bring the Roma question into the media

spotlight. During the first week of October 1963, every newspaper covered issues having to do with Roma. It started with *Stockholms-Tidningen* investigating the camp in Ekstubben, where they referenced Katarina Taikon's book, to be published in a few days. There, she posed the question: "Gypsies in Sweden have been on the waitlist for housing for 400 years: Isn't it our turn soon?"

The mood in the camp was frustrated. The nearly 40 people who lived there were almost all related; the children had nothing to do during the day: no playgrounds, no activities. Day-to-day socializing was so fraught that one family—two parents and one child—moved out in sheer desperation.

– We couldn't take it any more. The camp is overpopulated. Everyone is family and there's only fighting. It's a concentration camp: only the barbed wire is missing, said the father, Johan Kaldaras.

After many years in camp few of the residents there felt any hope regarding their situation; many were completely apathetic. During the spring, John Takman had made public the results of his medical study of Roma in Stockholm: he concluded that the poor social conditions were grave, that many suffered from chronic illnesses and that the children could not attend school under the current circumstances. He had a concrete suggestion: produce 40 to 50 cottages during the summer so that people could move in during the fall; but by that fall, there were no cottages.

The Kaldaras family's move from Ekstubben was not accepted by the city's administrators, and the housing office demanded immediate eviction. A reporter from *Stockholms-Tidningen*, Ove Nygren, turned to the municipal official responsible for the gypsy question. Many Roma felt that the official was condescending to them. Nygren asks about Johan Kaldaras and his family's move.

– He has to move back to the camp. He can't move any which way he wants and he won't get any light where he is now. We can't legalize moves like that. Then we'll soon have the gypsies spread out again, and the same chaos as before we organized the camps.

Concerning the suggestion regarding the 40 to 50 cottages for

Roma in the camps, the official says that there isn't enough land in Stockholm for the houses.

– Maybe we can build cottages for the most troublesome. I also have to protect regular homeowners against neighbors like that. Would you want to have a gypsy as a neighbor? I would pray to God to save me from having the neighborhood around my home ruined by gypsies. I can't deliberately move the gypsies in among normal, decent people.

The reporter points out that the official—who remains anonymous in the media—has a negative attitude toward Roma. Many people attest to the fact that he has called them riffraff, gangsters, and black devils. The official explains that he had high hopes when he started in this position. He talked to the Roma as if they were regular people. He asked them to keep the camps neat and tidy and promised that he would reward them for it. Now he has come to understand that they don't want to do anything but sit outside their tents and chat and smoke.

In the evening the TV newscasts brought up the official's statement. His supervisor refuted what his colleague had said. The following day the official resigned. He requested to be relieved of his duties "due to the attacks that have taken place," his superior reported. It is unclear if he is referring to the official's or the media's.

Many were relieved when the official resigned. Erland Kaldaras, Johan's older brother who resided in Malmö, hoped that the work of obtaining apartments for the Roma would continue. The situation in Malmö is miserable, he says. His family and a nephew live in apartments, but out in the neighborhood of Valdemarsro two families live in an old farmhouse infested with longhorn beetles; they are, in fact, afraid that the house will collapse at any minute. *Stockholms-Tidningen* publishes an editorial critical of the fact that the authorities still have not intervened.

On the same day that the situation with the official came to light, Katarina Taikon's *Gypsy Woman* was reviewed in nearly all the

Swedish newspapers. The book is unique in the rich range of other recently published books; the daily *Dagens Nyheter* writes of a loud alarm beginning to overtake the public debate.

It was the first time a Roma person had ever written about Roma life in Sweden. In the book, Katarina Taikon weaves together experiences and observations from her childhood with stories of Roma life and traditions: rules governing cleanliness, conflict resolution, marriage, and social relations. Different voices appear in the book. A solemn Katarina Taikon, an angry one, a sarcastic one, maybe even a vulnerable one. But the most resounding voice is the one that became specific to her writing: someone completely unsentimental. Katarina Taikon did not have time for self-pity.

The critics agreed that *Gypsy Woman* was matter-of-fact, engaged, and well-written. One of the critical voices was Bo Strömstedt, a critic at the tabloid *Expressen* and later the paper's editor in chief. He felt that the composition of the brief chapters was a bit too haphazard and that it in places was too imprecise; in general, however, he was positive about the book. In his full-page piece in the arts section he builds his article around an event described in *Gypsy Woman*. "This is where it happens," begins Strömstedt's article.

An old couple has gotten to move into their own house; previously, they had lived in a bus. Neighbors in the western community of Vårgårda write a letter to the County Administrative Board in Vänersborg. Twelve people respectfully ask to list the difficulties associated with the old couple's move into the neighborhood. The twelve of them have lived in Vårgårda for a long time: they have been loyal and they have paid taxes. Their properties are comfortable and financially sound. Now the municipality has decided to "settle the gypsies right up against us." The twelve of them very strongly want to underscore that they do not want to deny anyone the human right to tolerable living conditions, regardless of ethnicity, "but no one can in good conscience turn a blind eye to the fact that gypsies are gypsies." It is obvious to all

that the couple's move means that the neighbors' property values will decrease by several thousand crowns. It's a slap in the face, a penalty that they have been subjected to without regard for the fact that they are decent, hard-working citizens. The old couple's poor behavior—it is not made clear what they have done—will result in a loss of income for the neighbors, since the wife from now on will have to remain at home in order to keep an eye on the house. "We maintain that carrying out the decision in question, not more or less, would constitute an encroachment upon our personal liberty and individual rights."

At the end of his article, Bo Strömstedt, like Katarina Taikon in her book, names each and every one of those twelve letter writers. Strömstedt concludes: "They do not just live in Vårgårda."

After the investigation in *Stockholms-Tidningen* concerning the camps and the official's statements, the newspaper received many letters from readers. The editors asked Katarina Taikon to respond to readers' questions. The many thoughts and questions were reduced to eleven questions, edited by the paper in order to be somewhat constructive. An unedited question, or rather a comment, sounded like this: "I'm not a racist, but I do think that those dirty gypsy hags could very well tear off their carnival clothes and dress like regular people."

She answered questions about why the entire family accompanied someone who had to go to the hospital when they were sick; why Roma don't learn how to read and write; why do they buy campers instead of houses; and whether or not there were gypsy chiefs. Katarina Taikon started educating the public and often traveled with her husband, Björn Langhammer, on speaking tours. But making herself available for people's thoughts and questions also meant that she became part of their fantasies and subconscious aggressions. When people spoke of "dirty gypsy hags" it was not abstract to her. The desire to educate also had its drawbacks.

In an interview during those days in October 1963 when her name became well-known across Sweden, she says: "I don't know how people will react to the book; I just know that what's happening now is the start of a long struggle."

*

The proletarian writer Ivar Lo-Johansson and Katarina Taikon got to know each other in the mid-1950s. During the work producing the photo book *Zigenarväg* (Gypsy road), Lo-Johansson interviewed Katarina, and it was then that she put him in contact with other Roma; when necessary she also translated between Swedish and Romani. In addition, they collaborated on a radio program about the Serbian-Romanian poet Gina Ranjicic. Katarina visited Lo-Johansson once at his home on Mariaberget; it was a brief visit, mostly small talk.

When Katarina Taikon's book was published, a disagreement emerged between the two of them that each seemed to experience as difficult but unavoidable. She dedicated an entire chapter of *Gypsy Woman* to criticizing Lo-Johansson's outmoded and romanticized view of Roma. She attacked him and he responded by accusing her of lying and having stolen material.

Lo-Johansson had written his first report about Roma as early as 1929. At the time, he was driven by a desire to reveal the mysteries which, he believed, surrounded the Roma people. The portraits of the people he encountered were often written at a remove and were slightly condescending.

In the mid-1950s, his interest was reawakened, at which point he wrote a new story that together with the first ones were published in a volume titled *Zigenare—tjugofem år efteråt* (Gypsies—twenty-five years later). At the same time, the photo book *Zigenarväg* was published, with brief texts by Lo-Johansson and photos by the renowned photographer Anna Riwin-Brick. The books reached a wide audi-

ence and established Lo-Johansson, one of Sweden's most renowned writers, as something of an expert on Roma life and culture.

Lo-Johansson's point was that Roma, as a people, were in the process of dying out. To be Roma, according to Lo-Johansson, meant living an itinerant life and making a living performing music, doing tin-plating, running carnivals, and telling fortunes. He meant that the rigid welfare state did everything to eradicate their distinct character. If the Roma, this people who according to Lo-Johansson "gave color" to society, unlike the "gray and dull Swedes," moved into homes and abandoned their earlier professions, they would literally disappear: they would need to complete so much bureaucratic paperwork that they would no longer have time to just be Roma. At the same time, Lo-Johansson was aware that the professions practiced by Roma had disappeared and that many Roma were now turning to the authorities; as a "gypsy expert" he could not ignore this fact. His solution was that Roma should work in the scrap metal and car trade businesses. Concerning housing, he felt that, as long as Roma traveled, they kept themselves remarkably healthy; it was when they moved into houses and apartments that they grew ill. But, he admits, "it was still painful to see how they suffered in the winter." He could consider agreeing to having Roma live in permanent housing during the winter.

Katarina Taikon became furious. He wants to keep us in a reservation, like a Skansen diorama for the public to view, she wrote in *Gypsy Woman*. It was illogical, she felt, that Lo-Johansson's demands for equal rights did not extend to the Roma when he had so forcefully fought against other social injustices. She addresses his concerns that Roma as a people would be "extinct" if they had permanent housing by saying that the issue isn't extinction, but adaptation. "This adaptation should of course only take place if it is undertaken by free will—and the gypsies' will should also be taken into account." To Katarina Taikon it was plainly obvious that you could be Roma and live in an apartment, go to school, and have a job that you had not previously held.

Ivar Lo-Johansson's books were published during a time when the official policy towards Roma was being revised. The 1954 gypsy report was underway and Lo-Johansson was aware that he and the investigators had diametrically opposed views of what the challenging situation demanded. A stated purpose of the books was to engage in a polemic against the state's investigation; that Lo-Johansson, during such a critical period, would attempt to shift public opinion against equal housing for Roma was simply incomprehensible to Katarina Taikon.

Another point that she vehemently criticized was Lo-Johansson's description of Roma people's appearance and bodies. Due to their dark skin, Roma cannot blush, he writes. A "typical racial feature" is the jawline, "what is often called the gypsy jaw." Roma also have a "racial scent." To discuss racial characteristics and how fundamentally different Roma were, a mere decade after the conclusion of World War II, was upsetting to her. To Lo-Johansson himself, there was no racism behind his ideas concerning Roma: on the contrary, he saw himself as their protector. But in some peculiar way he could not see how his view of the Roma was deeply problematic.

An event from the summer of 1954: Lo-Johansson and Anna Riwin-Brick were in a Roma camp in Skåne during a solar eclipse. He handed out protective glasses to everyone and together they witnessed how the bright afternoon turned dark. When it grew light again, an older woman from the camp came up to him and returned the sunglasses, stating: "Thank you. It was very beautiful." Ivar Lo-Johansson writes: "She thought that I had arranged the solar eclipse for them as a show."

It is difficult to believe that an old woman who has lived in tents her entire life, and for whom nature, weather, and the environment have determined her circumstances in any way believed that Lo-Johansson could direct the sun. It also seems incomprehensible that Lo-Johansson himself believed this. Perhaps it was the scene as such—an old Roma woman's ignorance about how the

larger forces of the world are connected—that was irresistible to him. If only it had been true.

There was also a personal dimension to the argument between Katarina Taikon and Ivar Lo-Johansson. He had written about her in *Gypsy Road* (1955), while she worked in film and theater and was not yet a renowned author. In a photo, taken by Riwin-Brick on the cliff by the Katarina Elevator on Södermalm in Stockholm, Katarina stands with her arms extended towards the city and a wide smile on her face. She wears Roma clothing, is 22 years old and looks happy and strong. The caption reads: "Mixed marriages have seldom been happy. The parties have been subject to contempt from both the gypsies and the Swedes. Mixed marriage offspring have struggled in both communities." Katarina Taikon must have been disappointed that she was included in the book as a symbol of failure.

A perhaps unexpected aspect of Lo-Johansson's writings about Roma concerns just why he came to write so much about them, why they "moved and disturbed" him to such a degree. Lo-Johansson was dissatisfied with the rigid society built around rules and prohibitions: society's restrictions on individual freedoms frustrated him, and he wasn't alone, he writes. Lo-Johansson wanted to examine what he could learn from the Roma way of life, maybe even live among them. To him, the Roma represented a liberated existence, without the pressure and stress of modernity. It was an opinion that he had developed over a long time, resulting from a personal reckoning. During his childhood in agrarian Sweden he was terrified of and felt loathing toward Roma: as an adult he wanted to be free of this fear and hatred. Consequently, he sought out the Roma again in the 1950s and, in the same way that he had once combatted his fear of the dark, he now, by approaching the Roma, sought to free himself of his antipathy towards them.

During the argument between them it became clear that they stood for two completely different approaches with regard to the

Roma situation. Ivar Lo-Johansson's accusations that Katarina Taikon had stolen images from *Gypsy Road* stalled when Anna Riwin-Brick publicly defended Taikon. Katarina had been given the images by Riwin-Brick; it was the publisher who had made the mistake of not properly crediting the photographer. After a few days and a number of bracing exchanges, the public dispute came to an end.

5.

Bernd Janusch had fifty crowns in his pocket when he stepped off the train at the central station in Stockholm. He was hungry and did not know a soul in Stockholm or speak a word of Swedish. Someone suggested he go to the Tennstopet restaurant in the Klara neighborhood of the city, just a few minutes from the station.

– It looked like a simple pub. I went in there and was going to have a seat at a table, but wasn't allowed to sit there; there was already someone sitting there, alone at a table for six, so I was seated at the bar. I had a beer, then another. When I finally got to order I mistakenly ordered shrimp, which I had never eaten before. Peeling the shrimp didn't go very well. So then I thought: steak, that can't go wrong. Then the bill came: it was 35 crowns. The beer was what was so expensive. In Austria, beer was cheaper than soda.

When Bernd Janusch came to Stockholm in the spring of 1963, he was a 20-year-old architecture student from Graz. He needed to gain practical experience in order to receive his degree. From Tennstopet he got directions to the Swedish Public Employment Service office on Tegnérgatan. There, the employment official looked at him with pity and said that he had to seek a work permit in Austria in order to obtain that kind of apprenticeship; it was not something he could get now. Bernd Janusch sat by her desk and started to think about the collect call he might have to make home to his parents, something he truly did not want to do. The phone

rang: someone was looking to staff their ice cream parlor. After four hours in Sweden, Bernd Janusch met Katarina Taikon.

– I came in there, and the way things were at the time was you wore tailor-made clothes down to your underwear. I introduced myself and she said: If you want to work, I'm happy to have you. I started that evening.

So began a friendship that lasted an entire lifetime. Bernd Janusch was often at the home Katarina Taikon shared with Björn Langhammer and the three children, in the Stockholm suburb of Bollmora, where they had moved in 1962. Bernd and Rosa Taikon became a couple, and so Katarina became Bernd's sister-in-law. He states today that his time at the ice cream parlor was the best education of his life. Katarina Taikon had an enormous trust in other people.

– Katarina hired me and then vanished; she was preoccupied with her book. She worked at the ice cream parlor almost as a way of relaxing, to get away from writing her book. She didn't treat me like a naive 20-year-old: after a week she gave me the keys to their Volvo and had me go buy milk from the milk distributor.

Katarina Taikon was fastidious about making sure that the ice cream bowls for ice cream scoops and milkshakes were spotless. Everything was washed by hand: if she came in one day and the place was not immaculate, she could become angry.

– When she fixed her eyes on you, you quickly knew that something was up. And just as soon, it would pass.

The ice cream parlor Vips had many regulars who came in throughout the day. An older gentleman came by in the afternoons: he was an alcoholic and never had to pay. "If you run a business, you always have to have someone you're helping," Katarina Taikon would say.

When Bernd met Katarina, he thought she looked Spanish.

– Gypsies, as you said then, were something I didn't even fully understand. I was born in 1943. After the war you didn't speak of either Jews or gypsies in Austria: it was basically taboo. Gypsies,

I didn't think they were real people but rather some kind of invention: they simply didn't exist; they were exterminated. I had since heard about the situation for Roma in Austria before the war. They were deported. This wasn't discussed in school, either. When we studied history in high school, it ended with Hindenburg. The thirties didn't exist. Many of the teachers were implicated in what happened. I was 20 years old when I met Katarina and of course thought I knew everything. When she told me that she was a gypsy and how they had been treated, I said, that's impossible: we're enlightened beings. A world that I didn't think was possible opened up to me.

Keathy Ericsson-Jourdan was 18 years old when she and her family moved to Sweden from the autonomous Baltic Sea island of Åland. From the very first moment that she entered Vips and Katarina Taikon gave her a hug, they became friends. Keathy Ericsson-Jourdan was raised in a community consisting of a few hundred people. Her parents owned a nursery. To her, being idle was inconceivable. When they moved to Stockholm, she recalls her life changing overnight.

– I wanted to become an artist. I wanted to work with form and color and express myself that way. My father became enraged: don't think I'm going to support you, he said. Don't worry: I won't, I replied.

Ericsson-Jourdan also started to work at the ice cream parlor. She got her own apartment in the city but rarely stayed there. She spent her time with Katarina Taikon and her family in the apartment in Bollmora. Keathy became like a big sister to Angelica, Michael, and Niki.

– I came from a strict home: you were only supposed to work and please people. Here, I could work and have fun. I got to be myself and I learned about warmth and generosity. After a few weeks in Bollmora, I said: No, I have go to home and rest. Then I'd go back out there after a while.

When Katarina Taikon retreated to work on her book, Keathy wondered what she was writing. I'm writing my history, was the reply.

Christer Hogstedt graduated from high school in 1960. He developed a political consciousness during *lumpen*, his compulsory national military service. It was the Sharpeville massacre in South Africa that awakened him: the police murdered 69 black protesters who had gathered in opposition to the apartheid system. Christer Hogstedt became involved in the Swedish South Africa Committee where he met, among others, John Takman and Joachim Israel; at the same time, he began to study to become a physician.

– My father was in middle management. He had worked for Swedish Aid in Norway, which supported the resistance during the World War II. My father's father was a street-sweeper and worked with the union, which influenced me tremendously. My mother was an office worker. We lived on Vikingagatan in Vasastan, a working-class neighborhood in Stockholm. At first I wanted to become an actor but that felt selfish; there was essentially no political theater at the time. I wanted to get an education in a field where I could be useful and contribute to society.

During his studies, Christer Hogstedt became editor of the Medical Association's newsletter, which was how John Takman came to ask him to assist with a comprehensive investigation. Takman had received research funding to undertake a medical evaluation of Sweden's Roma population. Over the course of three years they examined and interviewed approximately 1,000 people across Sweden. They retrieved addresses and traveled to those who could not get to a hospital on their own. They were greeted positively.

– The first time I met Katarina and Rosa was when they came to Saint Göran Hospital to be examined. Then we decided to meet again in a non-medical context. Katarina and Björn liked a café on Norrlandsgatan called Gateau. This was right before Katarina's book was published.

The group of friends became tight-knit: everyone had their hands full with work and studying, but also shared an everyday routine where they ate together, shared child care, played board games, went on trips together, and struggled to make ends meet. At the center of Katarina Taikon's life stood, besides the children, Björn Langhammer. Björn was then employed at Christer Strömholm's photography school and worked alongside Katarina to document Roma living conditions during the 1960s. Katarina's book contains his images of the camps: poverty, weddings, school work, and joy, along with individual portraits. They collaborated closely throughout the years, both in their political work and on the books.

Björn Langhammer is described as having been intellectually demanding: he enjoyed political discussions and could often be critical of the left. He saw them as autocratic and loathed anything that had even a hint of oppression and racism; he was more inclined toward anarchism. In discussions, he might take an argument to its extreme conclusion, which was sometimes stimulating, sometimes exhausting. Katarina Taikon was instead more pragmatic and sought to develop alliances across political divsions: her network extended from liberals to communists. Her personality was also more forgiving, even of her tormentors, as Bernd Janusch puts it. Björn was never as forgiving. But what kept them together, perhaps the deepest value they shared, was their common belief in the inviolable rights of human beings. They were at their core anti-authoritarian, which might be expressed in large and small ways: once when their daughter Angelica was nine years old and wanted to be excused from eating the blood pudding – a ubiquitous and inexpensive dish in Sweden – that the school served for lunch, Björn Langhammer wrote her the note required by the school: "My child tells me that she does not enjoy blood pudding. Thus, I must hear what she is saying, and I hereby also request that her teacher do the same."

*

It was a midweek morning when seven people entered the prime minister's office at Mynttorget. They had been granted an appointment in the midst of the campaign season's final weeks. Their matter was urgent: they had interrupted a strike in order to meet with the prime minister, hoping that he would be able to quickly resolve their issue. Four of the seven were students at Sweden's first school for adult Roma. By their side they had Katarina and Rosa Taikon, as well as John Takman.

Located in the forest outside Nora in Bergslagen, a mining region in central Sweden, Skrekarhyttan is an estate that dates back to the 1800s. In the summer of 1964, it was transformed into a school for eight adult Roma who had never before received a formal education. Over the course of six intensive weeks, they lived and studied at Skrekarhyttan. The curriculum was developed on the initiative of the non-profit organization The Association for Gypsies founded earlier that year by the editor in chief Evert Kumm, public health physician John Takman, and Katarina Taikon. The first meeting of the Association for Gypsies was held at the Gondola restaurant in Stockholm, which overlooks a vast swath of the city. There, it was decided that the organization would work for the social integration of Roma while also safeguarding their integrity. Others who participated included Johan Kaldaras, cousin to Katarina and Rosa Taikon; the sociologist Joachim Israel; the teacher Britta Flodin and Christer Hogstedt.

As early as the spring of 1963, before Katarina Taikon's book *Gypsy Woman* was published, discussions were underway concerning the fact that something needed to be done about the education of adult Roma. Of the 500 who were over the age of fifteen, 85 percent were illiterate. At that point, however, the authorities had little interest in the matter and no curricula for reading or writing had yet emerged, primarily because Carl-Herman Tillhagen, who in the 1950s had contributed to a shift in the state's policies toward Roma, discouraged education for adults. Tillhagen was now, in his role as "gypsy expert," tied to the National Labour Market Board

(NLMB), the public agency which since 1960 was charged with giving Roma access to housing and education. In general, Tillhagen argued for integration and often pleaded for patience with and empathy for Roma. Now, however, he felt that Roma lacked both the mental stamina and motivation for academic study; additionally, he said, there would only be tension and violence if many Roma were brought together at one school.

The cause for this change in opinion could have been that Tillhagen felt pressured by a younger generation of activists making its voice heard in the Roma question, especially when one of the most vocal among them was an articulate young Roma woman. It was therefore only after pressure from The Association for Gypsies that the NLMB during the summer of 1964 announced its support for the course at Skrekarhyttan. At that point, Katarina Taikon and other activists had devoted the entire year to bringing attention to the lack of education for adult Roma. They distributed flyers at the public square Hötorget in central Stockholm, fundraised, and published numerous articles on the subject.

Responsibility for developing the curriculum was given to Åke Edfelt, who at the time served as laborator—a title which then denoted associate professor—in the Department of Education at the University of Stockholm. On short notice he engaged friends who were educators and psychologists and whom he knew would be interested in the project. One of his students, a large and practical young man, became housefather, and his girlfriend became the housemother. For Åke Edfeldt, Skrekarhyttan was an opportunity to apply his great passion: literacy.

– SSS – EEE – SSS – PPP – OOO – TTT and so on. Those who worked with literacy claimed that enunciation was how people learned best how to read. Hell no. If you instead make sure that those learning to read know what the text is about and then get to read it, things change. Then you engage all the knowledge that person possesses, rather than having them turn off all their intelligence in order to sit there and sound out "see spot," says Åke

Edfelt, today 86 years old and Professor Emeritus of education. He sits on a chair in his living room, leaning against the wall with his legs crossed, reading glasses in hand. Surrounding him are paintings by renowned Swedish artists Stig Claesson and Carl Fredrik Reuterswärd.

Before the course began he instructed the teachers in how to work with adult students. We will first give the students the opportunity to understand what the text is about. Then, once they have a clear understanding of the text and its context, we will assist them in understanding the content, step by step, he told them.

– "But that's cheating," they said. Yes, we are going to cheat our way through this, I said. Of the eight teachers there was only one I really needed to work on to convince him that it would work. So, the students were to decode the letters when they already knew what the text was about. If they went off course and read the wrong thing, the teacher did not say: "You read the wrong thing." Instead, they would say: "Think about it: Could the word you just said really be in that sentence?"

The first week was challenging. The students and some of the teachers said, "This isn't how you learn to read." They sat and flipped through newspapers and talked about the different articles. They paid particular attention to the car advertisements. After three weeks a representative from the authorities came to see how the course was progressing. One of the oldest students, he was around 40—Åke Edfeldt can remember his face but doesn't recall his name—got to read an ad for cars.

– He pulled it off nicely. When the man had left the student said: Åke, you're terrible: now that man is going to go back to Stockholm and say that we can read after three weeks. You know I can't read. "I'll be damned," I said. "Watch this: now you and I are going down to the village." They had people there who were in summer school. We drove up, knocked on the door, and asked the teacher if we could borrow one of those old-fashioned green

reading books. She brought it out, and while she was still standing there I said to him: You haven't seen one of these before. Start here. Read. Read aloud. "Hear – the – wind – in – the – pines." Thank you, I said, that's enough.

– That was his turning point. He hadn't believed that he would learn how to read. When they arrived at the school, none of the students thought they would. To me it was incredibly rewarding to see this development, how they on their own started to understand what reading was.

Everyone lived at Skrekarhyttan during those six week, students as well as staff. The days were intense, and the only time Åke Edfeldt left the school was when it was time to fish for crawfish in the southern province of Östergötland, a tradition he did not want to miss, so he took two days off. Being responsible for the program, he felt pressure for the course to be a success. He was aware that the students' results at Skrekarhyttan would impact the authorities' attitude toward future continuing education programs for the illiterate—not just the eight students at the school, but for Roma all across the country.

– We had conflicts and resolutions at the school and we sorted it all out. Everyone in the course completed the program; we didn't lose a single student.

When I ask Åke Edfeldt if there was a public sentiment that "these people" could not or did not want to learn to read, and that it therefore was pointless to invest in them, he answers:

– Oh yes, yes, yes. Of course there was. It was not a given for people in general that Roma would learn how to read. Even in the village there were a lot of people who said: "What are they doing here? Why are they at Skrekarhyttan when it's such a nice place?" I had heard both Katarina and Rosa Taikon speak when we met through friends: they had a persistent need to illustrate that this issue was important to them—important to Roma in general, but also to them, personally.

Three weeks into the course, at the end of July, the students had a meeting with Åke Edfelt and John Takman. They wanted the course to continue after the six weeks had come to an end. Everyone, education scholars and teachers alike, had thought that, after completing the course, the students would be tired and need a break, but for them both the curriculum and the logistics were ideal. They also received educational subsidies, which meant that they did not have to be concerned about making a living while in school. John Takman wrote a letter to the Director General of the NLMB and demanded renewed allocations of funds. He underscored that the students demanded that the education continue—in direct conjunction with the six-week summer course. But when the course ended on August 15, the NLMB could only state that there was neither funding nor faculty to continue. At that point the students initiated a sit-in. Naturally, the Association for Gypsies supported them: Katarina Taikon and the others immediately started a fundraising campaign.

Many newspapers that wrote about the students' strike for continued education—a strike with primarily symbolic and ethical value: they had no means of putting economic pressure on their adversary—also listed the banking information for the Association for Gypsies, so that potential donations could be collected.

The journalist Bo Strömstedt was one of those who received a flyer from the association. At the top of the page were three crosses in a row: + + +, the signature for someone who could not write. "A slip of paper in the mailbox. The situation is humiliating, both for the person who places it there and the person who receives it," wrote Strömstedt. "Your child starts school on Monday. Today and tomorrow and the day after that, you should walk around and beg for money to have a place for them to study." After approximately one week of intensive public campaigning and continuous media coverage, Swedish Prime Minister Tage Erlander took the time to meet with Bachero Taikumer, Gustav Müller, Lars Taikon, and Jeger Taikumer, who, in the company

of Katarina and Rosa Taikon, were the first Roma to meet with a Prime Minister. Katarina Taikon couldn't help but remark upon the historic nature of the event.

– This is probably the first time there's been a gypsy in these rooms, she said to Erlander who stood in front of the journalists that had gathered.

Initially, Erlander thought that Katarina and Rosa were also students at the school. His staff had failed to inform him that one sister was an author and the other a silversmith. Katarina Taikon explained that she and Rosa had had the privilege of studying respectively at a business and an art school.

In preparation for the meeting, Tage Erlander had received a report about the course at Skrekarhyttan, where the NLMB noted that the results were good, even excellent, but that the authorities did not have the funds available to continue. When Erlander paged through the report and mused aloud concerning the financing of an additional six-week course, Bachero Taikumer calmly interjected:

– How much do nine years of primary education cost?

With them, the group had brought a crowd of journalists and photographers. The next day a photo from the meeting was published in Sweden's most prominent daily newspapers—*Dagens Nyheter, Svenska Dagbladet, Expressen, Sydsvenska Dagbladet, Upsala Nya Tidning, Göteborgs Handels- och Sjöfartstidning, Skånska Dagbladet, Stockholms-Tidningen*—and a string of provincial newspapers. The image was remarkable: four dark-haired men in elegant suits and skinny ties, two women, equally as dark as the men, of whom one—Katarina Taikon, in *dikló*, a headscarf—were in conversation with the nation's prime minister. They were people who were seldom heard, especially in official circumstances. Now they were advocating for themselves and demanding the same right to education that was afforded to other Swedes.

The photograph of the four students together with Katarina and Rosa Taikon became more than just a glimpse of a meeting

with the prime minister. It planted itself in a broader national consciousness, a consciousness which had started to apprehend that something was amiss. There was a reason why a group of Roma activists had made their way into the inner sanctum of Swedish democracy.

*

The visit to Tage Erlander led to the NLMB extending and again assuming responsibility for the project at Skrekarhyttan. The following year, approximately ten schools were started across Sweden. The Association for Gypsies worked hard to keep the question of schooling alive. Evert Kumm, who had initially founded the school at the Skrekarhyttan farm, penned articles. Arne Trankell, Professor of Education at the University of Stockholm and a colleague of Åke Edfeldt, had participated in the summer curriculum, and when Edfeldt stepped back after that successful partnership, Trankell continued to do advocacy work through the Association for Gypsies. Katarina Taikon gave lectures, wrote articles, and visited with administrators and municipal policy makers.

In order to manifest its political objectives in terms of education, a Roma group, supported by non-Roma, gathered on May 1, 1965, in its first demonstration in Sweden. They gathered in Humlegården, a park in downtown Stockholm, an hour before the march was to begin.

– It was exciting, people were filled with anticipation. There was so much going on then with both housing and education. But it didn't happen on its own: we made demands.

This, according to Monica Caldaras, who was 22 years old when she participated in the demonstration. Her father, Erland Kaldaras, was a cousin of Katarina Taikon, and together with his brother, Johan Kaldaras, he carried the banner at the front. The slogans read: "We want to go to school, make it possible," and, "Studying demands financial security."

– Earlier, we were relegated to a forest where no one could see us. Now we were walking down a main street in Stockholm. It was wonderful, at least for me, says Monica Caldaras.

In a photo from that day, the march moves through Humlegården. Flags flutter in the wind. The trees are still bare. Katarina Taikon walks next to Monica Caldaras: she wears a shearling leather jacket and gloves; it looks cold. In her hand she holds a sign, "Invest in adult education." She walks in the demonstration but also a little bit to the side—like someone who wants to have an overview of the situation. A number of cultural figures and activists participate: the sociologist Joachim Israel; the nurse Thea Åström; Katarina Taikon's ex-boyfriend and Angelica's father, Ove Tjernberg; Johan Takman and Åke Edfeldt. Ivar Lo-Johansson had also shown up.

Within the Association for Gypsies one had discussed what it would mean for Roma to participate in the demonstration. Was it really a good idea to participate in that public setting, and to also then make demands? Many were concerned that they would be met with jeers and taunts, or worse. This is how Arne Trankell describes the mood in the march when they left Humlegården:

> The women's clothing gleamed in the sunlight, and the children's elation mixed with the adults' nervous anticipation, when the march turned on to Karlavägen [a commercial thoroughfare in the affluent neighborhood of Östermalm] and marched between the spectators that lined up along the street. Suddenly there was applause. Someone shouted bravo. The demonstrators were deeply moved and exhilarated. Along the street, new spectators would applaud, and the entire demonstration became a party, a triumph, where sympathy and appreciation flowed toward the participants. A few hesitant gypsy families who had remained on the sidewalk to

observe were drawn in by the enthusiasm and joy, and when the march reached Gärdet, on the northeast edge of the city, it included more than thirty gypsies.

That same day, 44 Roma delivered a letter to the government. All the signatories, save for Katarina and Rosa Taikon, were students in the newly founded adult education program. A number of authors, artists, and administrators also demonstrated their support by signing. Above all, they demanded educational subsidies during the program.

The May 1 demonstration, along with the letter, led the National Agency for Education to assume responsibility for the program starting on July 1, 1966. From that point on, rather than remaining with the NLMB, it was treated like any other educational matter. Illiteracy was not primarily a labor issue, according to the Association for Gypsies. That the mainstream educational system would assume responsibility for Roma education was an enormous victory for the activists.

At the same time, there was tension within the organization. Researchers like Arne Trankell, the social worker and gypsy consultant Nils Wall, and independent activists and intellectuals gathered under the umbrella of the Association for Gypsies. Katarina Taikon belonged to the latter group. Even if they shared the same political objectives, it was apparent that the members all had diverging visions. After two years of collective political work, Trankell wanted to move forward with his research and "test different scientific hypotheses" around Roma education. Nils Wall remained active within the bureaucratic machinery in order for Roma to obtain housing, literacy skills, as well as professional preparation. From his vantage point, things were changing, if slowly. Katarina Taikon felt somewhat restrained in that context.

There were advantages to working within a formal organization: for example, building networks took no time at all, and having an organizational affiliation strengthened advocacy efforts.

But, in truth, this was all something she could do on her own without compromising her speed, mode of address and, above all, her own viewpoint. Katarina Taikon was at this point an established voice in the public debate, and her strength lay in her ability to articulate and spread a message. In the spring of 1966, the Association for Gypsies disbanded.

*

It was pouring rain in Stockholm. Darkness had fallen. In the large downtown park Kungsträdgården, freezing youth stood and waited for the demonstration to begin. A few days earlier, Martin Luther King Jr. had received the Nobel Peace Prize in Oslo for his struggle against segregation in the southern United States. At 35, he was the brightest star of the civil rights movement and the youngest to ever receive the Peace Prize. At exactly five o'clock, the youth started to move. They walked with bright torches in the dark and rainy night, across the Norrbro bridge and up Slottsbacken, past the royal castle. Behind Storkyrkan, before the statue of Olaus Petri, a podium had been erected. There, they waited for the civil rights leader to speak. On this day in mid-December, Katarina Taikon met Martin Luther King Jr.

Paul Rimmerfors was responsible for organizing the demonstration. He was involved in the peace movement and was the executive director for the Youth Association for Peace. "We were kind of famous then," he recalls, "because we were the youth arm of The Swedish Peace and Arbitration Society, directed by the prominent author Per Anders Fogelström." The peace movement was powerful: other influential individuals who took a clear stance in favor of peace during the Cold War was the journalist Barbro Alving and the Social Democratic politician and diplomat Inga Thorsson. Paul Rimmerfors himself had left the youth arm of the centrist People's Party when they advocated for a Swedish atomic bomb. He recalls that the political awakening

of his youth was marked by his parents' involvement with refugees during the war and by the "huge catastrophes" Hiroshima and Nagasaki.

The same fall that Martin Luther King Jr. visited Sweden, the Youth Association for Peace had instituted their own peace prize. The first prize was awarded to Katarina Taikon: she received a diploma and a thousand Swedish crowns.

Before King took the microphone that night, Paul Rimmerfors—in the name of the thousands of assembled youth, all connected to a range of different political and religious organizations—gave a speech in honor of Martin Luther King Jr. At the podium stood King, in a black coat and hat, with Paul Rimmerfors and Katarina Taikon by his side.

"Youth around the world send you their warmest regards. Today, we pay tribute to a true democrat and an exceptionally fine human being," said Paul Rimmerfors. When it was King's turn to speak, he began by saying that the evening's demonstration made a strong impression on him. "This is most inspiring. And I can assure you that all of your expressions of support will give me renewed vigor and courage to carry on." The struggle must continue by peaceful means, consistently, King continued. It was a message he repeated several times during his visit to Sweden. After the speech, Katarina Taikon handed a bouquet of flowers to Martin Luther King Jr. For the occasion, she was dressed in an emerald green Roma dress.

– That Taikon and King would meet was a pretty obvious parallel. We had a minority fighting for its life, while he struggled for the rights of black people in the United States. What I clearly recall is that he became very engaged with her struggle in Sweden. He had an ability to listen and engage, and he related it to his own struggle. He asked her many question, while I translated, Paul Rimmerfors recounts.

After the demonstration, Katarina Taikon and Paul Rimmerfors entered Storkyrkan in order to hear King address nearly 3,000

other residents of Stockholm. Members of Parliament and the US ambassador were seated in the front pews. Martin Luther King Jr. and his wife, Coretta Scott King, were seated alongside Queen Louise. When the sermon concluded there was a reception for King in the parish priest's home located on the square at Stortorget, where Katarina had once lived in the City Mission's home for girls. Katarina Taikon took the bus home to Bollmora and, while she most likely sat with her family and recounted the evening's many events and conversations, Martin Luther King Jr., Coretta Scott King, and their colleagues celebrated the one-year anniversary of Kenyan independence at the Malmen hotel in Stockholm.

*

In the national self-portrait that emerges in newspaper articles and public debates in 1960s Sweden, a particular story recurs again and again. We do not have any racism in Sweden, and luckily we do not have any "minority problems" either, in spite of numerous reports concerning the treatment of Roma.

After a five-year wait, a family is permitted to move into a prefabricated home in the central Swedish city of Örebro. A neighbor says that of course they should live in houses; they are people like us. Another neighbor says, I'm not a racist, but they're better suited for the dump.

When winter comes, a family with five children in a small city in central Sweden gets to move into the woodshop of an abandoned school. Their life becomes national news: the papers write about the family as if their life were a serialized story. The politicians keep postponing their decision regarding whether or not the family is to receive housing. They are all Swedish citizens. When there is finally a vote, a majority of the elected officials vote against permitting the family to live in a prefabricated home. The Social

Democratic chairperson stands by the decision: Rome wasn't built in a day, he says. He invokes a letter he has received, signed "A Swedish Worker." He simply cannot disregard that letter. It is decided that the question should be further investigated, since the oldest child in the family, an 11-year-old boy, has been permitted to start school in the city. It is the boy's thirtieth school in four years. The family traveled until it moved to the small city. Now we can't move anymore because I want to stay in this school, the boy says. It takes two years from when the question is brought up to the municipal executive board to when the family receivs proper housing. In all the articles about the family, the parents never say a word. I call the mother; today, she is 84 years old.

– I don't want to revisit that. We traveled and that was fine, and then we moved here and that was fine, she says.

She sounds spry. What exactly do I want to talk to her about, she wonders. About when you moved to that city and your sons started school, I say.

– Well, that was fine.

I ask her if it's all right if I contact her sons. The reply is immediate.

– No. They work and have their own lives.

I do not call the sons.

An older woman owns a large house in the Stockholm suburb of Danderyd that she plans to sell to the municipality. The house is to become an orphanage for children between the ages of three and six. The neighbors protest and a meeting is held in the local community center. The orphanage will disturb the peace, the neighbors say. After an extended discussion, the woman finally says, if you continue to argue I'll donate the house to gypsies. The protesters fall silent.

A family with four children is to move into a house in Falköping, a small city in south-central Sweden. The house is placed outside

the city, adjacent to a dump. Industrial manufacturing lies beyond the dump, and there is a strong odor in the air. The mother of the family says that she has lived in tents her entire life, but she has never settled by a dump. The municipality states that it was the only land available. While waiting for the prefabricated house, the family lives in the kitchen of a dilapidated farmhouse. In an image in the tabloid *Expressen*, the mother, father, and two of the children sit on a couch, or perhaps it is their bed. A painting hangs above the father: a large ship sailing out on frothy ocean waves. The family regards the camera. The father is impeccably dressed in a suit and tie, the mother in a dress and dikló. She smiles, albeit without cheer. The teenage daughter looks self-conscious; the kind of expression children make when forced to confront their parents' vulnerability in the presence of others.

In Lidköping a group of homeowners comes together and writes a letter to the municipality: the idyll they live in will be spoiled if a Roma family moves in. They suggest that the family be permitted to live on a more suitable site, preferably one in a less central location.

A Roma family moves to a house in the Stockholm suburb Nacka. The municipal commissioner receives so many threatening phone calls that it is necessary for the police to guard the house at night.

A family of two adults and one child has purchased an apartment in one of Stockholm's southern suburbs. A few weeks before the move, however, they want to break the contract. They assert that they have been mislead, and sue the real estate broker. The broker had not informed the family that Roma lived in the building. The purchase is revoked.

In Arkösund, a small seaside community near Norrköping, a Roma man wants to purchase the old established hotel. Homeowners in

Arkösund call the seller and make a range of threats. Swedes need to keep a nice neighborhood like that, one of the residents says. Another says that the purchase would make the entire community flee. The residents form an association: they invite the Roma man. If worse comes to worst, the association's attorney states, they can invoke a law that makes it possible for the municipality to seize the property. The deal falls through.

Sweden is a progressive nation made up of citizens who are equals, free of any trace of racism. This was one of the apparently self-evident truths at the center of the Social Democratic welfare society. Sweden had, very quickly, managed to officially distance itself from many central aspects of its own recent history.

Special legislation in the 1800s was implemented to permit Jews who had immigrated to settle in Stockholm, Gothenburg, and Malmö, where they were limited to practicing only certain professions and were only allowed to marry other Jews. The flourishing nationalism at the turn of the century and the xenophobic mobilization against Jews who had fled the pogroms in Russia and the Baltic States. The racial biology that was popularly accepted and institutionalized in 1921 through the one-of-a-kind State Institute for Racial Biology in Uppsala. The measuring of indigenous Sami skulls, beauty competitions in blondness, exclusionary immigration legislation against Roma between 1914 and 1954, the state-sanctioned persecution of Roma during the first half of the 1900s, widespread Nazism among the Swedish elite during World War II, and the state's complaisance with regard to the Third Reich.

During the 1960s, this entire history was repressed somewhere far away from the Swedish success story. And since there was neither racism nor discrimination in Sweden, the wave of contempt and hatred that greeted the Roma when they moved into housing could consequently not be instances of racism: it was every ordinary person's right to not have to be near the Roma.

How did Katarina Taikon respond to the opportunity to meet Martin Luther King Jr. during his visit in Stockholm? She was fired up, says Paul Rimmerfors. Besides being personally happy, she also saw it as an opportunity to do outreach for the Roma peoples' equal rights. But her presence at the peace demonstration that rainy December night was barely noted in the reporting on King's visit. It was Paul Rimmerfors who felt that the parallels between King and Katarina Taikon were obvious; few others could see them. Nor did Katarina herself use the meeting with King as an opportunity to discuss the similarities between racism in the United States and Sweden. Not that the conditions and histories of the two nations were exactly comparable, but there were many common denominators. She could have very easily presented such an analogy: Martin Luther King Jr. embodied the global struggle for equality and justice against racism, and in Sweden she was the person most similar to the Nobel Peace Prize winner. On occasion she would speak of segregation in the United States, as she did when she recounted the story of when she and her sister Paulina wanted to go to school but could not to due to the principal's fear that parents would take their children out of the school if they were to enroll. Then Katarina Taikon would ask what the difference was between Linköping and Birmingham, Alabama.

6.

When the city of Stockholm expanded in the 1950s, Bollmora was one of the first areas where the city constructed housing outside its own municipality. Today, Bollmora is called Tyresö centrum. The small-town shopping center built here in the early '60s is today a mall with all the national retail chains. In the middle of the mall is a café that serves chilled shrimp salads and large "American-style" muffins. Outside, at the rear of the mall, the movie theater Forellen (The Trout) evokes an earlier architectural era. Above the white mid-century building sits a neon sign: *Forellen*, written in red letters and beneath it two rows of bobbing waves. From here it was only a few minutes to Bollmoravägen 8. The buildings on the street were new and tall and in the courtyard stood skinny birch trees which gave shade to the balconies. Families with children and young people moved in: it was easy to get an apartment.

Katarina Taikon, Björn Langhammer, and the children moved to Bollmora in 1962, the year after Niki was born. The municipality awarded them a three-bedroom apartment and they had never before lived in such a large space. The children shared a room; Björn built a three-tiered bunk bed for them. When Angelica went to sleep in the top bunk there was only a little bit of space left between her and the ceiling. One of the bedrooms became a guest room—essential, since many friends stayed the night when dinner was over and the conversation would begin to die down.

When Rosa Taikon moved to Bollmora the following year, she was initially given an apartment a few streets away, then later

another apartment in the same building as her sister. She and Bernd Janusch lived in an identical apartment two floors up. Rosa, the pillar, was nearby again. The two families practically formed a shared household. Katarina could leave traces at Rosa's.

Dear Rosko!
Swiping two pairs of pants from you,
since I don't have time to wash my own.
Don't get pissed.
Your lazy sister,
Kati

– I was pedantic in those days. I did nothing but clean. When Katarina came to our house for the first time, she cast a sidelong glance at the buffed floors.

We are sitting in the kitchen with a bottle of wine on the table. Hans Caldaras lights the candles while he remembers that he bought chips for tonight. He reaches for a bowl.

– We lived in a modern one-bedroom in Rågsved. To us, it was luxurious. Heated floors in the bathroom. Katarina would visit; she and my mother were cousins.

The year is 1965. Hans was 17 years old. Mara Kaldaras had told her son about the three Taikon sisters. They did not have an easy time with their stepmother, especially the youngest two. Hans Caldaras also knew of Katarina through the newspaper and had seen her on TV many times. When they became friends Hans had just realized what he wanted to do with his life: he wanted to sing.

Björn Langhammer took him to a vocal coach, an old friend named Max Lundqvist who lived in the affluent Östermalm neighborhood of Stockholm. Max Lundqvist was the first trans person in Sweden to have sex reassignment surgery. From the very first moment, Max Lundqvist loved Hans's voice. He offered him free classes once a week in his apartment on Birger Jarlsgatan, and a deep friendship developed. Within a year, Hans Caldaras

was so promising that, on May 1, 1966, at the Stockholm Olympic Stadium constructed for the 1912 games, Hans Caldaras received a scholarship from the Hans Karlsson Memorial Fund before an audience of 30,000. When Hans Caldaras's name was called, his little fan club cheered wildly: Katarina, Rosa, Björn, Bernd, and Keathy. They smiled wide as he stood on stage next to some of Sweden's most prominent actors and entertainers. Katarina beamed with pride. Mara Kaldaras was so nervous that she had to stay home.

– When the awards ceremony concluded, a woman came up to me and introduced herself as the wife of Hans Karlsson. She congratulated me on the award, and Katarina and I happily shook her hand and, without thinking, said, "Please thank him for us!" The woman stiffened: "But he's dead." We wanted to just sink through the ground. "So typical! Right: memorial fund," Katarina said.

Hans Caldaras shakes his head when he tells the story. I look at a photograph from back then: his glossy brown hair falls in a side-part across his forehead, and he wears a white shirt beneath a beige V-neck sweater. When Hans at the age of 14 started seventh grade—growing up in camps meant that he was a few grades behind, something he later remedied—he came to school in a blazer. His classmates called him Slipsen (The tie).

While Hans retreats into memories he takes a peek at the salmon in the oven. We can hear the wind outside the kitchen window. Hans Caldaras has lived in this apartment, a two-bedroom in the eastern part of Södermalm, since the late 1980s. He has lived in Stockholm since 1959, when he and his mother and older brother, Kenneth Kaldaras, moved from Malmö to Flysta, a camp in the northern part of Stockholm. They lived with a hundred or so other Roma, many of them relatives. Large power lines ran adjacent to the camp. The following year the municipality relocated the camp's residents; Hans and his family ended up in the camp in Skarpnäck. There, their caravan started to fall apart. The hinges

on the door came loose, and one day it simply fell off, so Mara Kaldaras hung a blanket in the doorway. She contacted the city's gypsy consultant and asked him to come see how they lived. During his visit to the camp, the gypsy consultant picked at the rotting wood and said, "This can probably be fixed." Mara Kaldaras asked him to get out of there.

When Hans speaks of his mother there is solidarity in his voice, and pain: the kind of sorrow passed on from parent to child, a child's lifelong affection and empathy.

But this was not something Hans could name at the time. Soon after he and Katarina had become friends, the day came when it was time for him to leave home.

– I was going to, what's it called? Well, I was going to liberate myself from my mother, Hans says with air quotes.

He was ambivalent. On the one hand he had very strong ties to his mother; on the other hand, he wanted to prove that nothing dangerous would happen if he went out into the world without her. Katarina encouraged Hans's decision: she liked the idea that he would go out on his own, do something new. He moved into the guest room in Bollmora.

– Katarina and Björn introduced me to French film. Sometimes we might go to two matinees in a row. I learned to appreciate directors like Chabrol and Godard.

Together they went to restaurants and bars that Hans did not even know existed. When Katarina and Björn were out on different jobs, Hans took care of Michael and Niki. Political discussions— the Roma question, Sweden, geopolitics—were a constant in their living room. He also met people that he otherwise would not have met: artists who were broke and had a temporary home with the family, or friends who had just broken up from a relationship. A few of them were strange to the barely 20-year-old Hans. Some, perhaps under the influence of alcohol or drugs, frightened him. But even if Katarina and Björn's home was a place where he could grow up, Hans started to feel guilty about his mother. She was

alone. When her son moved, Mara Kaldaras got a white toy poodle for company. After seven months, Hans moved back in with his mother.

Katarina Taikon's daily existence did not distinguish between work and pleasure, the personal and the political: the different spheres largely overlapped. For Angelica, Michael, and Niki it was not strange that the adults had long conversations about what was happening in the world and about the range of different projects they were engaged in. For a while, their home was more or less a social club; at other times, it was also a small publishing house.

When the first issue of *The Gypsy* was published after the May 1 demonstration in 1965, the editorial board sent it to the media, prominent cultural workers, those in the vanguard of public opinion, and all the members of Parliament. They had a mere 40 subscribers, but a considerably larger number of readers. *The Gypsy*, or, *Amé beshás*—"We live" in Romani—as the first few issues were titled, became a forum for the ongoing changes around housing and education for Roma. When the Association for Gypsies dissolved in the spring of 1966, Katarina Taikon and Björn Langhammer assumed responsibility for its publication. The gypsy consultant Nils Wall and professor of education Arne Trankell stepped down from the editorial board while new actors came on board, including a young reporter at *Expressen*, Herman Lindqvist, who contributed to a few issues. Hans Caldaras and Christer Hogstedt were members of the editorial board, as was a new friend, Lars-Erik Johansson, who came to know Katarina and Björn through Christer. Lars-Erik Johansson came from an impoverished home and had a very strong working-class identity. He was the first in his family to study beyond grammar school and he went on to become a dentist; a few years later he would become involved with the large mining strike in Malmberget. John Takman remained on the periphery of *The Gypsy*; Rosa Taikon and Bernd Janusch were part of the inner circle.

The editors worked hard to insert themselves into the public debate. They sat up late and hand-wrote addresses and sealed envelopes containing the publication. Most of the time they wrote the articles themselves. Björn was the photographer and Bernd took care of the layout, which involved cutting and pasting strips of text and captions for each page. The publication was black and white, the size of an A5 page. Eventually it went from 1,200 to 3,000 copies, with 300 steady subscribers.

In the spring of 1967, the publication started to move away from housing and education as its central concerns. After nearly four years of advocacy work, the camps in Stockholm had been vacated and Roma in Sweden were now living in proper housing. Furthermore, adult education programs had been systematically initiated across Sweden. That year, Katarina Taikon, for the second time in her life, came in contact with the human consequences of World War II. Her meeting with refugees from continental Europe impacted her deeply.

At the same time, *The Gypsy* now turned its attention to other pressing contemporary issues. One produced dispatches from the Russell Tribunal held at Folkets Hus, the communal People's House, in Stockholm in May of 1967. The war crimes of the United States against Vietnam were placed on trial in a symbolic hearing, and among the tribunal's participants were Jean-Paul Sartre, Sara Lidman, and Peter Weiss. People impacted by the war testified on site in Stockholm. The Vietnamese farmer Hoang Tang Hung had had his back burned by napalm. A nine-year-old boy, Do Van Ngoc, recounted how bombs had been dropped on his village one day when he was out playing with his friends. He had burns on his abdomen and genitals. The teacher Ngo Thi Nga worked at a school that was attacked by US bombers: she was shot and a bullet entered her head, but she survived.

The tribunal was criticized in the media and some called it a communist propagandist spectacle. Sara Lidman received misogynistic hate mail and Joachim Israel was described in one pub-

lication as "a strange bird, who step by step is seen increasing his impact on Swedish culture in an effort to destroy it."

*

One day there were three caravans at Stadsgården, the pier where the large Viking Line cruise ships today dock. The caravans belonged to two families from Poland. A gypsy consultant at the municipality called Katarina Taikon and asked her to come down and explain that the families could not live there. They had parked their caravans where the ships were loaded. The families could settle in Ekstubben, at the site which until recently had been a camp for Swedish Roma. Eventually another family arrived, this time from Italy. In all, there were twenty people, of whom half were children. Most recently they had resided in West Germany. After a year in Sweden, they were notified that their temporary residency permit would not be extended. It was early summer 1967. The families agreed to reapply for permanent residency.

– We've come to Sweden because we no longer want to remain in West Germany. Thirty or so of our relatives were killed by the Germans in Poland, in the Treblinka extermination camp. We don't want our children to grow up and have to do mandatory service in the West German military. We want peace. In West Germany we are treated as though we are diseased, said Sergu Kwiek, one of the men, to *Expressen*.

For the second time in her life, Katarina Taikon encountered Roma with immediate experiences of the Holocaust. That spring, she was at work on her third book—the second was the poetry collection *Gypsy Poems*, where she translated Roma poetry to Swedish—slated for publication that fall. She was aware that mobilization for the refugees would demand a great deal of time, but she did not want to refuse. She visited the editorial offices of the Social Democratic publication *Aktuellt i Politiken* (Contemporary politics). There she explained the situation to the editor that she

wanted to write about the refugees but that she could not do it just now. She then requested the confidence to receive an advance for the article: she got it right then and there. Katarina Taikon needed funds to be strategically agile in her work with the refugees.

The first thing she did was deliver letters to the government, where she clarified the families' stories and arguments concerning why they should be allowed to remain. In June she and the families' spokesperson, Maruzia Kwiek, were allowed to meet the Minister of the Interior Rune Johansson. In the photos from their visit, the summer appears to be warm. Katarina Taikon wears a floral-patterned dress in a simple '60s style and Maruzia Kwiek, next to Katarina, who serves as her translator, wears a sleeveless Roma dress. Rune Johansson listens and leafs through his documents. Everyone looks resolute.

The issue lingered during the summer months. The families had moved to a campsite adjacent to Lake Flaten in southern Stockholm. The children had managed to learn a little bit of Swedish and the men had paid work through Katarina's network. Everyone was in a holding pattern during the wait. Katarina had high hopes: the visit to the Minister of the Interior had gone well. She felt that he was positively inclined when it came to the family's situation.

On August 15, the independent Foreigner Commission unanimously ruled that the families should be deported. Katarina Taikon heard the news on the radio. She was shocked by the unanimous decision: she had expected that at least one of the members would abstain. According to the Foreigner Commission, which did not answer to Parliament, no new justification had been revealed to grant the families asylum. Katarina Taikon greeted this news by stating:

– The old ones are more than good enough. Twenty people, twenty reasons.

The disappointment ran deep: in sheer panic, some of the families went underground. But time was of the essence in order to right the situation. Two days later, Katarina Taikon delivered a demand that the government repeal the commission's decision, and now the media was reporting extensively about the families. Seeing asylum-seekers in the media was unusual, especially those who shattered the anonymity and became people with names and faces. People started to contact Katarina and ask if they could be of help. Someone offered the families housing; another wondered if they wanted work on a farm. The following week the ruling was announced: the government refused to repeal. Outrage ensued. August 23, the day following the ruling, *Aftonbladet* angrily stated that the government had the authority to ignore the Foreigner Commission and make the decision themselves. The family could demonstrate grave humanitarian justification: of course they should be allowed to stay.

There was frantic activity at Katarina and Björn's home. Now they could only make a final appeal to the government for clemency. The phone rang off the hook: people who were outraged got in touch, petitions started to circulate in Stockholm, Katarina was on the phone with authors, artists, actors, and other celebrities who wanted to sign a petition to the government. She visited newspaper editorial offices and radio and TV stations, and on the way she stopped in at the Royal Dramatic Theater. The stack of petitions grew thicker and thicker in her bag. Reporters at major newspapers boldly stated that these people must be allowed to stay. People came up to Katarina Taikon on the street and said: "This is going to work out: don't worry." Public opinion was in their favor; pressure on the government was enormous.

On Friday, August 25, a hundred or so people entered the courtyard of the royal castle in Stockholm. Many had brought their children, yet it was a silent group and the mood was tense. Right before ten o'clock, the ministers started to arrive to the parliamentary convening. Social Democratic Party member and subsequent

Nobel Peace Prize recipient Alva Myrdal wore a light green coat and dark hat. Katarina Taikon caught sight of her and tried to make eye contact, but Myrdal kindly but firmly warded off any conversation. Minister of the Interior Rune Johansson, whom Katarina Taikon had met with before the summer, stopped to chat. Rather, he was surrounded by Katarina and Joachim Israel. Gunnar Sträng said a few words in passing and quickly disappeared into the castle. The images from that morning show Katarina Taikon with a pleading look in her eyes, almost desperate. She stepped up and looked Sweden's most powerful politicians straight in the eye: it must have been difficult to ignore that gaze. At ten o'clock, the doors were closed.

Since the families' case was to be decided by the state cabinet assembling that day, the editorial board of *Dagens Nyheter* felt that the government was prepared to grant clemency, but at the same time it did not seem logical: why initially deny the families asylum, then deport them, only to finally grant clemency? This would be an expression of "heartless formalism," according to the paper. In the courtyard, those assembled paced back and forth.

The decision would not be announced until three o'clock, and the children grew restless. Then someone shouted that the phone by Storkyrkan was ringing: it was a call for Katarina Taikon. She rushed over and grabbed the receiver.

– Congratulations, Katarina!

It was the editor of the publication *Östgöta-Correspondenten*.

– What do you mean? she replied.

– They get to stay.

There was silence on the other end. Slowly, tears welled up. Katarina Taikon rushed out, and on the way she hugged a police officer. Cheers erupted in the courtyard, and they quickly drove out to Lake Flaten: Katarina, Björn, 13-year-old Angelica, Rosa, and Bernd. Happy, surprised, infinitely relieved. They were greeted by one of the mothers: she held Katarina in her arms for a long time while she wept. Finally, she said, in Romani, "You are my sister."

Over the subsequent days there was a public schism between the Foreigner Commission and the government. Several members of the Foreigner Commission threatened to resign: they felt steamrolled by the government and asserted that the Foreigner Commission had simply been following the government's prior decision. In May, the government had decided that the families could not stay. That decision was wrong, according to an editorial piece in *Expressen*: their reasons for staying should have been known at that point. The government should either have reviewed their decision in conjunction with the visit from Katarina Taikon and Maruzia Kwiek, or have provided new guidelines in the face of the committee's August 15 decision. When the government the following week still did not indicate that they would budge on the issue, the Foreigner Commission of course said no. *Expressen* writes: "Thereafter the government could announce its decision with a flourish. It's a scandalously careless course of action."

*

The last days of summer: cool, overcast days, and clear nights. To get to sleep during a night like that, an entire night. To wake in the morning and remain at the kitchen table with your coffee. It was on such an afternoon that a reporter from *Expressen* called Katarina Taikon. Evert Taube, Sweden's foremost troubadour, a national hero of sorts, had established a gold medal in her honor. It was called "Katarina Taikon's large gold medal for courage in the struggle against racism." Was someone pulling her leg? No. A medal of the highest order with a bright violet ribbon.

Four years had passed since Katarina Taikon's first book, *Gypsy Woman*, was published, the alarm that sounded when yet another winter approached the windswept camps. Katarina Taikon raised hell: there is no other way to describe it. There was a joy in seeing her at work, seeing one person carry so much hope. The books had been greeted with kind words and just one year later she was the recipient of the City of Stockholm's prestigious cultural award.

At the ceremony in City Hall she wore a Roma dress along with a silver belt made by Rosa. The applause was endless. There she stood: the girl from camp. The one who asked too many questions and got into the adults' business. The one who did not understand why she and her siblings had to be more compassionate and cleaner than everybody else, why she was scolded by her sisters when she tried to slip a borrowed doll into her bag—a real doll with real clothes—when they were forced to continue traveling. The one who had blisters on her palms from fetching water and hated that they lived so far away from water, hated that she and Paulina were mocked when they walked along the road with their splashing buckets. Never mind them, her sister had said, and she thought to herself: "I know you think I'm obstinate, and father says I'll make things harder for myself if I talk too much, but I don't care what you think, because the day I am free …"

That girl was now somewhere else entirely.

The day after the refugees were granted permission to stay, several journalists profiled Katarina Taikon. In a rare image, the entire family is captured at the same time, with Katarina and Björn gazing at each other and laughing. He is wearing a black turtleneck and shiny shoes, holding a cigarillo in his hand. Niki is making a funny face and has her arm around Michael. Angelica, her arms crossed in typical teenage fashion, is more restrained. Katarina says that her duty is to fight for the gypsies. She has always felt that way.

– When I get to do that, I'm happy.

Before, she was also afraid, like the refugees.

– People could accuse us of anything: we had no defense. Now things are a little bit better. Sometimes bus drivers and workers shout congratulations when they see me in the street.

At the same time, Katarina Taikon's third book was published, *Zigenare är vi* (Gypsies are us) a book of 94 pages, in a mauve cover. It is largely autobiographical, but also recounts the most recent years' shifts in Roma living conditions. New photographs by Björn

illustrate the transformation, while Katarina also addresses the literature about Roma throughout history and critiques the knowledge thus produced about Roma.

That autumn the daily *Expressen* asked her to imagine her dream government, in the form of a kind of evening-tabloid survey where popular celebrities participate. Of her 14 ministers, 9 were women. Children's book author Astrid Lindgren was selected as Minister of Justice while Minister of Defense was Barbro Alving. Domestic issues went to journalist and Holocaust survivor Cordelia Edvardson, disarmament to Rosa Taikon, and family issues to working-class poet Sonja Åkesson. Minister of Commerce was the popular singer Lill Lindfors, since "she can sell stuff better than most." The position of Minister of Finance was divided between two men, C.-H. Hermansson and prominent financier Marcus Wallenberg. The prime minister, his name was Björn.

Now, when she was everybody's Katarina Taikon, she was radicalized, and nowhere is this shift more apparent than in the publication Zigenaren (*The Gypsy*).

The final issue for 1967 concluded with a poem, "Gypsies 1967," by the poet Stig Carlson. He tells the story of the Roma of his childhood, the ones mothers warned him against but whom the children inevitably were drawn to. He calls the romanticism surrounding the Roma "our truth in the lie" and asks himself where the responsibility today rests. The poem ends:

> In 1960s welfare-bloated Sweden
> it is no longer a question of a
> maybe, sometime
> but of a large open y e s
> to sisters and brothers who do not
> need to beg for help
> but who demand their civil rights
> like the once starved proletarian!

The poet paints a picture of a Sweden overflowing with plenty but where "sisters and brothers" are still refused their rights. Katarina Taikon was an ardent supporter of the redistribution of wealth and the welfare state as such. Her work, the core of her dedication, was the idea that welfare and its possibilities should also be extended to Roma. Her intention was never to critique society because the welfare state was *too* robust. Stig Carlson's poem is therefore interesting, since it allows for the inevitable question that most social justice movements sooner or later must ask themselves: what happens when the legal obstacles to equal rights are eliminated, but social injustice still remains ubiquitous?

This question hovers like a cloud in Katarina's sky during the revolutionary year of 1968. She began to perceive an attitude she could not comprehend: Roma got to live in apartments, Roma got to attend school, great, it's taken care of: that is what she read between the lines in the new attitudes of the day. There was a tendency among politicians, civil servants, and bureaucrats to dismiss the most recent years' painful transgressions against a group of citizens. What had happened was not good, the most self-critical voices from the authorities seemed to say, but now it's 1968: Can't we just move on?

Officially, Sweden said nothing. Not a word was uttered to acknowledge what had been or where one currently stood. And not only that, Katarina Taikon observed another shift. The demands that she and the anti-racist movement had made for continued efforts against social discrimination and contempt were suddenly met with a new counterargument: What will the Swedish worker say? In an editorial in *The Gypsy* she writes:

"In time, the Swedish worker has begun to appear as not only simple-minded and cruel but also extraordinarily stupid. It is often representatives from the worker movement, organized labor, and political parties who have offered us this peculiar image. We do not want to accept it! But still, the Swedish worker is used as a

threat against us. In the same way that one frightens little children with the chimney sweep."

Katarina Taikon started to articulate her position in direct dialogue with the project of social democracy. She could not accept social democracy's use of "the worker," this subject who had transformed Swedish society over the past decades and who therefore should be revered and thanked, as a justification for upholding racism. Certain questions had to be posed. *What was racism? And why did it exist?*

As with previous generations of social critics, she turned to history to examine contemporary truths. As she had once sat in a classroom listening to a lecture about civil rights and been struck by the fact that the UN Declaration of Human Rights pertained to her, that its stated purpose was what she wanted to work on, she now studied the disturbing history of European nationalism.

The Gypsy published articles about the racial biology of the 1920s, about Per Albin Hansson's governmental support of scientific racism, Swedish authorities' desire in the 1940s to purge the country of Roma, the ban on immigration, German Nazism, about the deportations and the group of Norwegian Roma denied entry to Norway who were later found among the dead in the camps. The editors saw a direct line between the more socially acceptable nationalism and the crimes of fascism from the 1930s onward.

It is dark reading. The tone is ardent and accusatory. The genocide against Roma was at the time, approximately twenty years after the conclusion of World War II, still unknown. Their suffering at the hands of Nazis was rarely linked to the war, nor was there any understanding in Sweden about the nation's own history of racism and persecution. Katarina Taikon and her colleagues fought an uphill battle. In an editorial in the daily *Dagens Nyheter*, the gypsy consultant Nils Wall, who had previously collaborated with Katarina and others in the Association for Gypsies, directed criticism toward the editors of *The Gypsy*:

Can historical retrospection promote natural relationships between different groups when linkages to the misdeeds of the Third Reich are used to accuse the average Swede of being racist, and depicting national and local government as agents of a racist politics?

The discussion expanded in the fall when a group of young radical actors produced the play "The Gypsy" at the Royal Dramatic Theatre. Initiated by Ove Tjernberg, the ensemble included Lena Nyman, Stefan Böhm, and Ingrid Boström. Stefan Ringbom, singer in the pop group The Mascots, produced the music, and the couple Helena Henschen and Gunnar Ohrlander—aka Doktor Gormander—were asked to participate in developing the play when the group rehearsed in a house in the bucolic city of Halmstad. Ove Tjernberg hired Katarina Taikon and Björn Langhammer as consultants. They drove down there for a weekend to participate, listen, and discuss.

The play premiered on September 21, 1968. The critics were positive: although uneven in its episodic form, it was still a "brilliant provocation," according to Per Olov Enquist at *Expressen*. The play was funny and quick. Katarina and Björn disagreed. They felt that the ensemble had misunderstood the problems to such a degree that they arranged a counter-exhibition in the theater lobby, where they simply exhibited Björn's photographs and the document concerning the refusal of entry issued to a Roma family earlier that year. According to Katarina and Björn, socialism was presented as the only true solution to racism against Roma, well, to racism in general. According to Björn:

– The play is good, but it is a terrible oversimplification to let socialism appear as the sole solution for Roma.

The group's intention was presumably not to simplify complicated social conditions, and the simple fact that the play was performed on the Swedish national stage gave weight to the issue. But Katarina Taikon and Björn Langhammer were not the only ones

who were dissatisfied. In addition to a few civil servants who defended their activities, Arne Trankell authored a number of pieces where he took the ensemble to task. By virtue of their coarse depictions, Trankell states that the group unintentionally insults the very people they seek to defend. In their desire to reveal Swedish racism, they present Roma as stupid, Trankell asserts. In addition, they have appointed themselves as truth-tellers and everyone else as reactionary, when they in fact compromise socialism. One can sense that Trankell is on the verge of calling them nitwits. Initially, the entire ensemble responds and they in turn accuse Trankell of "selling them out." In the next round Ove Tjernberg responded alone, and appeared genuinely hurt by Trankell's criticism. Tjernberg states that he asked Trankell for help in fact-checking, but that Trankell dismissed him. Concerning socialism, he says that he approaches it based on what it looks like in society, not theoretical scholarship.

At that point, the debate ends. Over the course of this time, about four weeks, there is not a single word from Katarina Taikon. She could have expanded on the critiques she shared with Björn, and discussed Trankell's objections against an art that simplifies the human experience in order to score political points. It could have been an interesting debate. Katarina and Trankell had gone their separate ways since the Association for Gypsies, but it is likely that they still respected each other. But there is nothing but silence from Katarina Taikon.

What I then imagine is that she could have disappeared. Sometimes, Katarina would vanish.

7.

– I was swimming in Lake Flaten. When I walked back and had passed the campgrounds I saw a group of campers with French license plates. Outside, some women were washing clothes in a tub. I approached them and asked if they spoke French. It turned out to be a few families who had come here as a group and who wanted to remain in Sweden. I was invited in for tea with strawberries in it. We sat and talked, some of the children came in. When I left and had gotten as far as the exit, a little boy came running after me with something in his hand: it was my wallet that had slipped out of my pocket inside the camper. It made a deep impression on me. I had always been told that gypsies were thieves.

Kaj Engelhart was 25 years old and on summer break from the university. A few days after the first visit, he returned to the campgrounds. Another person was visiting the families; she introduced herself as Brita Reuterswärd, a journalist at the state-run Swedish Radio. Kaj Engelhart and Brita Reuterswärd became friends and decided to assist the Roma in their applications for residency in Sweden. They founded the Working Group for Gypsy Refugees. Then, they contacted Hans Göran Franck's law firm. Franck was known for representing refugees.

A swim in Lake Flaten on a perfectly unremarkable day in August 1969 led to one of the 1960s largest campaigns for refugees. But this time, something bigger than a few families' futures was at stake: the definition of the term itself, "political refugee."

That year, several Roma families had arrived in Sweden, from places including Italy, Spain, and France. When they in September were notified of the status of their applications, half of them were allowed to remain. The others, primarily from France, would be deported. They came to be called The 47.

Katarina Taikon was in contact with the group at the end of August. When they were turned down she felt that their reasons for remaining had not been properly addressed during the police interviews. They had been given a Yugoslavian interpreter, a language they did not speak very well, and no legal counsel was present during the questioning. It was later revealed that the families resented that they—during the police interviews—had to reveal what they had experienced. In conjunction with the rejection they were assigned Bertil Torbrand as legal counsel. He was young, relatively fresh out of law school and had applied to Hans Göran Franck's firm because he wanted to do human rights work. As they had with the previous group of Roma asylum-seekers, the only course of action was to make a final appeal to the state.

That same day Torbrand took their case, the families decided, in spite of the rejected applications, to move from the campground. October was around the corner, and the evenings were already cold. The Stockholm city government had updated Roo Farm, a farmhouse otherwise used only during the summers, 50 kilometers northeast of Stockholm: this is where the Roma families would spend their final weeks in Sweden. And here, on September 25, 1969, the media began its intensive coverage of both the families and the politics which would determine whether or not they could remain in the country.

When this tug of war began there was one individual of great significance to how the issue was ultimately presented. His name is Kjell Öberg and he was the head of what was then termed the Swedish Immigration Board, today the Swedish Migration Agency. Öberg frames the families' situation in such a way that his political opponents practically appear ignorant of the law;

he then proceeds to repeat his message practically every day for the duration of a month.

Who were these families, The 47? This family, primarily with the surname Kwiek, were a group of siblings with husbands, wives, children, and a few other families consisting of adults and their offspring, and were originally Polish Roma. In 1937, "when the land started to burn," in the words of asylum-seeking Michal Kwiek, they left their hometown of Sosnowiec in southern Poland. They were not destitute, but still lived a life of precarity. In a newspaper interview, Michal Kwiek describes his mother's great sorrow in the face of not being able to keep her children as fed and clean as she would have liked.

When the Germans invaded Poland, the family was already living in France. The relatives who remained were killed one night in 1942: they had to dig their own graves before being executed. When France was occupied, the family split up into two groups in order to not attract attention. They began a journey south, to Spain, and walked 200 kilometers by foot; they ran the last 10 or 20 kilometers. The journey was made together with hundreds of other refugees who hoped to make it across the border before the Nazis caught up with them. German planes flew low above their heads, and people panicked, tripped. At the border station in Hendaye, where the cliffs shoot straight out into the Atlantic and northern Spain is visible on the other side, they made it across the bridge just before Gestapo on motorcycles caught up with them. The border was closed. Families were separated. They could shout to each other across the narrow Bidasoa river. People threw themselves in the water and tried to swim across: they were shot. Michal Kwiek witnessed how Jews threw their passports into the river. The other half of the family, who had taken another route, were never seen again.

They spent the entire war living in Spain. There, Michal Kwiek met his wife-to-be, Maria Sabas. They eventually settled in Paris,

in the Roma ghetto Montreuille. They built a barracks out of old boxes and planks. Michal Kwiek looked for work, searching for many different kinds of jobs, but he was always told, "You are very kind, but if we give you work here in the factory we are afraid the other workers will leave. And if you cannot read, then you cannot operate our machines." Michal Kwiek then simply did what he knew how to do: he repaired pots and pans. Maria Sabas wandered around Paris and told fortunes. Some days she and the children went to the railway yard and gathered coal remnants to use back in the barracks. Michal Kwiek, Maria Sabas, and the others maintained that they were confined to the ghetto. They could not live anywhere else: at the campgrounds signs were posted stating, "Gypsies Prohibited," and apartments were out of the question. In the families' application for residency, Bertil Torbrand wrote:

> [They] have in France been provided with passports in accordance with the 1951 Geneva Convention. They have therefore arrived in France as political refugees and there been given political asylum. This must be regarded as meaning that France has assumed a special responsibility for these persecuted people, a responsibility to afford them a tolerable existence. But in fact the French authorities have continued the persecution and discrimination they were subject to in Poland.

On the morning of September 25, two police on motorcycles escorted the long caravan of The 47 out of Stockholm, north toward Norrtälje. The gypsy consultant Orvar Hjelm was asked if there was any point in housing them at Roo Farm: they were most likely still going to be turned down. He replied that the social workers were determined to offer the families a home while they waited.

– We operate from the assumption that the gypsies will be allowed to stay, Holm stated hopefully.

Roo was on a hill, surrounded by pine trees and with a view of the ocean. The families settled into the rooms and had lunch.

Everyone was tired. The children played outside. As a kind of moral support, someone had called Sven Andersson, who had once upon a time helped Katarina Taikon and her family move into the old wood-frame house in Tanto Grove. Now, 25 years later, he was at Roo helping the families handle their new situation, marked by complete uncertainty.

The following day it was reported that the families were seeking political asylum. They would not, as the other Roma did during this time, attempt to stay on humanitarian grounds or due to familial ties. The families felt that they were persecuted for being Roma. In France, they were denied housing and education: fundamental civil rights. In other words, they were persecuted due to their ethnic background. This was the attorneys' logic, and it was embraced by a growing number of activists, among them Katarina Taikon, Åsa Moberg, and Thomas Hammarberg. And, most importantly, it was a kind of persecution that met the criteria for how political refugeeism was defined by the law.

There was only one problem. The families were from France, a democracy. Kjell Öberg's strategy was to break down this logic based on its absurdity. How could the families be political refugees from France, a democratic nation? By his account, that simply wasn't possible. Political persecution is the product of dictatorships. They were *by definition* outside the definition of political refugees. Then Öberg issued a deadly blow that would weaken the activists' arguments: the families' defenders, according to Öberg, were demanding special treatment for Roma. They want us to be especially generous towards Roma and to regard them as political refugees when in fact—and it must be obvious to all of us—there is no justification. The Swedish state cannot grant favors to Roma in this way.

Few politicians possessed this kind of rhetorical deftness. In one quick turn, Öberg transformed impoverished and vulnerable people to greedy and spoiled Roma. And so began the great battle.

The day after the families' move to Roo, a demonstration was organized in Stockholm, running the short stretch from the royal castle to Parliament. It was a sunny and breezy day. Several hundred people attended, even though the march was organized on short notice. Nationally renowned author Per Anders Fogelström spoke.

– I am standing here spontaneously without having rehearsed. We speak of other nations with a degree of contempt for not managing their problems with foreigners. Here we are now, with a small, small number of people who need our help. We are a rich country. Let us pass this test.

Teachers from the adult school for Roma were there with their students, as well as teachers of children in elementary school. Parents, both Roma and non-Roma, had brought their children. The children held up signs as big as they were. Many of the refugees were present.

The journalist Viveka Hayman was also part of the demonstration. Rosa and Katarina Taikon saw to it that everything went smoothly. When it was over and the crowds had scattered, Katarina Taikon, Ove Tjernberg and a few other participants walked to the Swedish government offices by the Mynttorget square. They were waiting for the light to change at the crosswalk on Myntgatan when recently elected Prime Minister Olof Palme suddenly emerged from the building. As soon as he saw the group, he turned around. Inside the building Katarina delivered a petition to the Minister of the Interior Eric Holmqvist. A reporter from the national daily *Dagens Nyheter* caught the conversation.

– Yes, I heard that you came to see me, said Holmqvist.

– That's correct. I would like to deliver an appeal.

– We haven't received the paperwork from the Immigration Board.

– No, I know. I am here before you receive it.

– Yes, the matter will be treated in strict accordance with Swedish law.

– Excellent. Good. Thank you for those words. Then I am satisfied. Thank you, and goodbye.

While everyone was waiting for a response from the government, another debate erupted. Member of parliament Daniel Wiklund, of the liberal People's Party, coauthored a report about the Roma situation in Europe. The report was commissioned by the Council of Europe, an organization founded in 1949 to safeguard human rights in Europe and of which Sweden had been a member from its inception. In the report, Wiklund, Sweden's delegate to the Council, states that there were continuous violations of Roma's rights in member states. In France, for example, where half of Europe's 280,000 Roma resided, Roma in essence lacked the right to vote. In order to vote one had to continuously reside in the same location for three years, whereas Roma were driven away after 48 hours, or whatever amount of time the police felt was appropriate. Daniel Wiklund demanded that Roma be afforded their rights, but not equal rights: the ghettos throughout Europe's democratic nations should be upgraded to trailer parks with sanitation facilities, electricity, telephone lines, fire protection, and community centers.

Rosa Taikon was highly critical of Wiklund's report. In *Dagens Nyheter*, she writes how it is shocking that a Swedish parliamentarian can recommend new ghettos for Roma in such an important international context. "Daniel Wiklund cannot be ignorant of the fact that it is these very policies that the governments of Europe and other nations have advanced against the gypsy peoples for centuries: to isolate them and make them invisible to other citizens. This is otherwise known as fascism." Wiklund, who felt that he had made a commendable contribution to the Council of Europe, was taken aback. His response to Rosa Taikon begins: "Dear Rosa Taikon! It is unfortunate that you apparently have not had an opportunity to read the report to the Council of Europe." In four long paragraphs, he then proceeds to lay out the background for the report and how the authors collaborated. When he arrives

at the central question, the proposal concerning new ghettos, he explains that Roma are to be *offered* to live in such ghettos, not be *forced* to live in them.

Thomas Hammarberg had come to know Katarina Taikon a few years earlier and they had become good friends. He was involved in the People's Party youth association and active in Amnesty International. Thomas Hammarberg had simply looked her up, and they worked closely together during the fall of 1969. The innermost circle also consisted of the journalist Åsa Moberg: she and Taikon had met in 1965, when Moberg was 17 years old and had just dropped out of high school and was living with the photographer Tor-Ivan Odulf, 17 years her senior. Taikon was the first adult who took me seriously, Åsa Moberg recalls. At the time, she was a columnist at *Aftonbladet*, an unheard-of national platform for a young woman, and Thomas Hammarberg was the lead editorial writer at *Expressen*.

On October 1, they, along with Rosa and Katarina Taikon, Bertil Torbrand, Hans Caldaras, and Franciszek Kwiek (one of the asylum seekers) were permitted to meet with Minister of the Interior Eric Homqvist. Only a week or so remained until the parliamentary cabinet meeting was to take place for the matter to be decided: they wanted to make him understand.

– When we sat down, an associate went up and whispered something in Holmqvist's ear. Holmqvist turned to us and asked: Is any journalist here in any official capacity? Nooo, I said, and shook my head. And so the meeting began. And the more he talked, the more irritated we grew, says Åsa Moberg.

Eric Holmqvist spoke about his own understanding of Roma, of their passion for traveling and their unwillingness to go to school. He also referenced the idea that Swedish Roma did not want foreign Roma to enter Sweden. Do you turn to Greeks before you let political refugees from Greece stay? someone in the group wanted to know.

– We sat there and felt: he hasn't understood a single thing, Åsa Moberg remembers.

In separate articles, Åsa Moberg and Thomas Hammarberg make a final attempt to present the arguments. Hammarberg addressed the most common objections to granting the families asylum.

No, of course they should not receive special treatment. They should be treated like all other refugees.

Yes, these families happen to be refugees according to the law. They are persecuted as a result of their ethnic identity.

During the course of the debate Kjell Öberg had added yet another reason for why the families should not be granted permission to stay. If Sweden accepted these families, the country would be flooded with Roma. Thomas Hammarberg: "This argument specifically means that gypsies in particular should be discriminated against. A gypsy refugee must be treated restrictively, because one believes that so many other gypsies would otherwise come here. This argument is not made with regard to other refugees."

Kjell Öberg did not waver in his position: the families were not refugees in the true sense of the word. But he did slip up once. In an interview in *Dagens Nyheter*, Öberg maintained that he respected those who meant that the families were persecuted.

– The gypsies really are discriminated against and they lack civil rights. But the consequences of treating them as political refugees would be that gypsies across Europe would be able to immigrate to Sweden without exception. We're talking about a quarter of a million gypsies.

Perhaps the statement was not made in error: Öberg already knew how it would end, and it cost him nothing. On the contrary, the statements that Roma should not be treated favorably, and that Sweden would most likely be overrun with Roma if the families were allowed to stay, were probably a carefully calculated strategy in an attempt to rally public opinion. That is to say, the segment of the public which was opposed to granting the families residency. Sweden was divided.

At eleven in the morning on October 9, the families received their rejection notice. An hour later Roo Farm was swarming with journalists and photographers. The families reluctantly let themselves be photographed, then they retired to their rooms. They wanted to be left alone.

Bertil Torbrand made one final attempt. He had sent a physician to visit the French ghettos and to author a report about the situation there for the country's Roma. The report revealed new details and this made possible a new application. At the same time, the activists pulled together their final resources: a demonstration was organized, where author Barbro Alving, musician Fred Åkerström, and politicians Per Ahlmark and C.-H. Hermansson spoke. The Writers' Centre organized a protest meeting at the communal People's House with writers Sara Lidman and Katarina Taikon as opening speakers. Renowned author Vilhelm Moberg stated publicly in the press that he would be the financial guarantor for the families' subsistence, and he felt that the deportation was the most shocking decision since 1946, when Sweden extradited nearly 150 Latvian and Estonian soldiers to the Soviet Union. Viveka Heyman wrote an article where she, most likely as the only intellectual in the country, asked the following: let us assume that there are 1.3 million Roma in Europe: Why would Sweden be unable to accept them? Two hundred Social Democrats signed a protest letter to Sweden's new prime minister, Olof Palme. Per Gahrton and Olle Wästberg, junior members of the People's Party, appealed to the government's humanitarian instincts.

Katarina Taikon wrote her own open letter to Olof Palme, but she was unsure about the tone she should strike, and it is written as though she sensed that all options had been exhausted. The same day the letter was published, Bertil Torbrand, Katarina Taikon, and Per Anders Fogelström met with Olof Palme. Katarina had a fever. The following day, the final rejection was a reality.

The families left Roo Farm. On Sunday, November 2, the journey began toward the port city of Gothenburg on the southwest coast of Sweden. There, they would take the ferry to the Netherlands and then continue to France. The day before, some one hundred Swedish Roma had come to Roo to bid them farewell. On the journey south, the family rested for a night outside Mariestad, on Lake Vättern in south-central Sweden. Before the departure on Monday, a few of the refugees spoke with the journalists who had gathered. They were concerned about attracting unwanted attention when they reached the French border. For fear of conflict with French authorities they asked that the journalists leave them alone when they crossed the border.

– For you this is completely different than it is for us. You see it as if on film or television. For us it is reality, and the future for ourselves and our children.

The journey continued with a police escort to Gothenburg. There, the ferry to Amsterdam awaited them. But an hour before the departure, the Dutch authorities announced that the families would not be allowed to disembark in Amsterdam. They would not be permitted to travel across Dutch territory. It was nightfall, and the families would remain in Sweden for yet another night. They were exhausted: the campers were too cold to sleep in. A few social workers in Gothenburg tried to book them hotel rooms, but no hotel would take the families. Resignation grew into despair, and several of the parents wept in anger and humiliation. One young woman broke down. They were finally allowed to spend the night in some flop houses.

In the newspapers, there was speculation surrounding the Dutch authorities' decision. It could have been based on the fact that the families, with their French passports, could have the right to remain in the Netherlands for three months if they wanted to, and that was a risk the Dutch may not have wanted to take. *Aftonbladet* accused the Swedish authorities of deporting the families before the formal process was exhausted. Many were deeply

shaken by how the families had been treated: they are not boxes to be transported, wrote *Aftonbladet*.

Brita Reuterswärd had taken a leave of absence from her position at Swedish Radio in order to (together with Kaj Engelhart) accompany the families during their final days in Sweden. They helped plan the journey, played with the children, and kept the mood up as best they could. Kaj Engelhart was hired as an interpreter by the welfare authorities in Gothenburg, but was fired after just one day when it became clear to them that he did much more than simply interpret. For a week, the families' fates hung in the balance. Undercover police stood guard outside the flop houses. Franciszek Kwiek felt that it was offensive that they were treated as though they were criminals. The following Monday, November 10, the families boarded the ferry *Tor Hollandia*. When they reached the harbor in Amsterdam, Swedish police handed them over to Dutch authorities and the families were escorted into the country.

In Stockholm, Katarina Taikon was hospitalized: a case of double pneumonia had finally gotten the best of her, and the physicians warned her that she was in desperate need of rest. Friends and family who came to visit were turned away. Some, like Sara Lidman, were snuck in by Björn. The room was filled with flowers. Katarina wept in bed. It was not just her body that was at its breaking point.

Then the green paper was published, a preliminary government report on policy intended to foster public debate. The cover read, *About Organized Transfer of Certain Gypsies*. Black text in a beautiful 1960s font set against a green background. A group of experts at the Ministry of the Interior had been charged with reviewing the migration conditions among a group of immigrants: Roma. The background was that there were people of Roma heritage among the immigrants who had come to Sweden in the mid-'60s. They did not only arrive from dictatorships in Eastern Europe but also

from Western European democracies. The Swedish state regarded this as a problem: in their opinion there was here a seed for something that could come to spiral out of control. The experts' solution was that all immigration on the basis of individual applications should cease; instead, Roma should be "transferred in an organized fashion" from refugee camps in Italy and Austria. Thousands of people who had fled dictatorships were in these camps. Sweden was one of the nations that selected people out of the camps and gave them asylum. Now, a quota of those selected, approximately 40 to 50 slots annually, should be reserved for Roma. In practice, it meant that the Roma were forced to get into the refugee camps in order to have any chance of asylum in Sweden. It also meant that Sweden nullified the right to individual due process for a group of people on strictly racial grounds. This is how the policy was articulated in the green book:

> If an organized collective transfer of gypsies is managed, one result is that there will no longer be room for individually motivated humanitarian immigration, alongside the pure asylum cases. Individual applications for residency by gypsies should therefore as a rule be rejected.

After the rejection of the French Roma families, the debate concerning political refugees continued. Kjell Öberg repeated the same arguments as earlier. Thomas Hammarberg, Olle Wästberg, and Katarina Taikon honed theirs: Roma should not be given special treatment; on the contrary, they should be tried like all other asylum-seekers. Öberg carefully avoided addressing the heart of their argument.

At the same time, a letter surfaced. It was authored by Ingemar Lundgren. He was a mid-level bureaucrat at the National Labor Market Board, where he worked on the matter of the Roma right to housing and education. Lundgren was also part of the group of experts behind the green paper. The letter was sent privately to

his friend and party colleague Hjalmar Mehr, Commissioner of Buildings in Stockholm.

Dear Hjalle,
Ann-Margret came home last night after the city council meeting and showed me a memo dated Sept 9, 1969, re: gypsies.

Confidentially and for your own information I want to inform you: we are talking about a group of international gypsies, traveling through western Europe, who have specialized in black market food sales. They are seeing good profits, have expensive cars and campers, loads of gold, live high on the hog. During the winters they settle in houses in the cities. Pleading poverty, they call the press who photograph cute kids and pregnant women dressed in rags, and they are given preferential treatment on waitlists for housing and public assistance. They always claim persecution during the Hitler days and want to attend school. Nowhere else in the world have they found such a lucrative "labor market" as in Sweden ...

A working group within the Ministry of the Interior issued a report concerning the foreign gypsies this spring and it is currently being considered. I participated in the work and issued a special statement. I am sending the report, if it's of interest to you.

If it was a matter of impoverished and oppressed people in Europe, I could understand and participate in the pressure group now advocating on behalf of the foreign gypsies. But now we are talking about a self-aware, international gypsy upper class who by any means fight to keep their privileges and maintain a pleasant and parasitic existence. A modern continuation of our old Threepenny Opera, and Mackie Messer is certainly not hung: he lives and acts with impunity. The beggar army is still very much romanticized but now a great deal more modern. And the authorities convene and investigate and shuffle and bow and appear kind and get new positions,

and pay. On the scale of 500 million Swedish crowns over the next 10 years, one insightful person has estimated, if we keep going at this rate. I think this is on the low end. I would not think that it is expensive, if something came of it. But nothing does, except a comfortable life for those who get their hands on it and are able to assert their privileges.

Dixi et salvavi ...

Tuus
Ingemar Lundgren

The Latin words are the first part of a proverb which in its entirety states: *Dixi et salvavi animam meam* (I have spoken and saved my soul).

The letter landed like a bomb. Both the Minister of the Interior and the Immigration Board asserted that they had not known about it. The Commissioner of Social Welfare in Stockholm stated that the contents of the letter were a lie. Even though leading Social Democrats distanced themselves from Ingemar Lundgren's opinions, Katarina Taikon, Thomas Hammarberg, and Åsa Moberg wondered if Lundgren's view of Roma had impacted the green paper recommendations.

A decade had come to an end. One of the world's most progressive nations was experiencing a boom year. Sweden was on the threshold of the 1970s and for Katarina Taikon the time had come for a political reckoning. She really only saw one possible way forward. In the fall of 1969 she publicly distanced herself from the Social Democratic Party.

8.

Clouds hang over the water. At any moment, it might start to rain, but instead the clouds disperse and the sun emerges. In the yard lie scattered badminton racquets, balls, and tools. Tables and chairs are stacked one on top of the other. Things are being sorted and thrown out.

– I get stressed out when there are so many things out here. I know that it'll get better, but I can't help it.

Angelica Ström has just returned from Fårö. She attended the Bergman Week festival with her film group. Once a month, she and a group of friends go to the movies together. After the screening they have soup at the home of one of the group members and analyze what they have seen. During the summer some of the film friends holiday on the island of Gotland, connected by ferry to Fårö, the island where Ingmar Bergman frequently lived and worked. They have just heard the Dardenne brothers speak. Angelica Ström appreciated their sense of humor: Bergman's films are far too pessimistic, she states.

– With Bergman, things always go badly for the children, according to the Dardenne brothers. And it's actually true.

A house on the northern tip of Gotland provided the new beginning that Katarina Taikon had longed for. After the final years of the 1960s, and then especially the great disappointment following the deportation of the French families, she was exhausted. Demands had increased from all directions. Some were of her own

making: she believed that she had an obligation to transform society, that people should not have to suffer and struggle to survive. Other demands were external, from people who asked for help and whom she could not refuse. For a few years she was available around the clock.

The same autumn when she was hospitalized for pneumonia, she gave one of her most revealing interviews; it is as though all resistance has seeped out of her. The journalist asks how she has the energy to do everything that she does.

– I don't. It works for as long as I can keep going. But then there's this hopelessness. Sometimes I just go into the bathroom and cry.

She says that she runs away from home sometimes. Then she gets to be alone with herself, or with someone who lets her disappear into her anxiety. Everyone thinks she is strong, that she can withstand anything, but she is vulnerable: she just does not want anyone to know.

The anxiety would creep up on her a few times a year. During certain periods, several years could go by before it gripped her again, and you could see it in her eyes when it happened. She had to leave home. Sometimes she would show up on the doorstep of one her friends' homes. She needed to be weak, but she did not want to talk. Sometimes she was intoxicated: then there was no way to reach her, she would be deep inside herself.

Few people knew what happened in there. When Katarina was away, Angelica and her brothers would barely breathe.

One of the first occasions when I met Angelica was when the first book about Katitzi had been published as an audiobook in Romani. In a little room at the International Library in Stockholm, Hans Caldaras discussed the work of translating and recording the book. Angelica was in the audience, listening, when Hans asked if she wanted to say a few words about her mother's work. Angelica remained silent for a few seconds. When she started to speak, the

words got caught in her throat, "I have always kept this hidden," she said. "I don't want to any longer." That was three years ago.

We are sitting in the house that Angelica's parents purchased in 1972. A barn, a little cottage, a large lawn, and then the house itself, initially two separate structures—one white, one black. It was a ramshackle situation when Katarina and Björn moved in: the roof was missing from the white 19th-century building, while Katarina's office was in the black 17th-century house that had once belonged to a cobbler. With Bernd and Rosa's assistance they began to restore the place. They tore out walls and built a stairway to the second floor, laid down red patterned linoleum in the kitchen and put even brighter red tiles above the kitchen counter. The glass veranda from the 1920s had orange shades from Marimekko in the side windows. The window sills were painted sky blue.

– They were quickly accepted in the village, since they proved that they were willing to work, Angelica recalls.

– When they drove by the house in the summer of 1972 and saw that it was for sale, they simply kept driving all the way to the bank. I had just given birth to my first child and was here with my boyfriend's family. I said to my mother: I have never been in a more peaceful place. When she came here, she felt the same way.

Angelica remembers the first time she met Björn. She was four and a half years old and had been away at summer camp. Katarina met her at the train station: with her she had a tall man whom she introduced as Björn. Angelica took a liking to him from the very beginning.

– Katarina made clear to him that, if you are going to have me you are also going to have my children. We became a family and moved to Bagarmossen, a suburb of Stockholm. Björn had various things going on: he did a stint in advertising and made signs for the cigarette brand Pall Mall. For a while he delivered teeth for someone who made dentures. There wasn't a lot of money, but we weren't poor, either. My mother had a few ladies she cleaned

for while she did other work. Sometimes when I needed a winter jacket we went to the City Mission; she hated having to go there.

In the summers, they bicycled to the bay in Ersta and went swimming, with Angelica and Michael riding on the back of the bikes. They spent time with relatives who rented apartments in the same area. It was also there, during the peaceful years in Bagarmossen, that Katarina and Björn were married. When Angelica was entering the third grade, they moved to Bollmora. Katarina's first book was published the following year.

– I really only recall those two children from class. If my clothes ever had holes in them, I told my mother that I had been climbing in trees, Angelica recounts.

One day when Angelica came home from school, Katarina said that they had to talk. She had received a phone call: another parent had called and asked if she didn't care about her daughter. "Why are you asking me that?" Katarina replied. The other mother responded: "My daughter comes home and cries and says that Angelica gets beaten so badly at school. Why don't you do anything?"

– It took no time at all. I knew where the two children lived, she got it out of me at once. She took my hand and we walked straight to where they lived. Their mother opened the door. Katarina said: "This is my daughter and your children beat my daughter every day in school." In response, the woman shoved my mother and said, "Fucking gypsy bitch, get out of here." My mother almost fell down the steps: she was incredibly shocked. I didn't understand a thing. Why did the woman do that? And how could my mother not take her on?

After that, Angelica moved to a different school. She was able to attend the Kristoffer school on Karlavägen, just a short walk from Katarina's ice cream parlor. Some days she went to Vips after school and then she and Katarina and Björn commuted home together.

Angelica describes how everything changed after Katarina's first book was published. It was as if a dam had burst. Until that point she had been happy and proud of her mother's family: they had fun together, and Angelica felt like they were more or less like everybody else. But when *Gypsy Woman* was published and the living conditions for Roma were made public, she suddenly became someone else in the eyes of those around her. Katarina's struggle and the questions she placed front and center divided the public into two camps. The mood grew bitter, and Angelica backed away from what she saw around her: she stopped attending family reunions and marches; she did not want to participate in news articles. She slowly folded up a part of herself and stored it away somewhere inside her.

In addition, Katarina and Björn continued to talk to Angelica about the abuse at school, but those conversations never provided an opportunity for Angelica to have her experience affirmed. The children who beat her, they said, probably had a very difficult time growing up with a mother like that: that was why they were so cruel. Angelica started to empathize more with those who had beaten her than with her own experience of being beaten. She today understands that her parents came to the right conclusions, that they tried to demonstrate humanism in practice, but it was still not entirely successful. It silences you, she now admits.

At the same time, Angelica and her brothers had clear roles in the family. They received a lot of attention and were heard: they truly mattered. In addition, they had Rosa, Bernd, and Berit in their lives, with all the affection that came from them as well.

One summer they went on a road trip to Austria, to the region that Bernd was from. They lived on a farm in the mountains above Vienna. A room in the barn above the cows was set up for them: it smelled like a farm and through the floor you could hear the animals moo and cluck. In the evenings, before they fell asleep, Katarina and Björn recounted stories about what it was like when they were children. Angelica loved it.

Sometime in the mid-'60s, perhaps following the May 1 demonstration, it all became too much for Angelica: some days, there were so many people at their house that you could barely tell them apart. And then there were the refugees: 20 people at a time might ring the doorbell. During those moments, Angelica longed for a mother who worked at the Konsum food cooperative chain and a family that ate dinner together every day at five o'clock. When Angelica at age 14 met her first boyfriend and fell in love, she moved in with him and his mother.

– It was great because I became a Mrs. Nobody there on Ludvigsbergsgatan.

That year, in 1969, Katarina and Björn and Michael and Niki moved to Henriksdalsberget, to a large, bright apartment on the fifth floor of a building in a new development near the city. In October, during the middle of the campaign to support the 47 refugees, the first book about Katitzi was published.

*

Expressen was the first newspaper to publish excerpts from *Katitzi*. Katitzi is picked up from the orphanage by her father: he drives in silence, and Katitzi wonders if they won't get there soon—this is how her life with her family begins again. When the second book was published, in the fall of 1971, it was regarded as part of a longer series, and it was clear that Katarina Taikon had completely transitioned to writing for children. She had considered writing a children's book for a long time: when she tested the first book on her children they liked it, but also wanted it to continue. Rosa also read it, and cried: everything was accurate.

The first books were appreciated for their depictions from a Roma point of view at the end of the '30s and early '40s. One critic writes that Katarina Taikon manages to communicate an existence that

is alien to most. "Children appreciate Katitzi for, among other things, being so ordinary in the middle of her extraordinary life, for not always humbly appreciating what she has, but disliking cold gruel, for daydreaming and running off, for daring to be obstinate and not always so fair in her assessment of others."

Katarina Taikon's books about Katitzi became some of the 1970s most popular children's books, and she invested them with all her energy. She was done speaking to adults: she had written and said everything that could be said. If there were people who did not want to understand, it was no longer her business to try reach them. She was sick of all the questions, the same questions, everywhere, year after year. Why did Roma do things this or that way? Why didn't Roma want to be more like Swedes?

The interviews with Katarina Taikon from the 1970s bear a different quality: she no longer spoke about housing, education, labor, or refugees, or even about the struggle she had engaged with—that history remained too recent—but about her own childhood. She introduced herself to a new generation, to those who were not there in the '60s and who did not know her and what she had stood for during that time. To Swedish children, Katarina became Katitzi. She dedicated a few weeks out of each year to visiting schools and meeting her readers. When she read from the books and recounted her childhood, the schoolchildren sat transfixed.

The popularity of her books can be substantiated by the number of times they were checked out of the public libraries. In 1969, when the first book was published, her books were checked out 6,800 times from libraries across Sweden. In 1975 they were checked out 213,000 times and, in 1980, when the final book about Katitzi was published, 432,000 times. The books about Katitzi gained an even broader readership when selections were published as a comic book in 1975. Finally, from 1979 to 1980, *Katitzi* became a three-hour miniseries spanning six half-hour episodes that aired on the state-run TV 2 from 1979 to 1980.

In an interview, Katarina Taikon states that her very favorite thing is to receive letters from children. They sent her thousands of letters, sometimes twenty a day. Angelica has saved them in a box in her attic. Many of the letter writers have used their most precious stationery: horses and rainbows and drawings of candy adorn the notes. Now, they smell damp and musty. One letter is written with two different pens, with letters alternating in red and blue.

Sunday, May 17, 1981, 6:30 p.m.

Hi!
I'm good. How are you? Is there a speciel [sic] color you like? I like pinck [sic]. Maybe you can tell from the stationery!
Maybe you already know that I'm in Furuviksbarnen [a youth circus in the central northern city of Gävle]! Our show opens May 31. This year I'm going to be a clown (dance), can-can-lady (dance), do gymnastics and tricks, it's going to be fun. Today we've been to Furuvik to practice, they have a bounce house there this year too. It's a castle made out of plastic that you can jump around in. It costs 3 crowns and the man who takes the money says you can only be in there for 10 minutes. But the first time Helené and I were there for nearly half an hour. The second time we were in for nearly 20 minutes. It was so fun. Now I have a new boyfriend again.
Bye-bye from:
Anna

On the back of the envelope is written "reply" in Katarina Taikon's handwriting. She replied to every single letter she received. Some children asked if they could get a picture of her, others wondered what she was going to do over the summer. Some apologized for not having written for a long time. The most common question was if everything that happened in the books about Katitzi had actually happened.

*

A desk, a fireplace and an easy chair in the corner. Her typewriter stood on the table: red with a correction key. From her office window she could look out over the garden and the carrots and marigolds she grew. She had never been that kind of person, says Angelica. She couldn't even bake *bullar*, the ubiquitous Swedish cinnamon buns each mother and grandmother is expected to know how to produce at a moment's notice. The only thing she made was hastbullar, "hasty buns," made with baking powder instead of yeast. They didn't taste very good, but Katarina loved them.

She even bought a greenhouse. Every time she pulled something out of the ground it was a miracle, and it was a miracle that she could make *saft*, a sweet juice pressed from the currants in her garden.

The calm on Gotland gave Katarina new vitality. She traveled there as early as April and remained until early autumn. She let herself grow completely absorbed by the writing, producing thirteen books in eleven years. Björn was her editor: he helped her develop the history and proofread her writing. In the evenings they cooked together. Sometimes you could hear Nina Simone all the way into the kitchen, and after dinner they read on the couch. Björn Hedlund, Katarina's favorite illustrator, worked closely with them in that house.

There was work time and there was grandmother time: that was when Angelica would visit with her two daughters, Marika and Sofia. They went swimming, sometimes they hiked in the woods. If Björn came along he wore a tailored suit and dress shoes.

Katarina and Björn. They had been together for more than twenty years. Björn, he taught me to think and to understand that I could also make demands, Katarina said. Björn, who, when Katarina was told by a social worker that she was a lost cause, said to her: You're not going to let others tell you what you can do, are you?

It gave her the courage to apply to the adult education program at Birkagårdens folkhögskola. And Björn, who said that Katarina was the best thing that ever happened to him. They spent almost every day together, and now that was becoming increasingly difficult; their relationship was beginning to fray.

Katarina had deep depressions. She was thin, with chronic pain in her muscles and joints, and she turned to alcohol in order to get through the most difficult periods. During the 1970s, Katarina withdrew from her social circles and from the public—in some ways also from living. The series about Katitzi was a great success; Katarina was appreciated and loved for her books. But writing them also drained her, especially her work on the later books, where Katitzi is a teenager. To write is also to remember, and sometimes the work made her entire body tremble.

During their time together, Katarina and Björn had something to work toward together. They had struggled for change, stood side by side during those intense years, and now yet another project, the series about Katitzi, neared its end. Her friends think that she was anxious about what would come next, how she would grow as an author. This fear can be seen in the book *Raja, the Gypsy Woman*, a work of fiction for adults that Katarina Taikon wrote in 1979 in an attempt to broaden the scope of her writing. The book revolves around a young woman who has been banished from a Roma camp after being accused of having a relationship with a married man. Raja is forced to seek a new life outside the Roma community. She meets fierce resistance, both within Roma circles and society in general. By way of Raja's life story during the final years of the 1950s, Katarina Taikon is able to include a number of actual events and people in the book. For example, we can find Lundwall, the gypsy consultant, as well as a subtly disguised Nils Wall, and the young politically committed actor Olof, who in fact was Ove Tjernberg. The Stockholm police force's desire to prohibit Roma from settling in the city is included, as is John Takman's

refusal to abide by the authorities' directives. Toward the conclusion of the book, Raja has her own apartment and some of her relatives and friends resume their relationships with her.

Raja is one of Katarina Taikon's less successful books. Characters are portrayed without nuance, and emotions and motivations are depicted poorly. Certain scenes of sexual intimacy between Raja and the lesbian Eva, initially her protector, feel extremely speculative. Today Katarina's closest friends, as well as Angelica, feel that *Raja* may have been authored by Björn. Katarina Taikon reluctantly let herself be credited with authoring the book. Perhaps Björn believed that the book would sell and secure their well-being for the near future.

Katarina and Björn were divorced in the fall of 1981.

Angelica makes clear that she believes that there, in the midst of all the challenges, were certain things that made Katarina happy: Gotland, having someplace to live, and the children. In a letter to the family, written during a trip to Yugoslavia in the mid-60s, Katarina addresses Björn, Rosa, and Bernd, all in order. She tells them that she is staying at a top-notch YMCA. It reminds her of the summer camps of her youth, even if she never attended any of those. The lake, or if it is the ocean, is right outside, but she still hasn't felt like going swimming.

Then a few lines for Angelica, Michael, and Niki:

> Mama's beloved little girl,
> First of all, I should, as the outstanding mother I am, remind you to not do anything that is fun. But my little girl, if you can understand how to enjoy yourself without getting your toes stepped on, you have your old mother's blessing.

> My most beautiful son,
> Mama can't imagine that you are in Öringe, or wherever you are swimming, when I or another adult am not there to watch.

Try to get S. to teach you how to swim so that I don't have to worry. Little tofsen, remember to be careful.

Niki Niki, you are the one who keeps me young.

Departure, the thirteenth and final installment of *Katitzi*, was published the year before Katarina and Björn separated. Katarina Taikon had completed her epic project about the little girl Katitzi. She follows Katitzi until the year she turns 16. Katitzi is ready to spread her wings, step out into the world: there must be something for her out there.

And Katarina lets her go.

Epilogue

On June 20, 1982, Katarina suffered a cardiac arrest. Lack of oxygen to her brain damaged her cerebral cortex. About a month before her 50th birthday, she entered into a coma.

After a long period spent in long-term care, Björn tended to Katarina at their home on Henriksdalsberget. On December 23, 1986, Björn suffered a heart attack and died, and Katarina's children assumed responsibility for her care.

In all, Björn, Angelica, Michael, Niki, and Rosa cared for Katarina for thirteen years.

On December 30, 1995, Katarina Taikon died at a hospital in the central northern city of Sveg. Rosa Taikon, her sister, was by her side.

Afterword

Since this biography was originally published in September 2012, Katarina Taikon's work has seen a Swedish revival. General interest in her life and accomplishments led to my participation in book-related activities in Sweden for several years. While *The Day I Am Free* made its way to bookstores, the exhibition *Katitzi's Journey through Sweden* opened at Tensta Konsthall in Stockholm. This exhibition attended to Taikon's greatest contribution to Swedish literature: Katitzi, the Roma girl who is the protagonist in a canonical work of Swedish children's and young adult literature. Following the exhibition at Tensta Konsthall, *Katitzi's Journey through Sweden* toured for three years, in Sweden, the Czech Republic, and Hungary.

The biography is also the basis for the documentary film I made about Katarina Taikon, *Taikon*, which premiered in Swedish movie theaters in October of 2015. The abundance of materials—books, notes, drawings, photographs, moving images—available in the circles surrounding Taikon also made possible a photo-based exhibition of Björn Langhammer's images at Moderna Museet in Stockholm in 2015–16. Moreover, a discussion series titled Romsk höst (Roma fall) was organized at the Royal Dramatic Theatre in Stockholm in the fall of 2015.

These activities have led to a newly founded prize for human rights work in the city of Stockholm: the Katarina Taikon Award. Since 2016, the award is awarded annually to individuals or organizations working in the spirit of Katarina Taikon.

Finally, with regard to Katarina Taikon's writing, her central body of work—the thirteen-volume children's and young adult series *Katitzi*, as well as her debut volume *Gypsy Woman*—have been published in updated editions by the Swedish publisher

Natur & Kultur over the course of the past three years. In this way, Taikon has reentered Swedish literary history and her work is available to new generations.

As I write this, in the spring of 2018, Rosa Taikon has passed away. She died on June 1, 2017. She was 90 years old.

Acknowledgments

My deepest thanks to Angelica Ström and Rosa Taikon for their time, energy, and generous trust in recounting their mother and sister's history.

Everyone interviewed, especially Hans Caldaras who has patiently contributed information, and Thomas Hammarberg, who has fact-checked sections of the manuscript.

Lars-Erik Johansson, Paul Rimmerfors, Kaj Engelhart, Gun Qvarsell, Britta Flodin, and Margareta Kreuter for giving me access to their private archives, as well as Birgitta Langhammer for image rights.

Stephan Bergman at Scanpix who gave me access to an invaluable archive.

A special thanks to Maria Lind, Jennifer Hayashida, Sara R. Acedo, Ames Gerould, Richard Herold, Sternberg Press, and Emily Roysdon.

Bibliography

Berggren, Henrik. *Underbara dagar framför oss: En biografi om Olof Palme*. Stockholm: Norstedts, 2010.

Broberg, Gunnar, and Mattias Tydén. *Oönskade i folkhemmet. Rashygien och sterilisering i Sverige*. Stockholm: Gidlunds, 1991.

Catomeris, Christian. *Det ohyggliga arvet: Sverige och främlingen genom tiderna*. Stockholm: Ordfront, 2004.

Cavalieratos, Alexander. *Zigenarinventeringen måndagen den 31 maj 1943. Registrering av romer – välfärdsprojekt eller rasdiskriminering*. B-uppsats, Historiska institutionen, Södertörns högskola, 2001.

Crowe, David M. *A History of the Gypsies in Eastern Europe and Russia*. New York: St. Martin's Press, 1995.

Hagerman, Maja. *Det rena landet: Om konsten att uppfinna sina förfäder*. Stockholm: Prisma, 2006.

Hallberg, Lars. *Källor till invandringens historia i statliga myndigheters arkiv 1840–1990*. Stockholm: Riksarkivet, 2001.

Hammar, Tomas. *Sverige åt svenskarna. Invandringspolitik, utlänningskontroll och asylrätt, 1900–1932*. Akad. avh. Stockholm: 1964.

Johansen, Jahn Otto. *Zigenarnas holocaust*. Stockholm: Symposion, 1990. Original title: *Sigøynernes holocaust*. Oslo: Cappelen, 1989.

Kalander, Berith. *Min mor fånge Z.-4517*. Gällivare: Gällivare kommuns folkbibliotek, 1996.

Kenrick, Donald, and Grattan Puxon. *The Destiny of Europe's Gypsies*. London, 1972.

Lo-Johansson, Ivar. *Zigenare: En sommar på det hemlösa folkets vandringsstigar*. Stockholm: Wahlström & Widstrand, 1929.

———. *Zigenare: En sommar på det hemlösa folkets vandringsstigar – tjugofem år efteråt: med ett tillägg*. Stockholm: Folket i bild, 1955.

———. *Zigenarväg*. Stockholm: 1955.

Lundgren, Gunilla. *Aljosha, zigenarhövdingens pojke*. Stockholm: Bonnier Carlsen, 1998.

———. *Sofia Z-4515*. Stockholm: Tranan, 2005.

Martinson, Harry. *Nässlorna blomma*. Stockholm: Bonniers, 1935.

Montesino Parra, Norma. *Zigenarfrågan, intervention och romantik*. Akademisk avhandling. Lund: Socialhögskolan, 2002.

Rydberg, Viktor. *Singoalla*. Göteborg: 1857.

Sjögren, David. *Den säkra zonen: Motiv, åtgärdsförslag och verksamhet i den särskiljande utbildningspolitiken för inhemska minoriteter 1913–1962*. Umeå: Umeå universitet, 2010. E-book.

SOU 1923:2. Förslag till lag om lösdrivares behandling ... Stockholm: 1923.

SOU 1956:43. Zigenarfrågan. Betänkande avgivet av 1954 års zigenarutredning. Stockholm: 1956.

Svanberg, Ingvar, and Mattias Tydén. *Tusen år av invandring. En svensk kulturhistoria*. Stockholm: Gidlunds, 1992.

Takman, John. *The Gypsies in Sweden: A Socio-medical Study*. Stockholm: Liber, 1976.

Tenngart, Paul. *Romantik i välfärdsstaten: Metamorfosförfattarna och den svenska samtiden*. Lund: Ellerströms, 2010.

Tillhagen, Carl-Herman. *Zigenarna i Sverige*. Stockholm: Natur och Kultur, 1965.

Wright, Rochelle. *The Visible Wall: Jews and Other Ethnic Outsiders in Swedish Film*. Carbondale: Southern Illinois University Press, 1998.

Zaremba, Maciej. *De rena och de andra. Om tvångssterilisering, rashygien och arvsynd*. Stockholm: Bokförlaget DN, 1999.

Zigenaren. Amé beschás. 1965–1972.

Archive sources:

Riksarkivet, Landsarkiven i Uppsala, Göteborg, Östersund, Härnösand, Lund, Stockholms stadsarkiv, Härryda kommunarkiv, Landstingsarkivet i Västerbottens län, Filadelfiakyrkans arkiv, Kungliga bibliotekets arkiv för dagstidningar och tidskrifter, Expressens arkiv, Statens ljud- och bildarkiv

Interviews 2010–12:

Mårten Andersson, Hans Caldaras, Monica Caldaras, Peter Curman, Åke Edfeldt, Kaj Engelhart, Keathy Ericsson-Jourdan, Britta Flodin, Borta Friberg, Stina Hammar, Tomas Hammar, Thomas Hammarberg, Christer Hogstedt, Bernd Janusch, Lars-Erik Johansson, Franciszek Kwiek, Berit Langhammer, Gunilla Lundgren, Maj Lundmark, Åsa Moberg, Gun Qvarsell, Paul Rimmerfors, Kerstin Seth, Ann Smith, Birgitta Stenberg, Angelica Ström, and Rosa Taikon.

Books by Katarina Taikon:

Zigenerska. Stockholm: Wahlström & Widstrand, 1963
Zigenardikter: ett urval zigenardikter från olika länder och miljöer.
 Stockholm: FIB:s lyrikklubb, 1964
Zigenare är vi. Stockholm: Tiden, 1967
Dikter. Stockholm: Författarcentrum, 1968
Niki. Stockholm: Gidlund, 1970
Zigenare. Stockholm: Natur och Kultur, 1970
Raja, zigenerskan. Stockholm: Bonnier, 1979
Förlåt att vi stör!: Om zigenska flyktingar. With Hammarberg, Thomas,
 Stockholm: PAN/Norstedts, 1970
Hur blev det sen då, Katitzi? With Langhammer, Björn,
 Stockholm: Rabén & Sjögren, 1977

Books about Katitzi:

Katitzi. Tyresö: Zigenaren, 1969
Katitzi och Swing. Stockholm: Gidlunds, 1970
Katitzi i ormgropen. Stockholm: Gidlunds, 1971
Katitzi rymmer. Stockholm: Gidlunds, 1971
Katitzi, Rosa och Paul. Stockholm: Zigenaren, 1972
Katitzi i Stockholm. Stockholm: Zigenaren, 1973
Katitzi och Lump-Nicke. Stockholm: Tai-Lang, 1974
Katitzi i skolan. Stockholm: Tai-Lang, 1975
Katitzi Z-1234. Nacka: Tai-Lang, 1976
Katitzi barnbruden. Nacka: Tai-Lang, 1977
Katitzi på flykt. Nacka: Tai-Lang, 1978
Katitzi i Gamla sta'n. Nacka: Tai-Lang, 1979
Uppbrott. Nacka: Tai-Lang, 1980

Katitzi's Journey through Sweden

An Exhibition at Tensta Konsthall and Elsewhere

MARIA LIND

The subject of Tensta konsthall's 2012 exhibition "Katitzi's Journey through Sweden" was Katarina Taikon's (1932–1995) autobiographical figure Katitzi.[1] Katitzi is the main character in thirteen books and eight graphic novels written in Swedish and published between 1969 and 1982. This unique young female character from the world of children's and young adult literature whose Roma background is central to the story, was highlighted and discussed in the exhibition. Katitzi manages, despite quite dreadful circumstances, to find her way to an acceptable existence and, in time, to self-actualization. The *Katitzi* books have been described as an inimitable Roma literary legacy, extremely popular in Sweden in the 1970s and '80s, but virtually unknown to the rest of the world. The exhibition included first editions of the *Katitzi* books, comic books, and illustrations by Björn Hedlund, as well as articles, reviews, films, TV programs, photographs, etc. A series of events with, among others, Taikon's sister Rosa Taikon and Hans Caldaras, a singer and relative, also formed part of the exhibition.

Katitzi is one of the the most powerful characters in Swedish children's literature. In Katarina Taikon's books, which drew heavily from her own life, the reader follows Katitzi from the age of seven, when she lives in an orphanage, through her upbringing together with her large Roma family who are forced to travel around Sweden and live in tents and caravans, until she is married off at the age of fourteen. Eventually Katitzi escapes and builds her own life, starting at the City Mission in Stockholm's Old Town. The thirteen

1 The exhibition "Katitzi's Journey through Sweden" was first on view at Tensta konsthall from October 25, 2012–January 27, 2013. Later it went on tour from 2013 to 2016.

books about this Roma girl, published between 1969 and 1980, have been read by hundreds of thousands of children and young people; the books were printed in several editions and in 1975 alone they were checked out from Swedish public libraries 213,000 times. Five years later, they were checked out no less than 432,000 times. Since then *Katitzi* has appeared as a graphic novel, a picture book, a TV series, an LP, a DVD, and most recently as a theatrical play.

As Katitzi gets older, the literary genre changes; beginning as children's books, the series develops into literature for young adults. But throughout all of the books Katitzi remains brave and angry, but also worried and thoughtful, a girl who, although let down by adults time and again, never loses her willpower. Under precarious circumstances, Katitzi finds paths to a decent life and eventually self-actualization. With her willpower and unruly questioning of authority she unmasks the nascent welfare state's supposedly good will. For several generations of children and young people, Katitzi was a captivating and lovable eye opener. The *Katitzi* books are examples of the new type of realistic children's literature that emerged in the 1960s, characterized by everyday stories that disrupted previously harmonious narratives of children and young people's lives. A different sense of lived reality is given substantial space in the books, and current social issues are woven into the stories. More poetic moments are also present, with the depictions of Taikon's father being particularly sensitive.

We begin to know Katitzi when she is brought home after spending some time living in an orphanage. Katitzi's father and her siblings Paul, Rosa, and Lena are overjoyed to reunite with her. However, she does not recognize her family and is scared and refuses to come with them. The nice lady at the orphanage, Miss Kvist, persuades the grouchy matron Miss Larsson to let the girl stay for a while so that she can prepare for the move home. When Katitzi rejoins the family it is with the wicked "lady," her father's new wife, and together the Taikon family experiences a Swedish society that

discriminates against them. The family can rarely stay longer than three weeks at each site, children are denied regular attendance in the schools, and during the meagre years of World War II they have to survive without ration cards. Prejudices, violence, and other kinds of humiliation permeate their everyday life, a life that, in Katitzi's case, is also populated by friendly people who want to help. Characters range from the homeless alcoholic Lump-Nicke living in the Tantolunden park, the attentive teacher Carlström at the Maria School, both on Stockholm's Södermalm, to the potato-picking friend Karin. The dog Swing is a loyal and comforting companion throughout several of the books.

Katarina Taikon experienced both the film and the theater world before she wrote the first *Katitzi* book. She acted, for instance, in Arne Sucksdorff's film *Uppbrott* (Break up), and in *Singoalla* (1949), and appeared alongside Rosa Taikon in the play *Huset i Montevideo* (The house in Montevideo) at the Folkan theater. After completing her studies at the Birkagården adult education program and the trade institution Påhlmans, she ran the YMCA café Vips American Ice Cream Bar, located on Birger Jarlsgatan, Stockholm, for a few years. Additionally, she was already known as a champion of human rights. In 1963, her first book *Gypsy Woman* was released.

Gypsy Woman immediately stirred a debate concerning the conditions of Roma people in Sweden. Among other things, Taikon criticized the author Ivar Lo-Johansson for at once beautifying and disparaging the views of Roma people—he felt that they should be kept in their camps and not "forced" into a traditional Swedish lifestyle. Along with other social and cultural workers Katarina Taikon worked to empty the tent camps and allow the Roma to find permanent homes and go to school. Activists persistently met with local and national politicians, including Prime Minister Tage Erlander, and snuck into the Social Democratic Party's May Day demonstration protesting the prevalent racism and discrimination against Roma people, thereby disturbing the

governing party's self-image. They also fought for Swedish residency for newly arrived Roma people from countries including Poland and France.

Johan Taikon, the author's father, remained stateless throughout his entire life. Born in France, he came to Sweden with his family, which belonged to the Roma group Kalderash (copper workers), at the turn of the century after having spent many years in Russia. Together with seven other Roma families they formed the beginning of a new Swedish minority, which today ranks as one of five national minorities. They supported themselves as, for example, copper workers, tin-smiths, musicians and carnival owners. Until 1914, Johan Taikon's family often spent half the year in Sweden and the rest in continental Europe. The traveler tradition ended with the first Foreigners Act of 1914, followed by a spiteful debate concerning an imagined mass immigration of Russians, Poles, Jews, and Roma people, who were considered politically and racially dangerous for the country. The Roma people, exclusively, were, on strictly ethnic assumptions, banned from immigrating to Sweden. This meant in principle that the Roma people who remained in Sweden until the law was repealed in 1954 were not able to travel out of the country.

The first mention of Roma people in Swedish documents is in 1512. They are called gypsies (a group which also includes the so-called "travelers") and should, if found, be arrested and deported. Priests were not allowed to baptize or bury them. A regulation that forced Roma women and children out of the country and the men to be hanged came in 1637, after a period when monarchical power sought to distinguish permissible begging from vagrancy. Not being permanently domiciled was in the coming centuries considered a threat to the social order, something that Katarina Taikon, and ultimately Katitzi, also experienced.

The author was born in 1932 in a camp outside Örebro, and when her mother, Agda Karlsson, died less than a year later, the family found itself in a camp at the bridge abutment at Skanstull by

Gullmarsplan in Stockholm. Not having a fixed home also made it impossible to have stable employment. The racist "vagrancy investigation" from 1923 is an example of how government officials looked at travelers and Roma people as a threat, but while thinking that "travelers" could be integrated into society—they were seen as domestic vagrants—there was little chance for the Roma people—perceived as inherently foreign—to be integrated. They were simply too different, but since one could neither deport them (most were Swedish citizens) nor exterminate them, convincing them to leave voluntarily was considered the best method.

The artist and illustrator Björn Hedlund (1922–1987) illustrated all the *Katitzi* books, which can be described as chapter books with illustrations on about every other spread. A selection of original illustrations, including the books' covers, were shown in the exhibition. Related to literary stars such as Pippi Longstocking, Huckleberry Finn, and Nils Holgersson in graphic and expressive scenes, a wild and charming child is presented. The details and environments from different parts of Sweden visited by Katitzi, from Stockholm and Uppsala to Vännäs and Umeå in the north, are depicted in black-and-white images throughout the series. Along with the text they tell us about the injustices and prejudices that largely dictated the Roma people's living conditions in the recent past, struggles that continue to influence their situation even today.

The notion of illustration suggests that the image is less important than the text. In Katarina Taikon and Björn Hedlund's case, this is not quite true. Their long-standing and close friendship was reflected in their intimate collaboration on these books. The preparatory work was based on Katarina Taikon's stories about her childhood and her life, and Björn Hedlund depicted these stories with sketches and drawings. The creation of the Katitzi character can therefore be described as both a linguistic and a graphical process—even if the actual history precedes the drawings.

In the *Katitzi* books, text and image come together in a way that

makes the drawings move beyond the purely illustrative to become a vital part of the story. Björn Hedlund's artwork adds new layers to the stories in which the protagonist is given additional dimensions, sharpening her features and personality. His depictions of Katitzi signal the protagonist's inherent power, visible in her features and forming a contrast to the text's often cruel stories. The drawings are characterized by a realism that moves beyond the simplistic stereotypes of children's literature. Recurrent in the images is also the daring use of decorative elements in environments, backgrounds and dramatic perspectives. It is an approach that bears the traces of psychedelic poster art from the late '60s and early '70s.

But even before the series' first book, *Katitzi* was published by the Christian publisher Harriers bokförlag AB, with a cover text by the then very well-known Swedish actor and poet Beppe Wolgers. In 1969, the tabloid *Expressen*'s readers had already learned of the story. There it was published as a short story. Many of the events and incidents were already mentioned in Katarina Taikon's 1967 book *Zigenare är vi* (We are the gypsies), published by Tidens Förlag. Some of the books were published by Gidlunds förlag, but most of them were published by Tai-Lang, the publishing imprint set up by the author and her husband, Björn Langhammer. Even the children's magazine *Kamratposten* published *Katitzi* during two different periods, 1969–70 and 1973–75, but then as a serial and as a cartoon.

The impact that the *Katitzi* story had is also demonstrated by the comic *Katitzi* which was published once a month between 1975 and 1976 by Williams publishers in Bromma. In addition to the two sections about Katitzi, each edition contained games and puzzles with and without Katitzi and prizes such as coloring books, record players and *Katitzi* books. Sometimes there were even *Katitzi*-themed crosswords attached. In the "children's mailbox," a write-in column, Katarina Taikon, writing as Katitzi, replied to questions of various types, for example "Was it cold to sleep in a tent?—submitted by Annica Jansson in Vällingby," to which Taikon responded, "Ugh, yes, it was both cold and nasty." Stories

with titles like "Daddy Comes for a Visit" and "When Uffe Went to the Hospital" were also included in each issue, in addition to collectible picture cards of animals, and the series *Linus & Lotta*, a story about the adventures of two friends.

Linus and Lotta are two blonde and blue-eyed kids who celebrate Lucia, build go-carts and lose their money when buying milk for their mother. Like the magazine's other competitions and the collectible pictures, the series anchors the comics in a traditional Swedish children's culture in which the welfare state's norms prevail. There are also explicitly pedagogical elements about how not to behave in nature. The stories, however, suggest a contemporary social reality with divorced parents and modernized health care. The comic, although still focusing on Katitzi, is situated in a mainstream Swedish context. Interestingly, the motto "a Swedish comic book" is visible on several of the comic's covers, which can be read as a mark against American cultural domination. Björn Hedlund's colorful illustrations are adapted to the comic magazine aesthetics with simplified forms and compositions consisting of many small frames.

If the cultural importance of Katitzi had been evident for a long time, the commercial potential was proven when the comics were published as a book-like magazine by the publisher Bonnier Junior Press in 1979. The material is taken from the comic, but the publication is reedited and based on new color originals, again made by Björn Hedlund. However, the covers were made by Hans Thor. The magazines focused on Katitzi and the only other element was a drawn interior of a so-called box-tent, based on the one that housed the Taikon family, and a photograph of a so-called three-bar tent, followed by a section on Roma history from Katarina Taikon's 1970 book *Zigenare*. The publisher, Bonnier Juniorförlag, also published picture books such as *Katitzi kommer hem* (Katitzi comes home) and *Katitzi—det brinner* (Katitzi—it's burning) with sweet images by Lisbeth Holmberg-Thor, best known as the illustrator for Gösta Knutsson's tales about the cat Pelle

KATITZI'S JOURNEY THROUGH SWEDEN 195

Svanslös. Holmberg-Thor's Katitzi is a stereotypically prettier girl than Björn Hedlund's depiction, and in the picture book the first-person narration is mixed with third person writing. *Hur blev det sen då, Katitzi?* (Then what happened, Katitzi?) from 1977, with photographs by Björn Langhammer, tells the story of what happened to the gypsies when Katitzi grew up, with words and images depicting how Katarina Taikon's and others' activism, managed to change some, but far from all, problems with the Roma situation.

From 1979 to 1980, the Swedish Public Service company SVT broadcasted the TV series *Katitzi* in six episodes, starring popular actors Janne "Loffe" Karlsson as the Taikon father, Monica Zetterlund as "the lady," and a young Kjell Bergqvist as Paul. Directed by Ulf Andrée, Katitzi, as played by Sema Sari, becomes a physically expressive girl who is not as verbal as the protagonist found in the books. Music plays an important role in the series and is written by Katarina Taikon's relative and close friend Hans Caldaras, who also designed the Roma costumes. He also served as one of two Roma fact-checkers. In 2006, the TV series was released on DVD. In the 1960s and '70s, when the series first appeared, an audio version on LP accompanied the TV show. Interestingly, the *Katitzi* LP was released by Mariann, a record label owned by theme-park owner and subsequent founder of Swedish populist party New Democracy, Bert Karlsson. It involved well-known singers such as Lasse Holm, Anders Glenmark, and Ingela "Pling" Forsman.

The translation of the *Katitzi* books began as early as the 1970s, first into neighboring Nordic languages (Danish in 1972, Norwegian in 1975, and Finnish in 1977) and then into German in 1974. The French translation came in 1984, and in 1999, after the fall of the Berlin wall, when the discussion concerning the Roma situation was reinvigorated, a Czech translation was published; in 2001 the books were translated into Slovak, Hungarian and Romanian. A translation into Romani was done in 2010 by Hans Caldaras,

who also recorded the story on a CD. In English, there was only Emma Broström's dramatization in 2010.

It was Lars-Erik Brossner, the former trombonist in the legendary Swedish band Nationalteatern, and head of the Folkteatern theater children's stage En Trappa Ner, who commissioned Emma Broström to stage a family-friendly show based on the *Katitzi* books. In the winter of 2010, the play premiered in Gothenburg. The events in the story take place in a present in which rootlessness, overcrowding, and the search for a permanent home are frequent themes. Sören Brunes transformed the stage into a circular ramp upon which boxes served as flexible furniture. A common theme in the show is Katitzi's desire to go to school and, in Cecilia Milocco's interpretation, the nine-year-old girl becomes a curious and sensitive child who has been compared to Astrid Lindgren's fierce protagonist Ronja Rövardotter. In Emma Broström's dramatization, Lena, the sister who is two years older than Katitzi, is absent, but the grandmother Mami, whom Katitzi flees to when running away from home, has a prominent place. The warm reunion between the grandmother and Katitzi becomes a critical scene, and the rousing Roma-inspired music helps to accentuate the plot.

When the play was staged at Riksteatern in 2011, the music was also central but now with a hip hop sensibility. Director Kajsa Isaksson made Katitzi into a super heroine who energetically moves across the catwalk-like stage in a striped dress. The Lady has become fancy and the coughing father a charmer with a goatee. The actor Mia Ray's Katitzi draws with white chalk on the ground, hopes to go to school, and day-dreams about writing a book. Kajsa Isaksson herself says that, "Our show is about finding home, no matter where you are. Who you are. It's about prejudice and ignorance but also about community, struggle, family, bureaucracy, rights, and dreams." In collaboration with the anti-racist organization Expo, Riksteatern engaged in an ambitious effort to organize seminars and talks on democracy and equal rights. This version

of *Katitzi* premiered in Strömsund and was seen by thousands of primary school children across Sweden. The play was also performed in 2013 when Teater Piraten's staging premiered at the Hallonbergen Cultural Center.

The stories about Katitzi live on more than forty years after they were first published: the movie is frequently rented and purchased on DVD and CD, the play is regularly staged, and the books are widely circulated. Although the *Katitzi* books are a unique literary treasure, with few exceptions neither the *Katitzi* books nor Katarina Taikon are mentioned in general works of Swedish children's literature. In 2012, despite being the Swedish "Year of the Roma," only one of the books about Katitzi was still in print in Swedish, made available through the literacy organization En bok för alla (A book for everyone). Since then, the publisher Natur & Kultur has reprinted a revised edition of the entire *Katitzi* series.

The first, second and third editions of *Katitzi*.

Katitzi, 1969

In *Katitzi* we get to know the seven-year-old girl who lives in an orphanage, where she feels at home, even if Rut sometimes bullies her. One day Katitzi's father comes to the orphanage to bring her home to her family. When she is reunited with them, she experiences a completely different life than what she has become accustomed to at the orphanage. She soon finds her place, despite a wicked stepmother, but has difficulty understanding all the injustices her family members confront, and realizes that Roma people are not treated like everyone else in society.

Katitzi och Swing, 1970

In *Katitzi and Swing* we follow Katitzi, now eight years old, on a journey through northern Sweden together with her family and her dog Swing.

Katitzi rymmer (Katitzi escapes), 1971

Katitzi decides to leave life in the camp and the strict and unpleasant stepmother whom Katitzi calls "Tanten" ("The Lady"). She takes off, trying to find her grandmother, *Mami*, who is living in a nursing home in Uppsala.

Katitzi i ormgropen (Katitzi in the snake pit), 1971

Katitzi has just turned nine, the world is at war, and her family arrives in Strömåker in the north of Sweden. After a short time, they have to move again. We follow Katitzi's life in the camp, how she gets to know Saga and Sam before ending up in a real snake pit.

Katitzi, Rosa och Paul, 1972

Now Katitzi is 10 years old. Katitzi flees the oppressive family camp together with her siblings Rosa and Paul. They face many problems during their time of independence, but also meet new friends such as the kind Gösta, and Karin, who has a limp and wants to become an artist.

Katitzi i Stockholm (Katitzi in Stockholm), 1973
Katitzi, Rosa, and Paul visit their father, who now lives in Stockholm. To help her father keep the family afloat, Katitzi starts selling Christmas postcards. She earns money for the family, but will it be enough to make Papa Taikon truly happy?

Katitzi och Lump-Nicke, 1974
Katitzi is twelve-and-a-half years old. She is now considered an adult and her father thinks that she is ready to get married. Papa Taikon is seriously ill and hospitalized and Katitzi must fend for herself in the face of Roma tradition and Swedish society. In Tantolunden, Stockholm, she gets to know the kind homeless man Lump-Nicke and the well-traveled actress Julia Caesar, who makes Katitzi escape into fantasies where she is a carefree character named Carmen. Katitzi finds a wallet filled with money and is accused of theft.

Katitzi i skolan (Katitzi in school), 1975
Katitzi can finally start school like other children her age. But it will not be quite as she has imagined: the other children at school are unkind to her and bully her because of her Roma heritage.

Katitzi Z-1234, 1976
Katitzi meets a woman who has just been freed from the concentration camp at Auschwitz. The woman tells her about the atrocities taking place outside Sweden. Katitzi is deeply affected by what she is told, and to show her compassion she writes "Z-1234" on her arm, in solidarity with the Roma people who are tattooed and identified in the Nazi concentration camps.

Katitzi barnbruden (Katitzi the child bride), 1977
Papa Taikon's wife treats Katitzi increasingly worse and accuses Katitzi of theft. Papa Taikon tries to resolve the situation and decides to marry Katitzi off to Lazi, who is six years older, and who promises her a life of luxury.

Katitzi på flykt **(Katitzi on the run)**, 1978
Katitzi is treated very badly by her new husband, Lazi, and is both beaten and raped. She is unhappy and decides to escape. When she flees, everybody is upset with her, and her relatives search high and low to find her.

Katitzi i Gamla stan **(Katitzi in Old Town)**, 1979
Katitzi gets taken in by a home for girls in Stockholm's Old Town. For the first time since she was a little girl she can live in a house and sleep in a warm bed. Her future is still uncertain and she does not know how she will support herself or what she wants to do with her life. There is danger lurking around the corner because Roma customs maintain that Katitzi is still Lazi's wife.

Katitzi uppbrott **(Katitzi departure)**, 1980
In this last volume, Katitzi is fifteen years old, and she is the star of a short film. Her marriage finally gets resolved and Katitzi is on the threshold of an adult life.

Katitzi's Journey through Sweden

The exhibition "Katitzis resa genom Sverige" ("Katitzi's Journey through Sweden") was produced in collaboration with Angelica Ström, Katarina Taikon's daughter. A seminar series was organized in conjunction with the exhibition, in cooperation with the Workers' Educational Association (ABF), the publisher Natur & Kultur, and the libraries in Rinkeby and Tensta.

The Katitzi Club
25.10.2012–27.1 2013 In conjunction with the exhibition, the Katitzi Club was launched at Tensta konsthall. The focus of the club was on the fictional character Katitzi. The members of the group were 10–11 years old, and they all attended the Gullingeskolan primary school in Tensta. They gathered at the konsthall every Tuesday after school. The club was led by the mediator at Tensta konsthall. The group staged readings from the books, screened films, and produced drawings inspired by Katitzi.

Monday, 29.10, 17:00 City tour in Katitzi's footsteps, with Angelica Ström and Lawen Mohtadi. Gathering at 17:00 at the corner Sjukhusbacken/Ringvägen (on the Rosenlund side) at Södermalm.

Tuesday 30.10, 15:00 Reading with Angelica Ström at Tensta library and then a guided tour of the exhibition.

Wednesday 7.11, 18:30 "Katitzi: Messy Hair and Fighting Spirit," a lecture about children's literature by researcher Kristin Hallberg at Tensta konsthall.

Saturday 17.11, 14:00 Lawen Mohtadi presents her biography of Katarina Taikon, *The Day I Am Free*, at Tensta konsthall.

Saturday 8.12, 13:00 Reading with Angelica Ström at Rinkeby library and then a guided tour of the exhibition.

Saturday 22.12, 14:00 Maria Lind talks with Rosa Taikon at Tensta konsthall.

Wednesday 9.1, 18:30 Talks about Katitzi with Hans Caldaras who, among other things, wrote the music and designed the Roma clothing for the TV series (1979), and Kajsa Isaksson, who directed the Riksteatern's performance (2011–12), at Tensta konsthall.

Illustrations by the artist and illustrator Björn Hedlund (1922–87)

1/55
165 mm.

Opening of "Katitzi: A Literary Character Rooted in Reality" at Tensta Konsthall (25.10 2012–27.1 2013). PHOTO: EMILY FAHLÉN

Book wall in the exhibition "Katitzi: A Literary Character Rooted in Reality" at Tensta Konsthall (25.10 2012–27.1 2013).

PHOTO: EMILY FAHLÉN

Rosa Taikon in conversation with Maria Lind at Tensta Konsthall (22.12 2012).
PHOTO: EMILY FAHLÉN

Lawen Mohtadi and Maria Lind in conversation about Mohtadi's biography of Katarina Taikon, *Den dag jag blir fri* (*The Day I Am Free*) at Tensta Konsthall (17.11.2012).
PHOTO: EMILY FAHLÉN

Angelica Ström reading aloud to Tensta library's young visitors (30.10.2012).
PHOTO: EMILY FAHLÉN

Vitrine in the exhibition "Katitzi: A Literary Character Rooted in Reality" at Tensta Konsthall
PHOTO: EMILY FAHLÉN

Video installation of the six-episode TV series *Katitzi* at Tensta Konsthall (25.10 2012–27.1 2013). PHOTO: EMILY FAHLÉN

When the exhibition "Katitzi's Journey through Sweden" went on tour, its title was changed to "Katitzi: A Literary Character Rooted in Reality"

9.10–5.12 2013 "Katitzi: A Literary Character Rooted in Reality" at Gallery8 in Budapest, European Roma Cultural Foundation.

European Roma Cultural Foundation is located in Budapest in a residential area populated mainly by Roma people. The foundation is unique in Europe. The name of the newly opened gallery, Gallery8, refers to the eighth district in Budapest.

9.3–19.5 2013 "Katitzi: A Literary Character Rooted in Reality" at Gävle Konstcentrum.

Gävle Konstcentrum is a platform for Swedish and international contemporary art run by Gävle municipality. "Katitzi: A Literary Character Rooted in Reality" was shown as part of the project "Rom betyder människa" (Roma means human), which aimed to highlight and discuss the critical situation of the Roma people in Europe today. In the spring of 2013, Gävle municipality addressed this issue through different projects, including an exhibition, a film festival, musical performances, talks, and lectures.

27.6–18.10 2015 Exhibition at the Almedal library in Visby, on the island of Gotland. The tour started in Visby, where Katarina Taikon's books about Kaitizi were written. The exhibition opened during Almedalsveckan, an annual gathering of all Swedish political parties, and was shown at the Almedal library, presented by Svensk Biblioteksförening (The Swedish Library Association) in collaboration with Kulturbyrån. The exhibition was also shown at the movie theater and art space Panora in Malmö and at Kulturhuset in Stockholm, as well as at the annual Gothenburg Book Fair.

15.10–30.10 2014 "Katitzi: A Literary Character Rooted in Reality" at Czech Centre Prague.

Alongside the exhibition "Katitzi: A Literary Character Rooted in Reality," artist and activist Tamara Moyzes presented her photographic exhibition "Family Happiness," which deals with the institutionalization of Roma children. Czech Centre Prague opened in 2006 and is part of a larger network that promotes cultural activities and collaborations as part of the Ministry of Foreign Affairs of the Czech Republic. The exhibition was produced in collaboration with the Embassy of Sweden in Prague.

In 2016, the exhibition toured a number of Sweden's Folkets Hus and Folkparker, local cultural centers and performance venues, for example Söråker Folkets Hus, Rågsved Folkets Hus, Hallunda Folkets Hus, Lidköping Folkets Hus and Kosta Folkets Hus.

Screening of *Taikon*
28.10 2015 Screening of *Taikon*, with an introduction by director Lawen Mohtadi. The documentary *Taikon*, based on Mohtadi's book, was screened during the autumn holiday. The directors of the film, journalists and authors Lawen Mohtadi and Gellert Tamas, utilized rich archival material to create a portrait that is both timely and moving in its depiction of Katarina Taikon.

"Katitzi: A Literary Character Rooted in Reality"
at Czech Centre Prague (15.10–30.10 2014)

Lawen Mohtadi and Angelica Ström at the opening of "Katitzi: A Literary Character Rooted in Reality" at Gallery8 in Budapest, European Roma Cultural Foundation (9.10–5.12 2013)

Vitrine with comics and newspapers about Katitzi and Katarina Taikon at Gävle Konstcentrum (9.3–19.5 2013)

"Katitzi: A Literary Character Rooted in Reality" on tour at Söråker Folkets Hus (25.1–7.2 2016)

"Katitzi: A Literary Character Rooted in Reality" on tour at the Almedal Library in Visby (27.6–18.10 2015)

KATITZI

Katarina Taikon

Dedicated to my children
Angelica
Michael
Niki

Katitzi

– KATITZI! KATITZIII ...!
– Where is she? Why do you always have to go looking for that girl?

Miss Larsson was upset. During the twenty-five years she had directed the orphanage, she had never dealt with a child as difficult as Katitzi, she thought.

It was already seven in the evening and the other children had by now long ago eaten their supper and marched off to bed.

The light was out in all the rooms and the children were supposed to sleep. *Supposed to* sleep, but they certainly were not, at least not in room five. Whispers could be heard all around: voices in each and every bed murmuring about the latest trouble Katitzi had gotten into. Everyone was on edge: what would happen when Miss Larsson got a hold of her?

Miss Larsson was very strict about rules at the orphanage. If you didn't abide by them, she was merciless, and tonight she was especially angry: you could hear it in her voice as she shouted for Katitzi. Her voice rose to an ever higher falsetto each time she shouted, and sometimes it cracked to the point where she sounded like the steam whistle on a runaway train:

– Katiiitziii ... KATIIITZIII!!!

Every once in a while, Miss Larsson stomped her foot in anger while she continued to shout. So that when she stomped her foot

into a puddle of mud, the muck splashed high up onto her skinny legs, making her even more fired up:

– Ooooh! That child is going to get it! she screamed, Just wait until I get a hold of her!

That Miss Larsson now was so furious was not merely due to mud puddles and splashing muck and wilful children: she could handle most things if it was a regular evening. It was always difficult to get the children to go to bed, and Katitzi was in a league of her own. But tonight there was a tent revival with the handsome Preacher Pettersson down in the village. Miss Larsson had only seen his picture.

Imagine seeing him in person! And to hear him speak! Miss Larsson had fantazised about it ever since the other parishioners had told her about him an entire year ago.

But the meeting was set to begin at seven-thirty and Katitzi was still nowhere to be found. Miss Larsson was both furious and exasperated. She continued to call and look for the girl.

– Katiiitziii! KATITZI!!!

The lights were out in room five, and Katitzi's bed was empty. But there were six other beds in the room and they were not empty: tucked into each were Katitzi's roommates, who were chattering and arguing. Gullan was angry, mostly at Rut, or Ruttan as her friends called her. Ruttan had just said it was only right that Katitzi receive a beating once Miss Larsson got a hold of her. Gullan and her brother Pelle were Katitzi's best friends, who always tried to help her when she got into trouble, which she often did. But since Pelle was a boy he was not allowed to sleep in the same room as his sister. There were many strange rules at the orphanage.

– Ruttan! You're mean, and jealous of Katitzi, Gullan said.

– And what am I jealous of, if you don't mind my asking?

– I'll tell you. It's just because Miss Kvist likes Katitzi and is nice to her.

– As if it's any of your business! What makes Katitzi so special,

anyway, that she can do whatever she wants? What if everyone only did what they wanted? What would the world look like then?

Ruttan had picked up that last bit about the world from Miss Larsson during one of her countless dining hall lectures when someone had broken one of the many rules.

– Besides, I want to remind you that my name is not Ruttan! My name is Rut, Ruttan hissed.

The other girls were most likely on Gullan's side, but they didn't dare say it aloud so that Ruttan could hear it. Ruttan could bear a grudge, and there was always something she could squeal about to Miss Larsson.

– There she is! shouted a girl whose bed was near the window.

– Hurry! Open the window and tell her to come in through the back door so that Miss Larsson doesn't see her, Gullan urged.

– No! Don't do it! Leave that window alone! I am going to tell Miss Larsson! Ruttan shouted, and with all her might she hurled a pillow at the girls who had just opened the window.

The pillow missed the girls and flew out through the open window.

Down in the courtyard, the head of the orphanage had also caught sight of Katitzi and she rushed towards the girl and screamed:

– I've got you now! Now ...

But—Miss Larsson fell quiet and came to a standstill right in the middle of a large puddle of water. Katitzi was not alone. By her side was a man. And not just any man.

Was it really ...?

It certainly was. Preacher Pettersson, in the flesh.

Miss Larsson's tightly clenched jaw dropped and her chin fell.

At that point, the preacher and Katitzi had reached her. The preacher smiled and extended his hand.

– This must be the Miss Larsson Katitzi has told me so much about, he said.

At that moment, the pillow Ruttan had thrown came flying through the window. It hit Miss Larsson in the back of the head

KATITZI 217

with such force that she completely lost her balance. Fumbling for support, she gripped the preacher's hand and exclaimed:

–MY LORD YOU PETTERSSON!

Caught completely by surprise, Pettersson also lost his balance and together they fell into the puddle in a flailing mess of arms and legs.

Katitzi burst into laughter. It looked so funny as the strict Miss Larsson tried to appear composed, crawling around on all fours in the puddle.

Katitzi laughed so hard that she had to bend over. The lovely Miss Kvist came running across the courtyard: she had heard the commotion and wondered what was happening.

At first she looked shocked, but then she couldn't refrain from laughing, either. And in each and every window stood children who were laughing and laughing – and who had completely forgotten that good little children are supposed to be asleep by seven o'clock.

The only one who did not laugh was Ruttan.

Ruttan Is Mean

– Pelle! Hurry and eat up your gruel. We're going swimming, Gullan shouted.

– I hate gruel, it's almost worse than burnt oatmeal. I can't eat it: I'll be sitting her all day, Pelle replied.

– Hurry, you have to finish! Katitzi said. Wait: I'll help you. I can probably manage a little bit more. Katitzi quickly ate large spoonfuls of Pelle's gruel. At that moment, Miss Larsson entered the room and immediately caught on to what was happening.

– What on earth are you doing? Are you eating Pelle's gruel? I can't believe my eyes! March up to your room this instant, and stay there until supper!

– But Miss Larsson, Pelle said, it's not Katitzi's fault. She just wanted to help me, because I can't finish it.

Gullan hurried to add:

– And Miss Kvist gave us permission to go swimming! And it was going to be so much fun.

– Pelle and Gullan, you always defend Katitzi. But head on out now, and whatever happens don't come up with more mischief because then you're headed straight to bed, Miss Larsson said, looking very stern.

– Katitzi! Don't forget to bring your swimsuit! Pelle shouted. Gullan, you have the box for the mussels?

The day had been so hot that the milk quickly turned and the cat had crawled in under the porch for some cool shade.

By the beach, a few kilometer from the orphanage, Miss Kvist was waiting with nearly all the children, including Ruttan, who was in a terrible mood since she had heard that Katitzi had not been punished for finishing Pelle's gruel. Now she was wondering how to get to Katitzi and give her what she deserved.

Pelle and Gullan were changing into their swimming clothes, but Katitzi simply stood and looked on.

– Hurry up, then! Gullan said. We can't stand here all day.

– Aren't you hot? Pelle wondered.

– I don't want to swim, Katitzi complained. It's too cold.

– You're nuts, Gullan said. Swimming is great.

– *Too cold!* Pelle imitated. You're driving me ... Pelle's face was bright red.

– Why are you blushing? Katitzi asked.

– I'm not blushing, Pelle replied. It's the heat, don't you get it?

– All right, no more waiting for Katitzi, Gullan said. Come on, Pelle, let's jump in!

Gullan and Pelle set off toward the beach and out onto the dock.

– First one in! Pelle shouted and hurled himself in head-first. He was a good diver. Gullan jumped in feet-first.

Katitzi had come down to the dock. She sat and watched while Gullan and Pelle swam around like seals. She also gazed around at the other children, all of them swimming and seeming like they were having lots of fun.

– Jump in! Pelle shouted. Katitzi! Why don't you jump in? It's so nice!

Katitzi looked at Pelle with a level gaze, and then from Pelle to Gullan. Then she slowly said:

– Come up on the dock for a minute. I have to tell you something.

Pelle and Gullan crawled up to Katitzi on the dock. They were both curious and surprised that Katitzi didn't want to go swimming: something wasn't right.

– You know ... Katitzi started. You could tell that it was difficult

for her to make the words come out. I ... I can't ... I can't swim. I've never ...

– Ha, ha, ha! Ruttan jeered. She can't swim! Katitzi can't swim! Did you all hear that! That's so stupid! Katitzi can't swim.

– Here you go! Ruttan yelled and shoved Katitzi into the water. Katitzi resisted, but fell with a big splash and flailed her arms so as to not sink below the surface, but it was as if her head was pulled down by an invisible hand. There were violent splashes as she disappeared into the water. When she surfaced, she flailed around in a panicked attempt to get a hold of something to save her. She choked and her eyes were wide open in terror. Between her choking coughs she screamed:

– HELP! HEELLLLP! I'm drowning. I'm drow ...

– What is it? What's happening? What are you doing? Miss Kvist yelled and came running out on the dock towards the children.

– Ruttan pushed Katitzi into the water! someone said.

– She can't swim! another voice chimed in.

There was another splash and Pelle disappeared into the depths. After a second, he surfaced with his hand around Katitzi's arm, but she kicked and flailed around her to come loose. She was completely terrified, and it didn't help that Pelle was trying to hold on to her with all his might.

Everyone on the dock was paralyzed.

– I just wanted to scare her, because she's always so stupid. It was Ruttan, and she looked terrified.

Another light splash could be heard and suddenly Miss Kvist appeared next to Katitzi and Pelle. In one swift movement Miss Kvist got a strong grip on Katitzi's long, dark hair, and in a few quick strokes she reached the shore, where the other children now were gathered.

– Ruttan, how could you? Gullan scolded. Don't you know how dangerous it is to push someone who can't swim into the water?

Miss Kvist had placed Katitzi on her stomach and was trying

to resuscitate the girl who was now completely still. Miss Kvist kneeled next to Katitzi and pressed her hands against her back: slowly, up and down.

– Hurry back home and tell Miss Larsson to come here, she said.

At that moment, Katitzi opened her eyes. She hacked and coughed, gazing around at her friends, and then at Miss Kvist. Then her head fell back to the ground.

– Does Katitzi have to go to the infirmary now? one of the girls asked.

– No, I don't think so, Miss Kvist replied. But we have to head on home and put her to bed for a while.

– Are you better now? Miss Kvist asked.

Katitzi looked up:

– Yes, but I never want to swim again. Water is horrible.

– Not true, Miss Kvist said. Swimming feels great and is fun. But you have to be able to swim.

– Ruttan! It's your fault. And we are going to tell Miss Larsson, Britta said. Katitzi could have died.

Miss Kvist looked around at the children.

– Let's sit down and talk about this for a bit, she said.

She continued:

– Rut, and the rest of you. You have to understand that you can never push anyone into the water, not even someone who knows how to swim. How many of you can actually swim? Raise a hand, all of you who know how to swim.

Only two of the children didn't raise their hands: Katitzi and Ruttan.

– Then we will do swimming lessons with the two of you, Miss Kvist said. And let's start right away. Lie down on your stomachs, right here on the beach. Extend your arms and your legs, like this! And then move your arms in, towards your chest, and move your legs out. And do it all over again.

– Katitzi looks like a frog, Ruttan said.

– Well, so do you, Katitzi replied. She already felt much better.

– There, there, children, no quarrelling. Looking like a frog is not a bad thing when it comes to swimming. Let me tell you that frogs have no trouble swimming.

– When do we get to swim in the water? Ruttan asked.

– I want nothing to do with any water, Katitzi said. I'll keep swimming here in the sand: it's much safer.

– Oh no, you're going in the water, otherwise there's no point in learning how to swim. On land we can manage without strokes, but first you have to practice in shallow water, so you can touch the bottom.

All day, Miss Kvist worked with the two girls. And before the three of them grew tired, both Katitzi and Ruttan could swim nearly ten meters.

– It's great! Katitzi marvelled mid-stroke. And so much fun!

Pelle and Gullan were still a little bit mad at Ruttan.

– What do you think will happen to her for pushing Katitzi in the water? Gullan asked. What will Miss Larsson do?

– We are not going to tell, Katitzi said, so there.

And so also this day ended happily.

Katitzi Has a Visitor

One day there was a little square car parked in the courtyard with all the children gathered around it, and at the wheel was a large man. He was Katitzi's father and he had come to bring her home.

But as usual when something was happening, Katitzi was gone. She had hidden, and no one knew where. Everyone was calling for her, most of all Miss Larsson, of course.

– Children, hurry! All of you! Look for Katitzi. She has to come out right away, her father is here.

Pelle and Gullan looked at Miss Larsson for a long while.

– But Miss Larsson, maybe Katitzi doesn't want to go home at all.

– What on earth are you talking about! Of course she wants to go home. Now quickly run and find her. You probably know where she is. And Pelle, don't forget to look down by the lake.

– Pelle, we're not going to tell Miss Larsson where Katitzi is if we find her, right? Gullan asked.

– No, but we can pretend that we're looking for her. And if we find her, we can warn her.

– Katitziii! KATITZIII! Pelle and Gullan shouted. Come out: we're going to help you. You don't need to be afraid.

– It's Gullan and Pelle, the two friends shouted.

Katitzi crawled out from beneath an upside-down rowboat, where she had been hiding the entire time, tears streaming down her dirty cheeks.

– I don't want to, I don't want to, she sobbed.

– What is it you don't want, Katitzi? Tell us. Is there something you're afraid of? Stop crying: we'll help you, both Pelle and Gullan replied.

– Don't you get it? I don't want to go home.

Pelle and Gullan looked at each other with surprise.

– But sometimes we wish we could leave this place. Why don't you want to leave? Gullan asked.

– And imagine getting to ride in such a nice car, Pelle said. I've never ridden in a car: wow, that would be so much fun!

– No! I don't want to leave you, and I don't recognize my father. He looks so angry, and he has such a big, black beard. Please, Pelle and Gullan: help me! Help me to hide in a really good spot so they can never find me!

Pelle gave it some thought.

– I know! Everyone has run around the big house looking for you. I don't think they'll look there anymore. If you sneak in through the back door and up the stairs you can probably hide in Miss Larsson's room. I don't think anyone will try to find you there.

Pelle and Gullan ran ahead and looked to make sure no one was near the house, but they didn't need to worry: everyone was out in the woods, shouting and searching. You could hear all of them from far away.

Katitzi ran! As fast as she could, up to the house, to the back door, and then she crept, quiet as a church mouse, up the stairs. But when she was halfway up the stairs, a door opened.

– *Katitzi?*

It was Miss Kvist, looking out from her room.

– Katitzi, dear. Where have you been? Everyone is out looking for you. And your father is so sad that you don't want to come out.

Katitzi paused in the stairwell, feeling both defiant and confused.

– I don't want to come out. I don't want to go home. I'm going to run away, and never come out.

– Please, sweet Katitzi. Do you want to make everyone sad? And

look at you! You have to go wash up. You are terribly dirty, and your hair is a mess!

– Please, please Miss Kvist, can you please hide me? I'll never be bad again, as long as you let me stay here.

– Don't be afraid. You're trembling, all over. You know what, Katitzi, the man sitting down there waiting for you is your father. He's waiting to see you, and I am sure he is kind. He misses you, don't you understand that? That's why he's here.

– But have you seen the people sitting in the car? They look so strange. And they are wearing such strange clothes. I've never seen clothes like that.

– I think they're your siblings. And you know what, Katitzi? I don't think they're wearing strange clothes. They're just a little bit longer than what you and I are wearing. But have you seen how beautiful their clothes are? Such beautiful colors.

– I still don't want to go, Katitzi said.

– Run into my room now. I'm going to speak with your father and Miss Larsson, and we will see what we can work out.

Miss Kvist, kind Miss Kvist, understood that little Katitzi didn't remember her father and that she was afraid to leave the orphanage with him.

I'm going to speak with Katitzi's father, and ask if she can stay a bit longer, Miss Kvist thought to herself as she walked down the stairs and out into the courtyard. She called for Katitzi's father, and for Miss Larsson.

– Can we go into the office for a bit? she asked.

Miss Larsson frowned: she didn't like this one bit. What had Miss Kvist come up with now? I hope it's not anything unpleasant: I really don't have the energy for that, she thought.

Katitzi's father only looked saddened.

– I wonder where that child has gone off to? We can't keep looking all day, and I have to go home again soon. Everyone is waiting for us.

Once they entered the office, Miss Kvist spoke.

– Can Katitzi stay a little bit longer? She would like to so very much. This is very difficult for her: it all happened too suddenly for her.

– This is really too much! Is Miss Kvist going to really interfere in this? When Katitzi's father wants to come and bring his own child home. To her rightful *home*! It's completely against the rules! exclaimed Miss Larsson.

Miss Kvist tried again.

– Katitzi doesn't recognize her father. It's been too long since you last saw each other. Perhaps it is better if we have the chance to prepare her first, if we can tell her a little bit more about her family.

Katitzi's father brightened, and no longer looked as forlorn.

– Yes, maybe you're right. She hasn't been home in a long while. She must have forgotten a great deal. All right then, let's say that. I will return in two weeks. Do you think that will be good, Miss Kvist?

Miss Kvist smiled. She liked Katitzi's father, and was glad she did.

– Yes. I will tell Katitzi how kind her father is; she needs a kind father. And I think she will happily go with you the next time you come here.

Then they parted ways. Katitzi's father and siblings drove away in the car.

But Miss Larsson looked displeased.

– No, little Gärda, you are always sticking your nose in people's business, but this time you've gone too far.

– Why is that? Miss Kvist asked, whose first name was Gärda. She looked innocently at Miss Larsson, who added:

– You know how pleased I was that the girl was going to go home. She's given us nothing but trouble.

Miss Kvist shook her head.

– You mean that *you* have had nothing but trouble. The rest of us haven't felt the same way, actually.

– But you have to admit that Katitzi is terribly disobedient. She never goes to bed on time. She often arrives late to meals. And look at her: she always gets dirty and is up to no good.

– You've got a lot of ideas in your head, Emma. Can't you stop always thinking about order? It's not the most important thing in the world.

– Well, that would be fine if it was just about Katitzi, but the worst part is that the other children take after her: they think she's funny. And when Katitzi disobeys me, they laugh behind my back.

– But Emma, you have to admit that the children are much happier since Katitzi came here.

At that moment, there was a rumble in the stairs and Katitzi came dashing out of Miss Kvist's room. She had heard the car start and drive off.

– Oh, thank you, thank you, Miss Kvist! Can I stay now?

– Yes, Miss Larsson and your father and I have agreed that you can stay a bit longer, Miss Kvist said.

Nonsense, Miss Larsson thought to herself. We didn't agree on a thing: Miss Kvist decided this all on her own and took care of it. Aloud, she said:

– Yes, Katitzi, you can stay a little bit longer, but then you have to promise to behave.

– Oh, yes! Katitzi cheered and flew into Miss Larsson's arms, who was so surprised that her glasses fell off. They hit the floor and shattered.

This is off to a fine start, Miss Larsson thought to herself, but she said nothing.

Night Circus

– Good night, children. Sleep tight, Miss Kvist said and turned off the light.

– Katitzi! Hey, Katitzi! Gullan called quietly. Are you asleep?

– No, of course I'm not, Katitzi tried to whisper.

– Everyone has to be quiet and sleep! Didn't you hear? Ruttan's voice emerged out of the dark.

– Then I think you should be quiet, Gullan hissed. And why don't you go to sleep, too.

Katitzi dashed over to Gullan's bed and crawled under the covers. There was a moment's silence, and then a tentative question could be heard:

– Katitzi ... Where are you really from?

The answer came quickly:

– I have no idea. If you mean from the beginning, with a father and mother and things like that.

– So you don't know who your father and mother are?

Katitzi did not sound very concerned.

– Nope, I don't. Do you? I mean, do you know who your father and mother are?

– No, I don't, because Pelle and I were babies when we came here, and we didn't want to ask Miss Larsson, Gullan said.

– I only know that the circus people didn't want to keep me anymore, Katitzi said.

– The circus people, said Gullan. Who were they?

– People, of course. Ordinary people, but they ran a circus, Katitzi said. Haven't you ever been to the circus?

– No, I don't think so. The circus? I don't know what that is. I don't think I've heard of that before.

Katitzi grew excited, but continued to whisper.

– The circus is a big tent with lots of animals. Have you ever seen an elephant, Gullan?

– No ... Well, in a picture, of course. But they don't have elephants in Sweden, do they? Living ones?

– Yes! You bet they do! Big elephants. Large, gray elephants who lift people high up in the air.

– Why do they lift people up? That sounds crazy. Couldn't those people get hurt, then?

While Katitzi and Gullan had been talking, other children had gathered around Gullan's bed. All the children had tiptoed over and now sat wide-eyed and quiet as mice, listening to Katitzi's story.

– Oh no, the elephants didn't hurt anybody. They were friends. Those people had taught the elephants to lift carefully. They had learned other tricks, too. But there were other animals: monkeys, giraffes, sea lions, zebras, horses and so much more! There were so many! You have no idea.

– I am not going to sit and listen to this! Ruttan interrupted. Miss Larsson has said that we have to sleep, so there. And besides, I don't believe that Katitzi has seen all of that: she just wants to make herself seem special, the way she always does.

Ruttan went back to her bed. The other girls looked after her. Britta said:

– Never mind what Ruttan says. We believe you. Please, Katitzi, tell us more! What else did they do at the circus?

– Well, all the animals did tricks. The sea lion bounced a ball on its nose. And the lions, they ...

– Lions! Gullan interrupted. The ones in Africa, they were in the tent? But what if they had jumped on people? They're dangerous!

– Oh, but these lions were in a cage. And a man was in there with them and had a whip so that the lions would obey him.

– Did he hit them with a whip? Britta asked.

– No, he never hit them: the circus people were kind to the animals. He swung the whip around in the air and the lions did tricks. They sat on stools or ran around in the cage in different ways.

– Weren't you ever afraid when you were at the circus? Gullan asked. Weren't you afraid that the lions would get out and bite you?

Katitzi looked around at the others, then said:

– No. I was never afraid. What was there to be afraid of? I knew the man who cared for the lions: he was a friend of my stepfather.

But as Katitzi uttered the words, she thought to herself: Of course I was afraid of the lions, very afraid. But if I tell them, they will think I'm a coward.

Gullan wondered:

– Were you at the circus many times?

– Was it expensive to look at the animals? Britta asked.

– No, it didn't cost us anything since we knew the people who ran the circus, and the clown and I were best friends.

– The clown, what's that? One of the girls asked.

– A clown is a person who gets dressed in a bunch of strange clothes and paints his face white, Katitzi said.

– Why does he do that? Gullan asked. Does he think it's fun?

– All the children think it's loads of fun. Then he plays with the children and has a little monkey who gets to come out and say hello to people in the audience, and he can play all kinds of instruments: a violin and a guitar and a trumpet, and lots of other instruments.

Katitzi fell silent for a moment while she considered what she was saying. Then she continued:

– Besides, I don't really remember everything he did. It was lots of stuff, and I hope the circus comes here some time so that you can see for yourselves.

– The circus can't come here, can it? Gullan said.

– Why not? Katitzi replied. A circus travels around the country, so it can come here.

– But do you think Miss Larsson will let us go if they come here with a circus? Britta was doubtful.

– Maybe, if we can go for free, Katitzi answered. But it hasn't come here yet. And we don't know if it will come.

Then Katitzi grew excited:

– But I forgot to tell you about the princess who walks on a wire.

Gullan's eyes grew large.

– What! There's a princess, too?

– Yes, and she walks on a wire.

It was not easy to get the others to understand this business of walking on a wire.

– What do you mean she walks on a wire? Britta asked. Is it the kind that Miss Kvist hangs the laundry on? That's a clothes line.

– Yes, Katitzi said, but it's not called a clothes line: it's much stronger. And they put it up high in the air. They hang it from one end of the tent to the other. And then she walks across it.

– But doesn't she fall down? Gullan asked.

– No, not that I ever saw. But Jack, the clown, told me that the princess had fallen down once.

– Did she die? Gullan asked. Was it high up?

– Yes, the wire was high up. But she didn't die. She didn't get the least bit hurt, because they had put a net underneath that she fell into.

– Tell us more! The girls entreated. Tell us about everything you've done. It's so exciting! Please, Katitzi!

But at that moment they heard light footsteps in the hallway, as if someone wanted to walk quietly and carefully so as to not be heard. The girls knew what that meant, rushed to their beds, and tried to look like they were sleeping.

Indeed, it was Miss Larsson who cracked the door.

– I thought I heard chatter in here!

– Yes, it was Katitzi! Ruttan said. She always talks, even though Miss Larsson said she's not supposed to.

Miss Larsson went up to Katitzi's bed, but Katitzi's eyes were closed as she pretended to be asleep.

– Who was talking, Miss Larsson asked sharply. Was it you, Katitzi?

Katitzi looked up, blinked and tried to look drowsy.

– Huh? No, it wasn't. Oh, I'm so tired. And then she turned her back to Miss Larsson.

– I heard someone talking in here, and Rut says it was Katitzi. Girls! Was it Katitzi?

All the girls answered in unison:

– NO!

And one of the girls said:

– Maybe it was Ruttan talking in her sleep.

– It was not! I never talk in my sleep, Ruttan said.

– How can you know? Gullan teased. You're not awake when you're sleeping, are you?

– I know if it's me or Katitzi talking, and I heard everything she was talking about, so there.

Miss Larsson went up to Ruttan's bed.

– What did you hear, Rut?

– She was talking about lions and princesses and all kinds of things, and she said there was a circus that would come here and that we could go to it for free because Katitzi knew someone named the clown.

Miss Larsson fell quiet for a minute, and the room was silent. Then she said, in a very stern voice:

– I don't want to hear any more nonsense. This room is to be quiet. I am leaving now, and if I hear another word you will all have to go to bed an hour earlier tomorrow.

The strict Miss Larsson closed the door behind her.

– *Tattletale! Tattletale, cry baby, tattletale!* the children all whispered at Ruttan as loudly as they dared.

– That you always have to tell on us, Gullan said.

– You have to be quiet, Miss Larsson said so, Ruttan replied.

– Good night, everyone! Katitzi said. I'll tell you more about the circus another time. But then we'll talk outside so that no one can disturb us, and no one can tell.

That last bit was for Ruttan, and everybody knew it, including Ruttan.

The Tattletale

One evening, when all the children had eaten supper and washed up and brushed their teeth and done all the things that need to be done when the day comes to an end, Miss Kvist came to Katitzi's bed.

– Katitzi, put on your robe and come to my room. I would like to talk to you for a bit.

– Is it something exciting? Katitzi wondered.

– You'll find out. But maybe you're too tired?

– Oh, no! I love chatting in the evenings. But what will Miss Larsson say? She will get so angry if we aren't asleep on time.

– Don't worry about Miss Larsson, Miss Kvist responded. She has promised that you can stay up a bit later tonight.

– I'll hurry! Katitzi said and jumped out of bed.

And the girls in room five had not fallen asleep at all: they were almost as curious as Katitzi to know what Miss Kvist wanted to talk to her about.

– What do you think, Gullan? Britta asked as the door closed behind Katitzi. What is this all about?

– She's probably going to get a scolding for coming to dinner late, Ruttan said.

– You always think the worst is going to happen, Britta replied. Gullan, do you think Katitzi is getting a scolding?

– You're all stupid! You know that Miss Kvist never scolds. She is the kindest person at the orphanage: she defends each and every one of us.

– She defends me too? Ruttan asked and looked a little bit surprised.

– Of course she does. I said each and every one of us, Gullan responded.

Gullan continued:

– Britta, do you think it's time for Katitzi to go home?

Britta nodded thoughtfully.

– I thought Katitzi looked a bit sad today. She's been so quiet.

– I know that Katitzi is going home, Ruttan suddenly announced. I heard Miss Larsson talking about it yesterday.

– Why haven't you said anything to us? Gullan asked.

Ruttan tossed her head and looked at them with a smug expression.

– Because I didn't want to. You never tell me anything.

– But I don't want Katitzi to go home, Gullan said.

Ruttan looked at the other girls with an almost cruel grin.

– I know something else that you don't know.

– What? Tell us! Please, Ruttan, tell us! the girls yelled.

– I will not.

– You can have my pocket mirror! one of the girls said.

– You promise?

– Yes, yes! But hurry. You can have my pocket mirror, I promise.

– *Your precious Katitzi is a GYPSY!*

– What did you say? What is she?

– A gypsy. I said that she's a gypsy.

The room remained quiet for a long time, as if no one wanted or was able to say a word. Then Gullan asked again, but she sounded very hesitant:

– What is that? Gypsy ...? What is a gypsy? Ruttan ...!

– I'll tell you what Miss Larsson said to Miss Kvist last night.

All the girls were now listening to Ruttan. For the first time,

Ruttan was the focal point of the room, and she savored the moment. She was now more smug than ever.

– Well, she said to the other girls, yesterday in the laundry room, I heard Miss Larsson say to Miss Kvist that it would be good to get rid of Katitzi.

– Why did she say that? Britta asked.

– Listen! And don't interrupt me, Ruttan barked. Miss Larsson said: Those gypsies, you can never make them do things like everybody else. They don't want to follow the same rules that apply to the rest of us.

– But did Miss Larsson say what gypsy, or whatever it's called, is? Gullan asked.

– Miss Kvist wondered the same thing. But Miss Larsson didn't really seem to know. She thought that gypsies come from Hungary, and that's far away.

– So is Katizi from abroad, then? Britta wondered, looking very impressed.

Ruttan was starting to grow irritated.

– How should I know! Be quiet so that I can continue to tell you what Miss Larsson said. She said that Katitzi's father did busking and that his family lived in a tent.

The girls didn't understand a thing.

– What's busking? Gullan wondered.

– You keep interrupting me. How should I know what busking is? But that's what Miss Larsson said and it doesn't sound nice, because Miss Larsson looked very angry when she said it.

– It's when you play, Gullan speculated. But that's not something you need to get angry about, is it?

– Then Miss Larsson said that it was best for Katitzi to go home to her own again, because that's where she belonged.

– But what did Miss Kvist say? Gullan asked. Didn't she say anything?

– She did. She said that you have to think of the children. And that they, the gypsies, couldn't help it if they lived in tents. And that you have to be kind to them, I think she said that too.

– Shouldn't you, though? Gullan asked. Shouldn't you be kind to everyone?

– Yes, maybe you should, Ruttan said. But Miss Larsson said that gypsies aren't like us and that they don't understand when you are nice to them. And then she said they steal hens.

– What? Gullan said. I don't believe she said that!

– She did too. And Miss Kvist cried. So there.

– But ... I don't understand a thing. Katitzi doesn't steal any hens! Gullan exclaimed. Where would she find them? There aren't any hens here. Why can't Katitzi stay here?

– Miss Larsson said that Katitzi is going home in a few days, and that Miss Kvist, who seems to have a good hand with her, should prepare Katitzi for the fact that she has to go home now. So now you know! Ruttan said.

For the third time that evening, the room fell silent. Very silent. And Gullan thought: Poor Katitzi! I know she doesn't want to leave the orphanage.

Finally, Britta said:

– I think it's going to be so sad if Katitzi leaves. And then I don't care what they call her. Gypsy or busking ...!

– She's still a gypsy, Ruttan said.

– And you still don't even know what that is, Britta scoffed.

– Well I don't want to be with her anymore, Ruttan continued.

– But her blue dress, you'd love to have that! We've noticed that all this time you've been jealous of Katitzi. And I think you're mean who wants Katitzi to leave now. Gullan was sobbing.

– Don't cry, Britta said. It will work out. And Katitzi will probably tell us everything they talk about, she and Miss Kvist. I think that Katitzi will get to stay here, if she wants to. Let's get into bed. Katitzi will be here soon, and then we'll know.

– She's still a gypsy, Ruttan said, since she always had to have the last word.

Katitzi at Aunt Gärda's

– Come here, Katitzi. Have a seat on the bed. You can crawl in under the blanket if you want. But don't forget to take off your slippers.

Katitzi wondered what this was all about. She thought Miss Kvist was the kindest adult she had ever met.

– Do you want some juice and cinnamon buns? Miss Kvist wondered, or are you perhaps too full after dinner?

– Oh no! I'm never too full for juice and cinnamon buns. I can eat those anytime, Katitzi said. Both she and Miss Kvist laughed.

– But what about my teeth? I've brushed them, and then you shouldn't eat anything before you go to bed, should you?

Miss Kvist winked and smiled.

– Can't you brush them one more time? Now eat. But promise me that you will brush your teeth afterward. You know what happens when food gets stuck and wears away your enamel: you get cavities in your pretty teeth. And you don't want that, do you?

– Nope, I don't. Having cavities really hurts. And broken teeth are ugly.

– Right, so now you should go ahead and eat and drink.

Then Miss Kvist grew solemn.

– Katitzi, have you thought about the fact that ten days have gone by since your father was here to get you?

– Yes, I know. And Miss Kvist! Do you know anything about my father? Please, Miss Kvist, tell me a little bit about my father.

– I can try, Katitzi, but I don't know much.

– But tell me anyway, Miss Kvist!

Katitzi had often thought about her family, but she could not remember anything about her parents. The circus mother had only told her that when Katitzi was little, her mother died, but she was so little then that she could not remember it.

Miss Kvist asked:

– Do you remember anything from before you came to the circus people?

– No. Well, yes. I remember something strange. It must have been a long time ago. I remember a big barrel with a fire inside it. And I remember being tied up.

– What you remember about the barrel, that there was a fire in it, that must have been your wood stove.

– But Miss Kvist, why was I tied up. Does Miss Kvist think that ...?

– Katitzi, I think you should call me Aunt Gärda, since it will make it easier for us to talk.

– Thank you, Katitzi said, and tried to curtsy from where she was sitting in the bed.

– I think, you know, Katitzi, that you were tied up so that you wouldn't get burned on the wood stove. Maybe you lived in such

close quarters that you were always bumping into each other. Maybe the others bumped you by accident and they tied you with a rope so that you wouldn't get too close to the stove.

– But how awful! Why didn't we have a proper stove, like downstairs in the kitchen here? Or like with the circus people.

– You know, don't you, Katitzi, that there are many people on earth, and not all people live the same kind of lives.

Unfortunately, Miss Kvist thought to herself. Aloud, she said:

– There are people who are worse off than others.

– But, what does that have to do with my father?

– Katitzi, your father lives many kilometers away, and he has several children who are your siblings, but I do not know how many.

Katitzi brightened.

– I have siblings?

– Yes, you do. And you know, I know a lady who lives near your family, and she writes to me sometimes. She knows that you live here, and she knows your father and says that he is very kind.

– But Aunt Gärda! How big are my siblings, I mean, how old are they?

– Well, I really don't know, dear. But that lady has told me about a girl who might be twelve, thirteen years old. That girl came to the lady and borrowed a wash tub to do laundry. And the lady asked what her name was and found out that her name is Rosa and that she has several little siblings that she watches. Your sister also said that you are at an orphanage and that you are going to come home soon and that everyone misses you terribly.

Katitzi was quiet. She struggled to find words.

– Did she say ... that? That they missed me? Do they remember me?

– Of course. You understand, don't you, that Rosa, who is six years older than you, remembers you very well.

Katitzi had still more to consider.

– Why was she going to borrow a wash tub? Don't they have a laundry room the way we do here?

– I hardly think they have a laundry room, Aunt Gärda said. But they have probably gotten to borrow a laundry room, and it was the tub to wash the clothes in that your sister borrowed from my friend.

Katitzi now had a lot to think over, and she was not sure that what she had heard made her very happy.

– If they don't have a real stove or laundry room, not even a washtub, they must be awfully poor.

Miss Kvist was also quiet for a while. She had thought about this a great deal, and understood that it would be difficult to tell Katitzi. But she said:

– I don't think they are suffering. And you know, I think you will enjoy it a great deal over there, together with your siblings. You will like them, and soon you will have forgotten all of us.

But Katitzi did not agree at all.

– *No!* I will *never* forget Gullan and Pelle! And there is no way that I will forget Miss ... no, I mean Aunt Gärda, either. I will never forget those who have been kind.

– That sounds good, Katitzi. And perhaps we can see each other sometime in the future, and then we will see how well you remember us.

– I'm only going to forget the people who have been mean to me, Katitzi said. Then she looked at Miss Kvist and asked:

– Aunt Gärda, can my father help it that he has black hair and such a large beard?

– Not at all. And there are many men who have beards, you should know. My father also had a beard, and he was dark like your father, but my mother was fair. But I became red-haired, and I still remember how the children teased me at school. They called me the fox, and the torch.

– What did Aunt Gärda do then? Did you punch them? That's what I did when they called me blackie.

– No, Katitzi. I didn't hit them or say anything, because, you know, my mother was a teacher and so I had to mind myself more

than the other children. But there were many times when I would have liked to punch them.

– But you didn't, Aunt Gärda! I wouldn't have cared if my mother was a teacher: I would have given it to them so they keeled over.

– But Katitzi, is fighting really a good idea?

– It is, if someone teases you. Otherwise they just keep doing it.

– Katitzi, shouldn't you talk to the person teasing you? Try to explain?

– Yes, sometimes you can talk, and they will understand. But not everyone understands talking: they understand it better if they get punched between the eyes.

Miss Kvist looked carefully at Katitzi, but did not say anything.

– Does Aunt Gärda remember when I first came here? Ruttan teased me about all kinds of things.

– Ruttan? You mean Rut, don't you, Aunt Gärda corrected.

– Yes, but we always call her Ruttan, because she's so mean.

– But then you're teasing her! Don't you feel bad for Rut when you tease her? What if she is as sad about being teased as you are when you are teased? What would happen if you called her by her real name? Maybe then she wouldn't be as mean as you think she is. Have you ever tried that? Besides, what was it Rut teased you about, do you remember?

– Of course. And she teases me now too, but it doesn't matter as much anymore because I have my best friends who help me.

– But what was it she teased you about?

– That I'm dark. And my hair was long. And she said I had strange clothes. But my clothes weren't strange: they were beautiful. They had ruffles and one was blue and was the most beautiful dress I've ever had. My circus mother made it for me one time when we were going to a party.

– Yes, I also think that your blue dress is very beautiful.

– But Ruttan didn't think so ... I mean Rut. Because she said I looked like a scarecrow when I wore it. The kind we have in our strawberry patch.

– You don't look like a scarecrow in that pretty dress. But Katitzi, what did you say to Rut then?

– What I said? I don't know. I didn't say anything. I pulled off her headband and stomped on it so that it disappeared into the mud.

– Katitzi. That was not very nice of you.

Katitzi started to look uncertain. She shouldn't have talked about this. You probably shouldn't tell adults everything. They don't really understand. Aloud, she said:

– Aunt Gärda! Rut was not nice to me, either. And she was the one who started it.

– That's true. But you know, I think that she was very jealous of you and your pretty dress. She probably didn't have a dress like that of her own. It isn't easy to be jealous, either.

– Pelle and Gullan say that Ruttan is always jealous of me.

Aunt Gärda nodded. She fell quiet for a bit, then she said:

– I have an idea, Katitzi.

– What's an idea?

– Well, you know, I've thought about something. This is what I'm thinking: let's have a little party the day before you leave. You can lend your beautiful dress to Rut, and then I think she will be very happy.

Katitzi did not fully grasp the significance of the party.

– We're going to have a party because I'm leaving? Is it that fun to be rid of me? She looked a little bit hurt, but not entirely sad: there was going to be a party in her honor!

Aunt Gärda thought for a minute.

– You know, Katitzi, I just want to make sure that the other children get to have some fun, too. They will be so sad that you are leaving them. That's why we're going to have a little party.

– Then I understand. Will it make Aunt Gärda happy if Rut gets to borrow the dress?

– Yes, very happy.

– She can definitely borrow it, as long as it makes Aunt Gärda happy.

Now Aunt Gärda was smiling.

– Then I think it is time to really say goodnight. And you'll tiptoe so that you don't wake the other children?

Katitzi snuck quietly back into the children's room, but she didn't forget to brush her teeth. When she came back to her bed, only Gullan was still awake. She called out quietly:

– *Katitzi*! What were you talking about? Did Miss Kvist tell you that you are a gypsy?

– No. What's that? We talked about my trip home and about the party. And we talked about Rut borrowing my blue dress.

Gullan fell quiet. She didn't understand a thing, except that Katitzi was going to go home. But this business about the party and Ruttan borrowing Katitzi's blue dress, that didn't make any sense to her. Ruttan, who had been so mean and said that she didn't want to be near Katitzi because she was a gypsy. Besides, what a strange word that was, she thought to herself. Gypsy, gypsy. She tasted the word a few times, but then she pulled the blankets over her head and fell asleep.

The Fight

– Gypsy! GYPSY!

All the girls looked around in a daze. What was the commotion? That noise! Ruttan was standing in the middle of the room shouting from the top of her lungs.

– What is going on? Gullan asked.

– Are you crazy? Britta said.

– *Katitzi is a gypsy! Katitzi is a gypsy!* Ruttan howled. Katitzi looked up from under her blanket.

– I'm a what?

– You're a gypsy!

– I am? What is that? Katitzi asked.

– You're not like us! You're not like us! Miss Larsson said so, so there.

– Miss Larsson has said I'm not like you? Katitzi said. Her lower lip started to quiver.

– Yes! She said that gypsies aren't like us, and you're a gypsy!

At that moment, Miss Kvist was at the door.

– You all better hurry and wash up, breakfast is in ten minutes.

Katitzi had started to cry and Gullan tried to console her.

– What is it, Katitzi? Miss Kvist asked.

– Nothing, Katitzi sobbed.

– Well, something must be wrong. You're not crying for nothing, are you?

Gullan looked at Miss Kvist.

– Ruttan is so mean to Katitzi. She said that she's a gypsy, and that Katitzi is not like the rest of us.

– But Rut! What kind of nonsense is this? Where did you get those ideas, that Katitzi isn't like the rest of us?

– But that's what Miss Larsson said to Miss Kvist the other day in the laundry room.

– Have you been eavesdropping?

– I wasn't! But I did hear Miss Larsson say that Katitzi is a gypsy and that gypsies are not like other people.

– You've got it all wrong, Miss Kvist said. But to herself, she thought, Oh, how we adults cause trouble. Miss Larsson really shouldn't talk like that.

– Miss Kvist, am I a gypsy? Katitzi sobbed.

– Yes, you are, Miss Kvist replied. But you would be called a gypsy girl.

– See! I told you so! Ruttan shouted triumphantly, and looked around. I'm right: Katitzi is a gypsy!

– That's enough! Miss Kvist said. Rut! You have to stop teasing Katitzi. I'm tired of all this nonsense. Katizi is just like the rest of you, neither better nor worse. And now get going and wash up, and don't be late for breakfast!

The girls had never seen Miss Kvist so upset. They rushed out to the washroom, except Katitzi, who sat up and thought about what gypsies were.

– Hurry up, Katitzi, Gullan shouted. You don't want to be late, do you?

– I'm coming. You don't have to wait for me. I want to think for a minute.

But after a while Katitzi went to wash up, and eventually everyone gathered at the breakfast table. Miss Larsson said grace: she seemed to be in unusually good spirits today.

– This afternoon we will have a special visitor, she said. Preacher Pettersson is coming to conduct today's service. Won't that be fun?

Pelle whispered to Gullan:

– I don't think it's very fun when Pettersson comes here. Do you?

– Not really. But we get to sing, and that's always nice.

– I think Pettersson is stuck-up. He always shows off in front of Miss Larsson, Pelle said.

– And what about Miss Larsson! Gullan responded. She shows off in front of him too!

Miss Larsson had the eyes of a hawk.

– What are you whispering about, Pelle and Gullan? She barked.

– Nothing, both responded in unison.

Miss Kvist's thoughts were elsewhere. She wondered if perhaps they couldn't ask Preacher Pettersson for advice. Maybe he knew something about gypsies. The entire time, Miss Kvist had been thinking about how Rut had teased Katitzi about being a gypsy, and she thought that no one really knew anything for certain about those people they called gypsies. I'm going to try to talk to Preacher Pettersson: he must have met many gypsies and can tell us why that is what they are called, Miss Kvist thought to herself.

Ruttan came running up, out of breath, to the girls who were shelling peas for a meal.

– Where's Katitzi? Where's that gypsy brat?

– What's with you? Katitzi is somewhere nearby. What do you want with her? And why are you shouting like that? Gullan said.

– She took my pocket mirror! She's a thief! She thieved it!

– You're crazy! Katitzi hasn't taken a thing from you.

– How do you know, if I might ask? Maybe you're the one who took it. I'm going to Miss Larsson right away, and I'm going to tell her that either you or Katitzi took my mirror. But I think it's Katitzi, because she's a gypsy.

– You're not going to think anything at all, because none of us have nicked your mirror. But let's ask Katitzi, because there she is.

– Katitzi! Did you take Ruttan's mirror? Britta asked.

– Ruttan! How can you say that I took your mirror? Did you see me take it?

– No, I didn't, but you were the only one left in the room when the rest of us went to wash up. And when I came back, it was gone, Ruttan said.

– Why would I take your mirror?

– Because you're a gypsy, of course! All gypsies steal things, everyone knows that.

Katitzi started to cry.

– That's the dumbest thing I've heard! I wish I was dead, Katitzi sobbed.

– Did you take the mirror? Ruttan asked. I won't tell on you to Miss Larsson if you give it back.

– But I didn't take your stupid mirror. I don't want your mirror. Do you hear me! I haven't taken it!

– You have taken it! You're a thief! Damn gypsy brat! Ruttan shouted.

Now Katitzi was furious.

– I am not a thief! I am not a gypsy! Gullan, Britta! Tell her I'm not a thief.

Katitzi rushed at Ruttan and pulled at her hair.

The girls watched and tried to stop the fight. From a distance, they could see Miss Larsson approaching. This was not going to end well.

– Calm down! Calm down! Stop! Can't you see that Miss Larsson is coming.

Someone said:

– I know! Let's all go upstairs to our room and look for Ruttan's mirror. You'll be sorry, Ruttan, if we find it.

All the girls pulled off their aprons and marched up towards the house, just as Miss Larsson appeared.

– Girls, where do you think you're going? You should be shelling peas.

– We just have to pee, Gullan said.

– All of you? Naturally, Miss Larsson didn't believe them, but she was in an exceptionally good mood since Preacher Pettersson was on his way.

– All right, but you have no more than ten minutes.

Upstairs in the girls' room there was frantic activity. Everyone searched for Ruttan's mirror, everywhere. Well, not everyone was looking: Ruttan stood at the center of the room with a scornful look on her face.

– I don't think you'll find a mirror!

At that moment, Britta called out.

– Ouch! I cut myself, I'm bleeding. Here's your mirror! Under your own bed. It serves you right that it's cracked. That's what you get for calling Katitzi a thief.

– But how can it have fallen behind my bed? Ruttan asked.

– Well, it walked over there on its own, of course. Gullan was both sarcastic and angry. Then she grew serious.

– You've always been dumb. It fell down, of course, behind the bed. Don't you understand that?

– Ruttan! You know what you have to do now? Britta asked.

– No. Ruttan looked uncertain.

– You're going to apologize to Katitzi, of course. But you should know that: we shouldn't have to tell you.

– She doesn't have to apologize to me at all. I'm going to punch her in the face.

Suddenly they could all hear Miss Larsson's shrill voice from the courtyard downstairs.

– Girls! GIRLS! You were going to come down after ten minutes! And now it's been twelve! Hurry! Make it snappy, otherwise you can't listen to Preacher Pettersson this afternoon.

– We better hurry, Gullan said. So that she doesn't sulk.

– Hey, Katitzi, that party, when is it happening? Britta asked.

– The same day I go home, of course.

– Aren't you sad anymore about leaving? Gullan asked.

– No. I think it will be fun to meet my siblings, and they miss me! I have a big sister named Rosa, Katitzi said, looking proud.

The Preacher

In the afternoon, after they had all eaten, the children were instructed to go wash up and change clothes. They were to wear the best clothes they had: their Sunday finest even though it was the middle of the week. The teachers had set a long table out in the garden, and on it stood cinnamon buns and cookies of all kinds. And large pitchers of juice.

And here was Miss Larsson. But my, she looked strange. She usually wore her hair in a bun at the base of her neck, but now she wore it in curls and looked exactly like the head of a floor mop.

The children giggled.

– Gullan, look at Miss Larsson. How strange she looks! Britta said.

– Ladies are ridiculous, Pelle said. Making fools of themselves just because Preacher Pettersson is coming to visit.

– Quiet! She could hear you, Katitzi warned. But look at Miss Kvist, she looks the same. She's so pretty. Have you seen what a nice dress she's wearing? It's the one she wore at midsummer.

Miss Larsson anxiously eyed the clock. She rushed around the table to make sure everything was just so. Moved the trays of cookies here and there.

Then they heard a car down the road. Miss Larsson straightened her back and when the car entered the courtyard she greeted it with her nicest smile.

– Welcome! Welcome, pastor, she said.

– Thank you kindly! Oh, how nice it is here. Miss Larsson, you really have a knack for making it cozy for your little ones!

Pelle thought to himself:

– Why does she call him pastor? Is that fancier than preacher? And why do we have to sit like this? And in these awful clothes. It felt like wearing armor. And all the other boys looked just as uncomfortable. And you couldn't speak unless spoken to, but they never did. They just talked to each other.

– Pssst! Leffe, one of the boys from Pelle's room, hissed. Can't we make a getaway?

But at that moment, Miss Larsson glared at Leffe, and he fell silent.

– *Whoops*, Katitzi suddenly exclaimed. I spilled juice, oh no! I'll go get a rag and wipe off the table right away.

– KATITZI! You've spilled on your dress as well. Immediately go to your room and change! Miss Larsson told her.

She turned to Preacher Pettersson and said:

– Oh, the trouble I've had with that girl. And she lowered her voice so that the children could not hear:

– I think it's Katitzi's heritage that makes it impossible for her to behave properly.

– What does Miss Larsson mean by heritage?

– Well, the girl is from a gypsy family. So that must be why she is so difficult.

At that moment, Miss Kvist entered the conversation. This was what she had been waiting for: to hear what the preacher knew about gypsies.

– Really. Katitzi is a gypsy girl. That's interesting. What are gypsies? Does Preacher Pettersson know anything about gypsies? You've travelled a great deal, maybe you have met some of them?

– Oh, actually I have. They travel, just like I do.

– Have you met them? Have you talked to them? Miss Kvist continued.

Miss Larsson pursed her lips and thought, Gärda is always monopolizing whoever comes to visit.

But Preacher Pettersson started to tell them:

– I remember once, a long time ago, it must have been at least thirty years ago, when I first met gypsies. It was down south in Skåne county. I was young and had just become a preacher. I remember it so well, as if it was yesterday. A group of around thirty people came to our meeting. They had heard that we would have music, and they were very musically gifted.

– But didn't they come to hear the word of God? Miss Larsson asked.

Pettersson considered her question for a moment, then replied:

– No, little Miss Larsson. I don't think so. I think it was the music that attracted them.

The children around the table had heard that Miss Larsson and Preacher Pettersson were talking about gypsies and became very quiet. And Pelle could not keep quiet:

– What does musically gifted mean?

– PELLE! How many times have I told you that you should not speak unless spoken to! Miss Larsson said and looked very stern.

– But of course the children should ask, Pettersson said. We can make an exception today? Right, Miss Larsson?

Miss Larsson couldn't very well say no.

– What were you saying? Right, you wondered what musically gifted means. You see, it is when you have an easy time playing different kinds of instruments. But the gypsies prefer playing the violin, I think. I don't believe I've ever met a gypsy who couldn't play the violin.

– Can all gypsies play instruments? Gullan asked.

– You know what, I believe so.

– Why? Britta wondered. We can't.

– You know, I think that they have music in their blood. They're born with it, you might say.

That was the dumbest thing I've ever heard, Pelle thought to himself. In their blood? No, we shouldn't trust that Pettersson, even if he is a preacher or whatever he is.

– How do those gypsies live? Ruttan suddenly asked.

– They live across the entire country. In tents and trailers.

– Why? Leffe was interested. He liked tents. Why don't they live like other people?

– Gypsies don't want to live in houses. They like their freedom and they want to travel everywhere, see everything. They don't like being cooped-up in houses.

– But if they live in tents, aren't they cold? One of the girls asked.

– Oh, no. They have thick blankets that they wear. And they are more used to the cold than other people are.

– Katitzi is always cold. She complains even though it's summer. But maybe she's not a real gypsy? Britta said.

Preacher Pettersson mused on what Britta had said, then replied:

– Perhaps that's because Katitzi has been with us regular people for so long that she is starting to become like us.

Well, I don't know about that, Miss Larsson thought to herself. She's certainly not like one of us. Aloud, she said:

– But, tell me, preacher, how do those people make a living?

– Well, above all, they are musicians. And coppersmiths and tinners.

– Tinners? What's that? Pelled asked.

– You've never heard of tinners? They go around to different farms and ask if there are copper pots and pans. The kind you have here, for example. You must have seen them in the kitchen. They care for them so that they become beautiful and shiny.

– Miss Larsson, have we ever given our pots to a gypsy?

– No, we haven't. We have an old man nearby who does work like that.

– But they must have other jobs? Miss Kvist wondered, having listened quietly for a long time.

– Not that I know. But that might be because they cannot read or write. So it may not be so easy to find other kinds of work. They probably have to be grateful that they can play music and do tinning.

– They can't read or write? Don't they go to school? Once again, it was Ruttan.

– They don't want to go to school, my friend, Preacher Pettersson said. And they don't think it's important to be able to read or write. They are nature's children.

Pelle was still thinking to himself. This seems crazy. I don't believe a word he's saying. He's probably never met a gypsy. But aloud, Pelle said:

– Katitzi, don't you want to go to school?

– Of course I do! Don't be stupid, everyone wants to be able to read. I want to read stories.

– Have you asked the gypsies if they want to go to school, Mister Pettersson? Pelle wondered.

– No, my friend. You don't ask about that kind of thing. But I've read somewhere that they don't want to. Then he smiled widely and said:

– But they are very hospitable and kind.

– Are they kinder than other people? Pelle asked. Why? Pelle was still suspicious of Pettersson.

Miss Kvist, who had mostly sat in silence, thought that it may have been foolish to ask Preacher Pettersson about gypsies, since he did not seem to know very much, either. So she remained silent.

– Mister Preacher! Where do gypsies come from? Are they Swedes?

– I don't really know where they come from? But it's supposed to be Hungary.

– Katitzi, speak that kind of language! Leffe asked.

– I can't talk like that! Katitzi replied.

– You can't? Ruttan said.

– Why would I? You can't!

– Yes, but I'm not from that kind of country, Ruttan said.

– Neither am I, said Katitzi.

Miss Larsson thought there had been enough gypsy talk.

– Now, children, I think you can run off and play!

– But wasn't Preacher Pettersson going to preach a little bit for the children? Miss Kvist wondered.

– I think it's enough for today if we all together sing the beautiful psalm "Jesus Loves the Little Children."

The children stood and broke into song:

Jesus loves the little children
All the children of the world
Black and yellow, red and white
They're all precious in His sight ...

The song had barely ended before all the children rushed up to their rooms to change from their Sunday clothes into something they could play in. And then over to the farm, where they knew that a cow was soon to give birth to a baby calf. They had been given permission to go look, as long as they didn't get into too much trouble.

Miss Larsson followed Preacher Pettersson to the car. There was something that still bothered her: she felt that Miss Kvist had taken up too much of Pettersson's attention, far too much. And it could not be a good thing for so many children to listen.

– Well, thank you, then. For this time, said Preacher Pettersson. It has really been a very interesting visit. And to see how interested the children are in everything! And Miss Kvist, it would be delightful if the parish could see more of Miss Kvist some time. You are so welcome to visit us!

Miss Kvist smiled and said:

– That will be very nice, when I have the time. But right now I have so very much to do.

– So it is. Well, farewell, then, and welcome back another time, Miss Larsson said.

The Farewell Party

Miss Kvist had gotten up early, as early as five o'clock, to prepare for the party. Today, Katitzi was going home. Miss Kvist had spoken with Miss Larsson about the fact that the children would not have to do any chores at the orphanage that day.

Miss Kvist had a good friend who owned the toy store in town, and through him she had been able to buy toys at a discount. She had also bought fruit, oranges as well as apples. And, on her own, she had stayed up into the wee hours of the night, making caramels — toffee as well as chocolate — with lots of almonds, and now she stood wrapping beautiful paper around each and every caramel.

There were thirty bags, and in each bag, Miss Kvist placed an apple, an orange, and six caramels, three of each kind. Cinnamon buns and cookies were left from Pettersson's visit, too. But, just in case, Miss Kvist had baked three scrumptious strawberry cakes. She had also built a few wooden benches and hung sheets in front of them. Lastly, she had put together some fishing rods, so the children could fish for toys from behind the sheet, a popular party game.

Up in Katitzi's room, the girls were slowly waking up, since it was seven o'clock.

– Wake up, everybody, Katitzi said. I'm going home today.

Gullan rubbed her eyes, yawned, and said:

– You seem cheery, before you were so sad about leaving.

– Let's not think about it anymore, we're having a party today, aren't we? By the way, Ruttan, do you want to borrow my blue dress?

– Aren't you still mad at me, for calling you a thief and a gypsy brat?

– Not at all, I'm not the least bit angry now. Miss Kvist has said that you shouldn't hold a grudge. But what's it going to be, Ruttan, do you want to borrow the dress or not, yes or no?

– How nice of you, Katitzi, of course I will. Can I borrow your headband too?

– Sure, if you're going to be dressed up, you should do it right.

Gullan thought to herself: Katitzi doesn't quite understand. She thinks Ruttan is good somewhere deep inside, even though she isn't.

– Gullan, come help me so that we can make Ruttan look really nice. If you comb her hair, I'll find the patent leather shoes my pretend mother at the circus gave to me.

Katitzi had put on the pink dress, the one with ruffles, so that she almost looked like the girl who walked the high wire.

– Hurry, children, the party is about to begin! Miss Kvist called, and she didn't need to call more than once: all the children hurried down to the courtyard. Everyone looked so nice and scrubbed clean, even the boys who used to cheat had washed their faces so that they gleamed pink and their hair lay flat as if licked by a cat.

– Pelle, you look so strange, said Katitzi. What did you do?

– Hey, can't you see that I washed up? Don't be like that. But wait, what happened with Ruttan, she looks so nice: where did she get that dress?

– She got to borrow it from me. But Pelle, can't you try to be a little bit nice to Ruttan once I'm gone? Miss Kvist has told me that Ruttan doesn't have a mother or a father and that's why she's jealous sometimes.

– I am not going to be nice because you say so. If she is nice to me, I will be nice to her. It's as simple as that, Katitzi.

– You're all welcome to go fishing now, Miss Kvist called.

The children rushed to the fishing game. One at a time, they were handed a fishing rod and tossed the fishing line over the sheet that Miss Kvist had hung up. She stood behind the sheet, and each time the line flew across the top edge, she attached a toy.

Then everyone sat down at the long table and ate strawberry cake, cookies, and cinnamon buns, accompanied by lots of juice.

And here was Miss Larsson, dressed in the same clothes that she wore the day Preacher Pettersson came to visit. She cleared her throat. Maybe she's going to give a speech, Pelle thought, and he was right, even though Miss Larsson didn't quite know how to begin.

She cleared her throat again.

– Well, my little friends, today little Katitzi is going home to her own.

– Did you hear? Pelle said to Gullan. She said, little Katitzi, what's next?

– Well, as I said, now little Katitzi is going to go home and I must say that it won't be the same without her.

– Wow! Pelle whispered. She's got a lot of nerve the way she has treated Katitzi.

– Did Pelle say something? I thought I heard something about a cow, Miss Larsson said.

– I said to Lasse that the cows must be unhappy, because it's so warm today.

– We aren't going to think about cows right now, but about Katitzi. Like I was saying, many times it has been difficult, since Katitzi can't be on time, but otherwise she has always been kind and helpful.

The old lady must have gotten sun stroke, Pelle thought to himself.

At that moment, Preacher Pettersson came walking toward the table and Miss Larsson lost her train of thought and her cheeks turned bright red.

I wonder why she's blushing, Pelle thought. Is it because she's pretending that she likes Katitzi?

– Hello everyone, what a nice time you're having. Miss Larsson really knows how to care for her little ones, Pettersson said.

Miss Larsson turned an even brighter red, so that she now looked like Santa Claus.

– It's not Miss Larsson who has made it so nice, it's Miss Kvist. She baked the strawberry cakes too, Gullan said.

– I see. Well, the main thing is that you are having a good time. I've actually come to give little Katitzi a going-away present.

There's an awful lot of littling of Katitzi today, Pelle thought.

– Oh, how lovely of the preacher to think of little Katitzi, Miss Larsson said.

– Lasse, if they say *little* Katitzi one more time I'm going to scream, Pelle said.

– Did you say something, Pelle? Miss Larsson asked.

– Oh no, I never speak unless spoken to, Pelle said.

– Well, little Katitzi, you should take very good care of this gift. You understand, this is a Bible and it will give you great comfort time and again. You will probably need a lot of comfort in your life, I'm afraid.

– Now say your nicest thank-you, Katitzi, Miss Larsson said.

– Thank you very much, Katitzi said. What does it say?

– When you learn how to read you will understand everything written in it. It's about God and Jesus and then this book says that we should be kind to each other. Katitzi, you must know the Ten Commandments?

– No, I don't know what commandments are. Do you know them?

– Yes, I do. You see, they are the ten rules that God wants us to follow, otherwise he will be sad. But you will probably learn what they are when you can read, I hope.

– You may be right, as long as they're good, of course, Katitzi said.

– Katitzi! You can't say "you" to Preacher Pettersson.

Miss Larsson sounded completely shocked.

Really, not *little* Katitzi? That was odd, Pelle thought.

At that moment, a car could be heard. It was Katitzi's father driving up the road. Everyone rushed up to the squat little red car.

– Are you leaving now? Gullan said.

– Yes, I think so, doesn't it seem like it? Miss Kvist had gone upstairs to fetch Katitzi's little bag that was packed and ready. A large doll that Katitzi had brought with her when she came to the orphanage had been placed in a paper bag. But Katitzi had not been permitted to play with the doll while she had been at the orphanage: it was too nice to play with, Miss Larsson had said.

– Katitzi, Katitzi, wait, I have to go upstairs and change, I'll be right down, Ruttan said.

– Ruttan, don't worry about it: you can keep the dress, and the shoes too, I have other clothes that are just as nice.

– You're crazy: are you going to give away this beautiful dress? You must be kidding?

– I'm not. You go ahead and keep it, wear it well.

– Oh my god, you're the nicest person in the world, Ruttan said.

– Rut, do not use the Lord's name in vain, Miss Larsson reminded her.

– Oh, I'm so very sorry, but I was so happy, Ruttan said and threw herself into Katitzi's arms.

Miss Kvist remained quiet. She was glad that Katitzi was kind to Rut, but she was saddened by the thought of Katitzi leaving.

Katitzi's father got out of the car: he no longer looked as tall, for whatever reason.

– What is it with Katitzi's father? I can't recognize him, Gullan said.

– Don't you have eyes to see with, can't you see that he shaved off his beard?

– You're right, that's why he looks smaller.

– You're nuts, he didn't get smaller just because he shaved off his beard. You girls are crazy, Pelle said.

– Well, I think he does, Gullan said.

– Are you ready now? Katitzi's father asked. We have to go home.

– Soon, father. I just have to say goodbye to everyone.

Miss Kvist gathered Katitzi into her arms and gave her a warm hug.

– May life be kind to you, little one, Miss Larsson said.

What does she care, Pelle thought. She just wanted to get rid of Katitzi.

– Goodbye, everyone, goodbye. Maybe we will see each other again. Katitzi tried to look confident, but she could barely hold back her tears.

Someone placed her bag in the trunk, and Katitzi stepped into the backseat.

Katitzi's father sat back down into the car and started to release the brake, but at that moment Preacher Pettersson approached the car and suggested that they all sing for Katitzi.

Jesus loves the little children
All the children of the world
Black and yellow, red and white
They're all precious in His sight ...
Jesus loves the little children

And while all the children stood singing, the car started rolling ever so slowly. Katitzi's father wore a sad look on his face. Why? No one could tell. Katitzi turned to wave and the last thing she saw was Ruttan who stood, singing, while tears streamed down her cheeks.

And so Katitzi left the orphanage to begin her journey home.

At Home in Camp

Katitzi felt like the car ride would never end: they just drove and drove. Finally, she couldn't stay quiet and asked:
 – Aren't we there yet, father?
 – Sure, there are just a few kilometers left.
 Katitzi wondered why her father was so quiet. He hadn't said a word the entire way. Perhaps he doesn't like bringing me home, Katitzi thought.
 – Were you all right at the orphanage? he suddenly asked.
 – Yes, everyone was kind to me, but mostly Miss Kvist.
 – Didn't you ever miss home?
 – Well, sometimes I missed the circus people, but I couldn't go back there. Father, do I have many siblings?
 – You have four sisters and two brothers.
 – Where do we live, and why don't we have a laundry room?
 – What are you saying? Laundry room, what do you mean by that?
 – Miss Kvist said that my sister has to borrow a washtub when she does laundry, and then she said that we don't have a laundry room. Is that true, father?
 – We don't have a laundry room, that's true. You see, we don't have a real house to live in and to have a laundry room in a tent and camper is tricky.
 – Father, why don't we have a real house? Why do we live in a tent and a camper? Are we poor?

– No, we're not poor, but you see, or maybe you are too young to see, we aren't allowed to live in a house. People don't want us to live in houses.

– But father, why don't they? Are you mean?

– Katitzi, listen and try to understand what I'm telling you. We are Roma, but people call us gypsies.

– Are you also going to tell me that we're gypsies? That's something bad, I know that, because Ruttan at the orphanage teased me for being a gypsy and said that we were buskers.

– Katitzi, it's not something bad, but people are afraid of us because they think we're mean. They don't know us and they are afraid to be near us.

– Father, that's silly: If they don't know us, how can they be afraid of us?

– You might think so, but that is how it is.

– Where are gypsies, or Roma, from, father?

– A long time ago, well, a thousand or so years ago, they came from India.

– Why did they come here? Are you also from India, father?

– No, I'm not, and why Roma came to Sweden, well, I don't know, but maybe it was to have a better life.

– Father, am I also called gypsy?

– Yes, you are, but we don't call ourselves gypsies. Gypsy is a name others came up with for us. We call ourselves Roma, and that means human being.

– Roma, it sounds so strange. What kind of language is that?

– It's our own language, it's called Romani, and it is spoken by all the Roma across the world. Look! There's our camp, down in the clearing, do you see it?

Katitzi looked. There were lots of tents and it was radiant with colors, it almost looked like a rainbow. At the center of the clearing stood a large barrel with smoke billowing out of it.

– Is that where we live?

– Yes, that's where we are living right now: what you see is our

carnival. You see that big girl, she's your sister, she is who you should ask if there is anything else you want to know. She knows nearly everything you need to know.

– Father, don't I have a mother?

– Your mother died when you were very small, but you have another one now that you should call mother. But you should try to stay out of her way as much as possible, because she is sick and she doesn't care much for children. And remember, Katitzi, always obey her, even if you sometimes think that she is being unfair.

Katitzi considered what she had just been told, but said nothing. She wondered why her new mother would be unfair, and why her father didn't object when she was. But she soon forgot about what she had heard, as a flock of children ran toward her.

– Hi, Papa! Have you brought Katitzi home? She looks so nice, one girl said, who was wearing a long red skirt.

– Who's that? Katitzi asked.

– I'm Paulina, don't you know? Don't you recognize me?

– It's not so strange if she doesn't, she was so little when we gave her up. But you are three years older, you must remember Katitzi? By the way, you have to help her get settled, I think she has to change.

A stately woman approached them: she had grey hair and looked very strict.

– So, she's here now, the lady said. Get a move on and change. You, Paulina, get her some clothes, take some of Rosa's old ones.

– No, I don't want to have any clothes other than my own, Katitzi said.

– Now you will be so good as to obey, I am the one who decides around here.

Paulina quickly grabbed Katitzi's hand and ran off with her.

– Please, Katitzi, you have to obey her, you must never talk back to her. She gets so angry. And you have to call her mother.

– Was that my new mother? She looked so angry. I will never call her mother, I can feel it in my bones.

– But please, please promise to never talk back to her, because it just creates more trouble. Come, and I'll show you where you will live. You and I live in this little tent. We can live in it all summer, but toward the fall we have to move into the other, larger, tent.

– Rosa, Rosa! Where are you? You have to help me find some clothes that will fit Katitzi.

– Well, let's try. Oh, it's so lovely to have you home again, Katitzi, Rosa said. But how will I find some clothes that will fit you? I'm so much bigger than you are! Well, there must be something.

Rosa started rooting around in a bundle, pulling out dress after dress, but all of them were too big for Katitzi.

– We will have to take this one, it's the smallest, and if we take one of Paul's belts to cinch it, it should stay up.

At that moment, a young man came walking across the camp. It was Katitzi's brother Paul, who was fifteen years old.

– So, Katitzi has finally come home. That's good, now all of us siblings are together. Rosa, don't forget to rosin the dance floor really well tonight: last night it wasn't done very well. Bye for now, I'm going to go look over the instruments.

– Paulina, what's rosing?

– It's not rosing, but rosin, and it means that you sprinkle something over the whole floor so that it becomes slippery, then people have an easier time dancing. But we can help Rosa so you can see how it works.

Katitzi now had on her new clothes and could no longer recognize herself. She wore a long dress that dragged on the ground, and around her waist, Rosa had tied one of Paul's belts so that Katitzi would not trip on the hem of her dress.

– What should I wear on my feet?

– During the summer, you don't need to wear anything: it's good for your feet to not wear shoes, Paulina said.

– But I can't walk around barefoot: What if it gets cold? Katitzi said and looked very surprised. She started to wonder where it was she had ended up.

– Don't be silly. In the winter you'll get shoes, of course. Papa will make you a pair. Katitzi, what do you have in the bag?

– Do you want to see? It's my pretty doll that I got from the circus people: she can close her eyes and say mama.

– Quick, hide her! The lady is coming, Paulina said and looked truly frightened.

– What do you have behind your back? Katitzi's new mother spoke to the girl in a demanding tone.

– It's my doll.

– Give it to me so that I can see! Oh my, it's far too nice to play with here in the camp. I will put it away.

She took the doll and marched off. Katitzi was close to tears.

– Why did she have to take my doll? I never get to play with it: first Miss Larsson took it, and now this lady is taking my doll.

– Please, Katitzi, don't be sad. Tomorrow I'll make you a doll that no one will take, I promise. And tomorrow I'll show you all the fun

things to do in the forest. I'm so glad you've come back home, because I've been so lonely. Rosa is much too big to play with me, and she doesn't have time, anyway, because she always has to work.

– But don't you play with the little children?

– Sometimes, but they're so small, and the lady doesn't like me playing with them.

– Are they the lady's children? Aren't they our siblings?

– Well, you see, when Papa married this lady he had them with her. They are named Nila, Rosita, and the little one is Lennart. They are our half siblings.

– That's so silly, half siblings! Either they're our siblings or they aren't, no one can be half.

Paulina did not know what to reply, but simply said:

– You'll understand all that much better once you are older.

– Why is that barrel smoking, Paulina?

– Don't call me Paulina, call me Lena, it's easier. But you can never call me Kalle, because then I'll get so mad that I don't know what I'll do.

– Why would I call you Kalle? Are you nuts: that's a boy's name.

– The lady calls me Kalle, she says I'm like a boy and that's why she cut my hair off, too.

– My goodness, what if she does that to me, too, but you know what, then I'm going to tell on her to my father.

– No, I don't think she will, because you will probably become a dancer and then you have to have long hair.

– What did you say I would become?

– A dancer, didn't you hear me?

– Yes, I heard you, but I don't know how to dance.

– You might not now, but you will learn. You see, everyone in the camp has to help out. If you listen, you will hear Paul practicing on the accordion, he has no choice. And Rosa plays the drums, even though she would have liked to play the violin, but Papa wouldn't let her.

– I don't understand at all. Drums, the accordion, a violin, me dancing: What are you talking about?

– We have a carnival, and we all have to help out if we are going to make any money. Papa, Rosa, and Paul play. You see the dance floor over there, that's where people dance, and in order to dance they have to have music.

– But what do you do, Lena, are you one of those dancers you're saying I'm going to be, too?

– No, Papa said that wasn't in the cards for me, so my job is to stand in the Guessing Game booth instead.

– The Guessing Game, what's that? Can you tell me? You might think I'm dumb, but I have no idea.

– It's a bunch of cards on a table. There are numbers beneath some of the cards. If people point to the right one, so a card with a number on it, they win something.

– Do you ever guess? Katitzi asked, thinking that it might be exciting to be at a carnival.

– No, why would I point? People have to do it if we are going to make any money. Each time they point, they pay twenty-five öre. We have other games, too: we have a shooting range, and a man who's a friend of Papa's works there, he's *gadjo*.

– He's what?

– Gadjo. Right, you've obviously forgotten how to speak Romani. Gadjo means that he isn't Roma. Gypsy is what other people say instead of Roma.

– I see. I think I'm starting to understand. It will probably take a while before I understand all of it, but it will happen eventually. Lena, what else do we have at the carnival?

– We have slot machines, string-pulling and ring-tosses, and the carousel of course.

– We have a carousel? Why didn't you tell me that at once? I love the carousel. You must ride that sometimes?

– Yes, sometimes, when I have time and Papa lets me. I also love to ride the carousel, but we have to help out and I can't if I'm riding the carousel: then who will take care of my customers?

– Well, Lena, I'm going to ride the carousel, mark my words.

– Well, I can't, because I can't write. But maybe he will let you ride the carousel tonight since it's your first day at home, and you probably won't have to help out tonight.

– Yes, I can't stay up at night, I have to be in bed by seven o'clock.

– And who do you think decides that? Katitzi, you're not with the circus people anymore, and not at the orphanage, either. Here it is Papa and the lady who decide, and we have to obey. But I can tell you that we have loads of fun sometimes, and your sister Rosa is never mean: she never beats us so you never have to be afraid of her. Come on, Katitzi, now they are calling us to dinner. Then we have to change clothes. Tonight, we open at seven and everything has to be ready. We have to sweep the grounds.

– Sweep the grounds—do we use a broom, then?

– Yes, we do, but a very large broom. We have several and everyone helps.

– The lady, too? Katitzi asked suspiciously.

– No, not the lady, Lena said. She's apparently a bit of a weakling, they say, so she doesn't help with much.

– But she must care for her children?

– No, she does not. Rosa does. But come now so that we get to eat.

The two sisters walked over, hand in hand. Katitzi really looked funny: she looked as though she might trip in her clothes any second, but she tried to walk with as much dignity as possible. She didn't want to stumble so that Lena would laugh at her.

A big wax tablecloth had been spread out on the floor of a large tent, and a large pot stood at the center of the tablecloth.

Katitzi's father served soup to everyone. Katitzi and Lena were given a bowl to share. Katitzi turned up her nose, but Lena gave her a warning glance.

Katitzi thought to herself, there is so much I don't know, but I will get used to this soon enough.

Carnival Night

It was six o'clock in the evening and the carnival was bustling. Everyone was helping out so that things would be ready for when the gates opened. Everyone besides the lady, of course, who had a migraine and had gone to bed.

Katitzi and Lena had two large brooms that they used to sweep the grounds.

– Hey Katitzi, tomorrow it'll be fun to sweep the grounds, Lena said.

– Why is it more fun tomorrow? I don't think it seems like much fun to sweep. Do you really think so?

– No, not now, silly, but tomorrow morning: you watch.

– What happens tomorrow morning? Katitzi looked dubiously at Lena. Maybe her sister wasn't too bright, after all.

– We will find lots of money. If Lennart, who works the shooting range, doesn't beat us to it.

– What kind of money?

– People drop money and when we sweep in the morning we'll find it, of course, and Papa has said that we can keep any money we find. Not bills: those he has to hand over to the police.

– The police get the money we find?

– No, Lena said. But people who lose bills go to the police and report that they have lost the money. When we find it, we hand it in to the police station and then people can go get it. Sometimes

you get a reward if it's a lot of money. Once I found a fifty-crown bill, then I got five crowns as a reward.

– Hey Katitzi, they're starting up the carousel.

– But it isn't open yet.

– They have to test it to make sure nothing is wrong: they do that every night before we open. Look! There's Papa. Wait, and I'll ask if you can have a turn.

– Papa, Papa! Can Katitzi have a turn on the carousel?

– Can't Katitzi ask on her own, or do you actually want to ride, too? Yes, go ride a few times, but then go get changed: it's Saturday night and there will be lots of people here. And don't forget, Paulina, you have to explain to Katitzi what needs to happen.

Katitzi and Lena rushed off towards the carousel. They were so excited that they simply threw aside the brooms right then and there, but then Lena paused and ran back. She carefully returned the brooms to where they had taken them from behind a tent. She thought to herself that it was best to be as careful as possible so that Katitzi would learn from the very beginning.

Katitzi had already taken a seat on the most beautiful horse. It was painted silver and had a mane black as coal, and it was so long that you didn't need to do anything but hold on. Lena sat on a giraffe with a long, long neck. Then the carousel started to spin, and the music box inside the carousel played "La Paloma." It looked so funny with just the two girls alone on the carousel, and the old man who ran it let it run several times before he stopped. Katitzi savored the ride: she felt like a princess and dreamed that she was riding toward her prince. But the ride stopped: that was the end of the carousel and the girls had to get off.

– What are we going to do now, Lena? Katitzi asked. Oh, it was so much fun to ride the carousel! Can't we do it one more time?

– You're out of your mind: we should be glad that we got to ride that many times. Maybe another time when we've been really good. No, now we have to go change.

– What are we changing into?

– We have to wear our Romané Tsali, Lena said.

– Our what? Katitzi said. That's what she said now whenever she didn't understand what Lena was saying.

– Our Roma clothes, Lena said. Come on, I have an extra outfit that you can wear.

They entered the tent where Rosa was already done getting dressed and was now sitting and combing her hair. Behind her ear she had stuck a yellow paper rose. Katitzi stopped short, amazed. Was this the Rosa she had seen on the grounds? No, it couldn't possibly be the same girl. This one looked like a fairy tale princess. She had the most beautiful red skirt you could ever imagine: it was long and had lots of ruffles. The embroidery on her yellow blouse looked like it was made of the purest silver, but it couldn't be, Katitzi thought.

– There we go, have a seat here now, Katitzi, and I will begin by doing your hair, Rosa said.

Katitzi was dumbstruck as she gazed at her sister Rosa.

– Oh, you are so beautiful, she said.

– You will be, too, Rosa laughed, as long as we comb out this tangled hair and get some nice clothes for you.

When Rosa was done with Katitzi she was barely recognizable: Rosa had braided her hair and put two big bows in it, and Katitzi was wearing the prettiest little gypsy outfit you could imagine: a yellow skirt, a white blouse, and with it a little red vest.

– Turn around now, Rosa said, and Katitzi spun around: the skirt spread out like a fan around her. Katitzi felt so proud.

– Do you feel pretty now? Rosa asked.

– Yes, I've never been this pretty, Katitzi replied.

Lena looked just as pretty. There was just one problem: having short hair made her very sad.

Papa entered the tent.

– Katitzi and Lena, here are your scarves. A kind old woman gave them to you, and you really shouldn't have them now, but since it's the first night Katitzi is back, you should have something special.

The scarves were made of pure silk and covered in ornate embroidery. The girls wrapped the scarves around them: they looked like elegant little ladies.

– Tonight, Katitzi, you will be helping Paulina in the Guessing Game booth. Then we will see what we can come up with for you, Katitzi's father said.

– Rosa, are you ready soon? Paul asked. It's late and we have to start playing: people are getting impatient.

Paul, Rosa, and their father started to walk toward the dance floor and soon music could be heard across the grounds. People started streaming into the carnival.

– Is this where you guess and point? a man asked Lena.

– Yes, do you want one try? It'll be twenty-five öre.

– Little miss probably wants to get paid in advance.

– I don't care, all that matters to me is that I get paid.

– Can you guarantee a win, then? the man asked.

– Of course she can't, Katitzi said. She thought the man seemed a little bit strange.

– Oh, she can't. What kind of little lady are you, then? I haven't seen you before, what's your name?

– My name is Katitzi and I'm not surprised that you've never seen me before, because I came home today.

– Can you sing "You Black Gypsy" to me and I'll give you a whole fifty-öre piece? The old man asked.

Katitzi looked over at Lena, who hurriedly replied:

– Katitzi hasn't learned how to sing that one yet, but I can sing it for you this time, sir.

– Well, I'll let it go this one time, but I want to hear this little girl sing it next time.

Lena began to sing "You black gypsy come and play your song," until the man was satisfied. Then he guessed and pointed several times and won twice. The first time he won a creamer and the second time he won a bowl.

– Lena, how late are we going to stand here? Katitzi asked, since she was not used to going to bed late. She was starting to grow tired and couldn't stop yawning.

– Silly, you can't stand here yawning, Lena said. We have to stand here until midnight, but if you want you can run over to the dance floor and watch them dance.

Katitzi ran towards the dance floor and at every point people would stop her and ask her to sing "You Black Gypsy", but Katitzi would just shake her head. No, no, she shouted. I don't know it.

When she got to the dance floor she crept up close to the bandstand, where her father sat playing beautifully on the violin. It sounded as though the violin was weeping when he played something sorrowful, and when the melody was joyful it sounded as though the violin was laughing.

– Now Rosa is going to do a solo dance, Katitzi's father suddenly announced. Everyone moved toward the edge of the dance floor. Katitzi's father and brother started playing a brisk melody and Rosa danced.

Katitzi could not stand still, but started swaying her skirt,

moving her feet in the same pattern as her sister, and it almost looked as though she was also dancing.

Katitzi's father had caught sight of her, and he smiled. He probably thought that one day she would become a good dancer, as well.

The music came to an end and Rosa stopped in the middle of a whirling move.

– Bravo, bravo! People shouted and threw money at Rosa.

Katitzi ran back to Lena and told her that people had thrown money at Rosa.

– They always do that when Rosa dances. Maybe they will do the same thing if you are a good dancer, too.

– Can I keep the money then? Katitzi wondered.

– No, Papa obviously gets that. That's the money he pays to the person we rent the land from. All the money we get goes to a cash box and then Papa pays all the expenses: rent, food and clothes, and everything we need. For this stall alone, we have to buy the prizes, otherwise people have nothing to win.

Katitzi started to get an inkling of how everything worked, but she did not yet understand all of it. At night when all the visitors had gone home and their father sat and counted what was in the cash box, Lena told him that many people had asked Katitzi to sing "You Black Gypsy." We will have to teach her that song, he thought to himself. But Katitzi had fallen asleep on her chair. It had been a long day, from the orphanage to the carnival.

Katitzi and Lena

– Katitzi, wake up, hurry. We have to sweep the grounds.
Lena was trying to wake Katitzi, but it was difficult to rouse her.
– Come on, wake up!
– What's going on? Gullan? I want to sleep.
– It's not Gullan, Lena said. It's me, Lena. Come on: we're going to look for money.

Katitzi sat up with a jerk and remembered that she was no longer at the orphanage: she was home.

– I'm coming. I'm just so tired.

But soon Katitzi had gotten dressed and the girls started to sweep the grounds. They found many five-öre pieces, and by the shooting range Katitzi found a whole twenty-five öre piece.

– Katitzi, shall we go to the kase and play? Lena asked when they were done sweeping.

– The kase? What's that?

– It's very fun, but we have to hurry because we have to fetch water before the others wake up.

– We have to fetch water? Why?

– Because it's our job, of course.

Lena thought to herself that Katitzi really didn't know very much. She probably thinks that water fetches itself.

– We have to gather wood, too.

– Really, is there something else we have to do?

– Oh no, in the mornings we just need to gather wood and fetch water, but we have to do it before the lady and Papa wake up, so that it's ready for them.

– Come on, let's go to the cash.

– The kase, stupid.

The girls made their way deep into the woods, and when they had walked a good while Lena came to a stop.

– Here it is, Katitzi. This is the kase.

– Are you crazy? This is a dump, Katitzi said.

– But it's called the kase, just look and you'll see how much fun stuff there is here.

Katitzi gazed all around, and sure enough, there were many things. An easy chair, a broken table, and several broken old pots and pans. And a chamber pot.

– What are we going to do here? Katitzi wondered.

– Play, of course. We are going to pretend that we live in a real house. You just wait and see.

Lena started to arrange things. She moved everything around so that it nearly looked like a room. In a broken jar with some water she placed something she'd been carrying in her pocket.

– What do you have there? Katitzi asked.

– Soft soap. We're going to make a cake, Lena said. Run over and find some rowanberries and you'll see.

In the meantime, Lena whipped up the soft soap so that it turned to foam. Katitzi searched and found lots of rowanberries: she picked them and carried them in her apron. Lena made a cake out of moss and on top she spread out the soap foam; she decorated the foam with the rowanberries. It almost looked like a real cake.

– Lena, what's migraine? Katitzi suddenly asked, while they sat and pretended to drink coffee and eat cake.

– Migraine? Why are you asking? Lena responded.

– The lady had to lie down and she said she had a migraine.

– I really don't know, Lena said, but I think it's a kind of illness. You get a headache. Not always, but most of the time.

– So, why does she have white hair, when the rest of us have black hair?

– I suppose it's because she is *gadji*, you know, not Roma.

– She isn't Roma, then why is she with us? Has she lived in a real house?

– Yes, isn't that strange? She lived in a big, pretty house when she met Papa. We had set up the carnival where she lived. And then she left her house and came with Papa.

– Then she must really care for Papa, since she left her pretty house, Katitzi said. But why is she so mean? Why is everyone afraid of her?

– I don't know, but I think she didn't know that he had children. And I think she thought Papa was very rich and that living in a tent was fancy, somehow. But never mind her. Grown-up ladies and men are strange, sometimes. But you and I are always going to stick together, right?

– Yes, pinky swear.

– But Katitzi, we had better hurry home so that we don't get a scolding.

The girls started to walk back. On the way, they gathered sticks and pine cones to use as kindling in the stove to make tea for the entire family.

When they arrived back at the camp they saw that there already was smoke floating out of the little chimney.

– Katitzi, they're awake. Oh, now we're in for it. Hurry up: we haven't had time to fetch water.

But they could stay calm. Paul was the one who had woken up, and he was also the one who had made a fire and fetched water. Paul just laughed when he saw their faces.

– Yes, I figured you'd lost track of time. But don't worry: everything's taken care of, and one day when I have lots of money I'm going to buy you watches so that you can keep track of time.

Rosa also got up. At first she made gruel for the three little children, then she prepared sandwiches and tea for the older ones. She looked a little bit tired but she still wasn't grumpy.

– We have to do laundry today. You, Lena, have to help me carry clothes to the lake. And please, Katitzi, can you gather sticks so that we can light a fire beneath the washtub? We mustn't forget to go to the neighbor woman and ask if we can borrow her tub.

– Can't we go borrow it? Katitzi asked.

– Absolutely, you go. But are you strong enough to carry it? And please do not forget to be as polite as possible when you ask to borrow the tub, Rosa reminded them.

The girls walked off to the neighbor, who lived a ways away from the camp. They came to a big farm, and Lena knocked on the kitchen door. The farmer's wife opened the door and asked what they wanted. Lena and Katitzi curtsied so that their skirts trailed in the dirt.

– Good morning, ma'am, Lena said. We're are wondering, please, if we could please borrow the washtub, because Rosa is doing laundry today.

– Rosa is doing laundry again? She did laundry just a few days ago. You must be very dirty, she said.

– Yes, it's so muddy where we are living that we probably get especially dirty.

– All right, all right, of course you can borrow the tub. Come with me to the barn: it's down there.

The girls followed the farmer's wife across the yard to the barn. Katitzi looked around and thought to herself that things looked very nice there at the farm. This is how it should be, she thought to herself. In the barn there were loads of animals: cows, pigs, and chickens and a little goat.

– And who are you, little girl? The farmer's wife asked Katitzi.

– I'm Katitzi. I came back from the orphanage yesterday.

– Poor thing. You may as well have stayed there. This is no life for you, if you'd gotten used to something else, she said.

– But I am glad to be home. I have real siblings here, and Lena has missed me so.

– Oh, dear child, as long as you stick together it will be all right. Listen, girls, come with me into the kitchen and I'll give you some freshly baked cinnamon buns.

Katitzi thought the woman seemed very kind, but she could not understand why it wouldn't be good for her to come home.

After being given a large bag of buns, which the girls placed in the washtub, they each grabbed a handle and made their way back.

– Hey, Lena, why did she say that? Why was it bad for me to come back home?

– Don't worry about that. Some people feel sorry for us because we live the way we do, but they can't do anything to help us.

– Why not? Couldn't we live on her big farm?

– You're crazy. I can tell that you've been gone for too long. You must understand that they don't want Roma on their farm.

– No, I don't understand at all. Why not?

– Never mind, let's not talk about it anymore. Hurry up: we have to get home so that Rosa can start doing the laundry.

The girls lugged the heavy tub. Eventually, they got to the edge of the lake, where Rosa had started a fire on the small beach using pine cones and twigs.

– Katitzi, hurry up and gather more wood, Rosa said.

And Katitzi ran around as quickly as she could so that Rosa would have enough wood for her fire. When she felt that she had enough, she ran back. At that point, Rosa had heaped all the clothes in the tub and placed it on top of the fire, and put soft soap in it, as well—things had to get very clean. While the clothes boiled, the girls sat down and talked. Rosa tried to explain to Katitzi why they had to live in tents, but Katitzi had difficulty understanding: she thought they should be able to live like everyone else.

– Rosa, has Papa told other people that we want to live in a house? she asked.

– Many times, Katitzi. You will get to hear your father talk to different men about the fact that we want to live like other people, but you will also hear those old men say no. But let's not think about it any longer.

Rosa took the clothes out of the tub. She spread some clothes out on a flat rock, and there she brushed the clothes with a scrub brush until they were completely clean. While she brushed, it looked as though she was furious, and in truth that is how it was. She thought about the fact that this was how she would like to brush all those old men who denied her father and his family a place to live.

Fire!

Katitzi started to settle into her new life, even though a lot of it still felt strange. At the orphanage, she had her own bed, but here she was forced to share a bed with her sister Lena. She thought the bedding felt strange, but was still warm and cosy: they used down feather beds, one beneath them and one on top. She thought the food was strange: they never had gruel like they did before, but spicy food. For the most part, it was soup with plenty of vegetables, and sometimes a small portion of chicken.

She started to grow accustomed to the fact that she and Lena and their big sister Rosa, who was thirteen, had to work as much as they did. That the lady who was her new mother never lifted a finger, but simply lay in bed and read and ate, well, that was just how things were—but she could not get over the fact that the lady constantly yelled at Katitzi or pulled her hair whenever she got the chance. She often asked Rosa why the lady did that, but Rosa's reply was simply that she shouldn't be sad: it would surely get better once Katitzi got older.

Katitzi thought to herself that when she got older she would move into a pretty house and not let the lady move with her.

One day, Katitzi's father and the lady drove off in the red car. Paul had told the others that they were going to try to find another spot where they could live and set up their carnival. Fall was on its way and it was starting to grow cold. Katitzi and Lena's feet were

cold. They wondered when their father was going to make shoes for them, but they didn't dare ask him about it, since he seemed so sad, as if he was weighed down by many, many sorrows.

That day, they had been given strict instructions to watch the other children and make sure that nothing happened to them. The very smallest boy, Lennart, was only five months old. He lay in a laundry basket in the little camper where the children's father and the lady slept at night.

As usual, Rosa was doing laundry down by the lake and Paul had gone down to the village to see if there was any work for him to do. He was a very skilled tinner and good at making copper pots and pans shiny and as good as new. Down at the bakery, Paul had been promised that he would get to work on their pots and restore them. Lena had gone off into the woods to gather pine cones and Katitzi was alone with her three little siblings.

All of a sudden she saw that smoke was coming out of the little window of the camper. She dropped everything and rushed over. When she was about to enter she recoiled: the entire camper was full of smoke and Lennart was screaming from his little basket. Katitzi was terrified and had no idea what to do. I better run over to the farm and get help, she thought, but then she noticed that the curtain had caught on fire and understood that she didn't have time to fetch help. Katitzi's little sisters stood out in the yard and wailed, one louder than the other. Katitzi's heart pounded in her chest: she thought everyone in the camp must be able to hear it. Please, Miss Kvist, help me, she thought and rushed into the camper. Katitzi coughed when she inhaled the smoke and she could barely see her hand in front of her, while her eyes stung as though they were on fire. At first she pulled down the curtain and then she grabbed the little boy out of the basket. She threw the curtain out into the yard and placed Lennart on the ground, then she ran back into the camper to see if anything else was on fire. One of her father's feather beds had caught fire: Katitzi grabbed another feather bed and used it to smother the fire. Her hands

were covered with blisters, but in that instant she couldn't feel a thing. She was just glad the fires were out.

At that moment, Lena came running: she had smelled the smoke, and then Rosa came running. They were terrified, and now Katitzi began to weep.

– What if our little brother had been trapped in the fire? she said.

– Little Katitzi, you were so brave, Rosa said, but how could this happen?

In the meantime, Lena had entered the camper to see how the fire had started. A kerosene stove was the cause of the disaster: it had exploded, the kerosene had caught fire and spread all around.

– We had better hurry to tidy up before they come home, Rosa said. But Katitzi, what happened to your eyebrows? They're completely singed. And let me see your hands: my god, they're burned! Come, let's bandage your hands.

– No, we have to tidy up the camper first, Katitzi said. Because what if they come home and see that there was a fire, then I'll be blamed for not keeping an eye on the little ones, she said.

– Don't worry: I'll take care of that, and Lord have mercy on whoever tries to blame you for this. Everyone should be grateful that you saved our little brother, and if the lady says a single word I'm going to tell her what's what, Rosa said, looking grim.

Rosa bandaged Katitzi's hands and then Rosa and Lena worked together to tidy up the camper. Katitzi sat with Lennart in her arms, rocking him. After a while he fell asleep, and she placed him in the bed she shared with Lena.

Lena had stood looking on while Katitzi rocked Lennart, and remembered that she had promised Katitzi a doll when the lady took the one Katitzi had brought with her from the orphanage.

– Rosa, Lena said, do you have any rags?

– What do you need them for? Rosa asked.

– Do you have any or don't you? It doesn't matter what I'm going to use them for. But if you absolutely have to know I'm going to

make a doll for Katitzi. I feel so sorry for her: Why did she have to come back home? She was probably better off where she was.

– Lena, I don't want to hear any more talk like that. Katitzi is our sister and she should live with us. Don't you understand? Even if we often have a hard time we have to stick together. Come with me and I'll see if I have some fabric somewhere.

Rosa rummaged through one of her bundles and found a piece of red fabric, then she took out some yellow silk ribbons and handed it all to Lena.

Lena went off to the kind woman at the farm and asked if she could have a wood log.

– What do you need a log for? You are welcome to pick some sticks, but I can't give you a log.

– But ma'am, I don't want firewood, I'm not going to make a fire. I'm making a doll for Katitzi.

– Making a doll out of a log, I've never heard of such a thing. But go ahead, take a log. You know what, take two in case the first one doesn't work out.

After eagerly searching through the pile of wood, Lena found a log that was suitable for a doll, just the right width and length. She didn't need to take two, because she knew that she would not fail. Then she borrowed a carving knife and carved a little bit where she thought the head should be. She wound the fabric around the wood piece and in order to make it stay she tied the yellow silk ribbon around its waist. Where the face was she used a piece of coal to draw a mouth, nose, and eyes. Then she attached a small piece of the fabric as a kerchief around the doll's head.

Katitzi was overjoyed when Lena gave her the doll, and she kept it for many, many years.

Katitzi and Lena Learn to Ride a Bicycle

It was just another day in the camp. Maybe not a completely ordinary day, because the girls' father and the lady had left for a wedding that Katitzi's uncle had arranged for his oldest son. The girls were very happy when the lady was away, since they were left alone: then there was no one to nag them, no one who said that they hadn't fetched enough water or that the wood they'd gathered was too damp.

Today Lena and Katitzi were so happy that they had gotten dressed in their finest clothes in the middle of the day. Rosa, who really thought they were being silly, said nothing. She understood that the girls wanted to take the opportunity to look especially nice: she had heard Lena mention that girls from the village were coming to visit. When Katitzi and Lena had been to the village one day to fetch water, they had met the girls, who in turn wanted to see how the gypsies lived.

There they were: they were dressed very nicely and they had bicycles. Katitzi and Lena stood gazing for a long while, wondering how it could be that such young children had bicycles of their own.

The girls' names were Greta and Inga. Inga had long red hair and freckles: it looked beautiful and no one had ever teased her for it. Greta was fair and had long thick braids that were practically golden.

Katitzi and Lena were dumbstruck for a long while. They looked at Greta and Inga as if they were afraid that the two girls would simply vanish into thin air at any moment.

– Hi, Greta and Inga said. Have you been waiting for us for a long time?

– No, not very, Katitzi said, even though it wasn't entirely true: Katitzi and Lena had gotten up at five in the morning to eagerly prepare for their visitors.

– We have so much to do, Lena said, that we don't have time to wait for anybody.

Inga and Greta gazed in wonder at the sisters, they thought they looked so beautiful.

– Why are you so dressed up? Inga asked.

– Dressed up? Katitzi said. We're not especially dressed up: we always wear these clothes.

– Well, not when you come down to the village to fetch water. Then you don't wear clothes like that.

To herself, Inga thought that then they just wore rags. But she didn't want to say anything out loud for fear of hurting the girls' feelings.

– Any fool would know that you can't wear the same clothes when you work as you do the rest of the time, Katitzi said. You have to change into work clothes sometimes, don't you understand that?

Inga thought to herself that she didn't understand at all why little girls like that had to help with such heavy work as fetching water. Neither she nor Greta had to do work like that, but she didn't say this aloud, either.

– Who gave you such nice bicycles? Lena and Katitzi asked.

– We got them for our birthdays. Inga and I are cousins and born on the same day. We wanted bicycles so we got them.

Katitzi and Lena looked at each other and both of them thought: that's ridiculous! If we asked for bicycles no one would care at all.

– Do you have nice parents?

– The best in the world, Greta and Inga replied in unison. No child in the world has nicer mothers and fathers than we do.

– That's strange, Katitzi said, who felt that the girls bragged far too much. How would you know? You haven't met all the children in the world, so there. Besides, we have a nice sister named Rosa.

– But in this village our parents are the nicest. We're going to get a dog, too, for Christmas. If we're really good.

– What, you're getting a dog? Katitzi said. Lena, do you think we can get a dog?

– You can't have everything in the world, Lena said. It was something she had heard the lady say and she thought now was a good time to try out that expression. We have so much else to be happy about, she said.

– What would that be? Katitzi said, looking skeptical.

Lena mused, then said:

– May I ask if you've forgotten all about the carousel? Which children in the village have their own carousel: can you tell me a single one?

Greta and Inga stood silent and really could not think of a single child who had their own carousel, and Inga laughed to herself.

– Imagine if the cobbler or baker's children had a carousel! But it would be fun, of course.

– Oh yes, you can't have everything in the world, she said, imitating Lena.

Inga and Greta whispered something to each other. They looked very secretive and Katitzi and Lena wondered if they were whispering about them.

– It's rude to whisper, Katitzi said. You should speak loud enough for everyone to hear, she continued.

– But we have to whisper, because it's something we're thinking about.

– But can't you say it aloud, then? Lena asked.

– We think you'll think we're stupid if we say it, Inga said. You'll probably just laugh at us.

– How can you know unless you say something? Katitzi said. Come out with it, then.

Inga mustered her courage and said:

– We'd like to be gypsy ladies.

– What? Katitzi and Lena looked surprised.

– You want to be what?

– We want to be like you. We want to wear the same clothes that you wear.

Lena laughed, then she said:

– Well, maybe that's not such a bad idea, if you wear our clothes and we wear yours. Then we can move into your house and you can live here in camp, so we get to live in a house for a change.

– Oh no, that's not what we meant, Greta said. We meant that we could pretend to be gypsy ladies—if we get to borrow your clothes while we're here today.

Katitzi and Lena looked at each other, and now it was their turn to lean in and whisper to each other. After a minute, Lena said:
– If we get to borrow your bicycles, you can borrow our clothes.
– But we don't know how to ride bicycles, Katitzi said.
– Greta and Inga might teach us. Will you? Lena asked.
– Sure, as long as we get to borrow your clothes.

Katitzi and Lena traded clothes with Greta and Inga, while Rosa, who came out to look, thought it looked so funny that she had to laugh. But the girls didn't laugh: they took the game very seriously.

Greta had tied a scarf around her hair so that you wouldn't see how fair she was, and she wanted Lena to use a piece of coal to darken what little hair you could see beneath the scarf. Just as Lena was about to do it, Rosa put her foot down and said that such nonsense was out of the question.

Then Katitzi and Lena sat on the bicycles and tried to ride. They must have fallen off at least a hundred times, but eventually they learned to keep their balance on the bicycles.

It was a wonderful day for all four girls. Katitzi and Lena had learned how to bicycle and Greta and Inga had lived their dreams, namely, to be Roma for a day.

The Move

One day the mailman came down to the camp. He had a large envelope for Katitzi's father.
– Can Mister Taikon please sign here? he asked.
– I don't know how to write, Katitzi's father replied.
– I don't believe it: you don't know how to write? How on earth are you supposed to accept this letter, then? I have to get your signature, otherwise I can't hand over the letter.
– Well, I can put my mark where my name is supposed to go.
– Your mark? What's that? The mailman looked perplexed.
– Well, I put three crosses where I'm supposed to put my signature. I've always done that, so it should work now, as well. Katitzi's father put three large crosses where his name should go.
What's this about, then? He thought to himself. I hope it isn't trouble, that nothing has happened to my brother.
– Papa, why don't you read the letter? Katitzi said. Aren't you curious?
– Shhh, quiet, Katitzi, Lena hushed her. Papa can't read: the lady has to do it for him.
– What, Papa can't read? Why not? Katitzi asked.
– Because he never got to go to school, of course. None of us have. Rosa and Paul can't read or write, either.
– I've never heard of anything so stupid, Katitzi said. I'm going to go to school and learn about everything, and then I'm going to read for Papa. Don't you want to go to school, Lena? Katitzi asked.

– Stupid, of course I do, but I don't think we ever will.

– Why not? Papa would only be happy if we could read, don't you think?

– Of course Papa wants us to learn how to read and write, but I don't think the school will have us.

– Oh, you're so stupid, and you're old, Lena. Of course the school will want us, why wouldn't they?

– I have no idea, but that's what they say, anyway.

– Now I'm going to talk to Papa about this, Katitzi said, and she looked so determined that Lena couldn't object.

The girls' father had gone into the camper where the lady was in bed with a headache. She was the only one in camp who could read, but then again she wasn't Roma: she had gotten to attend a regular school and had learned how to read and write. When he came out of the camper he looked miserable. He called for Rosa and Paul.

– Well, Paul, that letter didn't have any good news in it. Besides, I never get good news when I get letters.

– What is it? Paul asked.

– The usual: we have to move. The village police wrote to say that if we don't move within four days he'll come here and tear down the camp and force us to move, so we had better start packing: I don't want any trouble.

– You never want any trouble, Papa. But what would happen if you said something? We can't keep moving like this: we have to settle somewhere, I don't want to move around forever. And Papa—what's going to happen with the children?

– I am too old, Paul, to try to get those old geezers in the municipality to try to understand that we are regular people just like them, that we need to have a proper home someplace. But maybe you can try to talk to them.

– Yes, Papa, trust me. I'll try to talk to them. Maybe we can at least stay through the winter.

Paul went off to try to talk to the powerful old men who had

decided that Katitzi and her family could no longer stay where they were. But he had nothing for it, because when he returned he looked even more defeated. The old men had said that they needed to get the hell out.

Everyone started to pack, except the lady, who said:

– Oh, my terrible migraine, what a life we lead.

Paul and Papa took down the tents and placed them in large crates. Rosa packed up all the china, carefully wrapping each piece in paper so that it wouldn't break during the journey. No one thought to make food: no one was hungry, except the lady who took her three little children down to the inn for a meal. Katitzi's father and brother had once tried to do that, but had been refused service. The woman who ran the restaurant said that she didn't want gypsies in her dining room. But the lady, whose skin was fair, could eat at the inn.

In the meantime, everything was readied for the journey. Katitzi's father carefully looked around to ensure that nothing was left behind and that they had returned everything they had borrowed from the woman at the neighboring farm. Katitzi and Lena had to sweep the yard so clean that it in the end looked like a ballroom: then the girls' father was satisfied.

Katitzi's father had rented a few trucks and loaded them with everything that would fit. Then Paul tied thick ropes around the load so that nothing would fall off. Papa hooked the trailer to the squat little car and all the children had a seat in the trailer, save for the littlest one, Lennart, who sat in his mother's lap in the car. Katitzi and Lena wondered where they were going.

– Where are we going, Paul?

– If only I knew. Probably to some neighboring municipality, we'll see. But hey, why do you look so sad?

– We don't want to leave our new friends, Katitzi said. We like Greta and Inga so much.

Paul knew nothing about Greta or Inga, but he didn't say anything and just reassured them that they would make new friends in the next place.

They were on their way. The girls' father had told them that each time they came to a hill everyone had to jump out of the trailer and push in the back, otherwise the car couldn't pull up the trailer. The girls were not afraid because it went very slowly and they were quick to jump out of the trailer whenever they needed to.

Toward the evening they came to a village. At the police station they asked if there were any Roma there. The police looked at them with suspicion and said there was a group outside the village, but that Katitzi's father shouldn't get any ideas and think he could stay there.

– Because we've got enough with the gypsies already here, and besides, they're going soon.

Outside the village was a small camp, where a few families lived. They were very poor: they did not own a caravan, only a few small tents. When the car stopped by their camp everyone came running and wanted to know who was there. Katitzi's father and a strange man spoke to each other in Romani, and Katitzi couldn't understand a word.

– Lena, what are they saying? Katitzi asked.

– Papa is asking if we can stay here, but that man is saying we can't, because they can't stay, either.

Katitzi suddenly caught sight of a bunch of puppies: they looked like little teddy bears and they were the cutest creatures she had ever seen. A little girl around Katitzi's age came up to her.

– Do you like our dogs? she asked. Would you like to have one?

– Oh, yes, Katitzi said, but are you allowed to give them away? Besides, I don't think our father will let us have a dog, but I can always ask, she said.

Katitzi ran over to her father and pulled at his coat. Lena looked terrified.

How did Katitzi dare to interrupt her father when he stood talking about such serious matters? But Papa just smiled and patted her on the head.

Katitzi ran back to Lena, beaming.

– Papa is the nicest person in the world! she said. We get to have a dog.

Lena could not believe her ears.

– Besides, she said, do you remember what you said to Inga and Greta when they said that they had the nicest parents in the world? How can you now say that your father is the nicest in the world?

– It's different, don't you see. Because I know he's the nicest, otherwise he wouldn't let us have a dog. Do you see?

The girl who had promised the dog to Katitzi came up to the two sisters.

– But I'm not going to give you a dog if you don't give me your scarf, she said.

Katitzi looked at Lena and wondered if she really dared to give away the beautiful scarf that her father had taken such good care of. But Katitzi wanted the dog so badly that she only gave it a minute's thought before she took off the scarf and handed it to the girl.

But which of the dogs should she choose? She stood and stared at them: some were white, some black, and all of them were just as cute.

– No, I can't choose, Katitzi said, I simply can't.

– Do this, the girl said, pet each and every one.

– Why should I do that? Of course I want to pet all of them, but that's not going to make deciding any easier.

– No, but they will choose you, the girl said. The one who follows you is the one who wants to stay with you. Then you are the one who is chosen, you see?

Katitzi didn't fully see, but she didn't want to let on that she didn't. She bent down among the puppies and petted them all: they were so cute that she wanted to cry.

– Now, the girl said. Walk away a bit and you'll see if any of the dogs follow you.

Katitzi started to walk. She was so afraid that she did not dare turn around. What if none of them followed her?

– Katitzi, Katitzi, turn around! Lena shouted. Look!

Katitzi turned around. And what do you know: one of the little puppies had followed her, a little white one. Katitzi scooped the puppy into her arms—she was so overjoyed. Now they could chase off her family as much as they wanted to: she and her siblings finally had someone who could comfort them.

A New Place

Night had fallen, but they were forced to continue their journey. They could no longer remain at the camp: the village police would not permit it. Katitzi sat in the wagon and held the little puppy close. It seemed as if both she and the puppy were asleep.

The car rolled through the night and behind them rode two large trucks containing Papa Taikon's carnival. The rain was relentless, pouring out of the sky. It seemed as if the entire sky had simply opened wide. Suddenly the car stopped and the girls could hear their father's voice: he was speaking loudly and seemed very upset. The girls opened the little window in the trailer to hear what was going on.

– My god, are you really going to unload everything right here in the middle of the night and the middle of the woods? Papa Taikon said.

– We are: we were only hired to drive to the village we just passed, one of the men replied.

– But you yourselves saw that we weren't allowed to stay there in the village, and if you're afraid that you're not going to get paid properly, I'll pay you in advance, Papa Taikon insisted.

– Oh no, we won't go any further. We'll unload this junk here,

and you'll just have to see to it that you get it when you have another camp, the other man said gruffly.

– Are you really going to do this? Why can't you just do us this favor? Papa Taikon tried.

– I'm done talking: the stuff has to go. And the men started unloading everything in a field by the side of the road.

Papa Taikon spread tarps over everything to try to protect his things from the rain, but it was no use: almost everything was soaked.

– Paul, we have to try to find a spot here nearby, Papa Taikon said.

– But how? It's night and dark. Can't we try for a hotel nearby?

– We can try, but I'm not sure we'll be able to get a room.

– Well, it's worth a try, Paul responded. I'll go to the farm over there. I can see a light and maybe they have a phone that I can borrow.

Paul took off, but soon returned and happily told them there were plenty of rooms. Everyone was overjoyed because they would soon get to be warm: they almost forgot how tired and hungry they were.

When they arrived at the hotel and everyone had gotten out, a tall man approached them. He looked frightened.

– What do you want? he asked.

– We've reserved rooms here for the night, Paul said. I was the person who called just a while ago.

– Reserved rooms? No, there must be some mistake, we have no vacant rooms.

– But what do you mean? You just said that you had plenty of rooms available when I called.

– Well, we may have had vacancies, but we don't now. Besides, I can tell you that, in this town, we don't rent rooms to gypsies. And you better leave on your own so that I don't have to call the police.

The family got back into their car and camper and Papa Taikon said that he had to try to find a place where they could pitch their tents and park their camper.

Katitzi couldn't make much sense of what was going on. She

thought everything seemed so unfair. Why had the tall man sent them away, and why had he said to Paul on the phone that there were empty rooms? She considered what was happening for a while, then thought perhaps Lena had the answer.

– Lena, why do they do this to us, why are we driven away wherever we go? What have we done?

– How should I know? Lena said. Maybe they don't like us because we're dark, maybe they only like fair people. Besides, I've told you that you can't have everything in this world.

– No, not everything, but how about a little bit? Just a little hotel room, Katitzi said and yawned widely. After a while, the girls fell asleep.

But they had not slept long before they were startled awake.

– Wake up, girls! We have a place to stay. A kind old woman has promised us that we can have our camp here, the girls' father told them. He looked very happy, even though it was the middle of the night.

– You can sit here for a bit while I set up the tents, but then you have to pitch in and carry bedding.

Papa Taikon, Paul, and Rosa pitched the tents. They installed a large metal drum with a pipe that led out through a hole in the tent. Soon there was smoke coming out of the pipe. Paul was tending the fire and the girls hurried to carry in bedding. Rosa had spread out fir branches on the floor and on top of that she had spread out rugs.

– Yuck, Katitzi said, the blankets are wet. Are we really going to sleep on this, Rosa?

– Put them next to the stove and they'll be warm soon, Rosa said.

– Right, but I don't want to sleep in them if they are wet: then I'll be cold.

– Quiet, Katitzi, Papa is coming. Lena was shushing her sister.

– But I don't want to be here. It's cold and wet. I want to be back at the orphanage.

– Hush! Be quiet. What if Papa hears you, then he'll be so sad. You can have the puppy with you, he'll warm your bed.

– You call this a bed? You don't even know what a bed looks like. You should have seen the one I had at the orphanage: it wasn't just a few pillows on the floor, but a real piece of furniture with a mattress and sheets and then we had blankets on top, so there!

– Yes, yes, but now we don't have those things: we have pillows to sleep on and we should be happy about that, because there happen to be people who don't even have pillows, Lena said.

It was clear that she was mad at Katitzi for whining. And Lena was also probably a little bit jealous, since she had never slept in a real bed, but she of course did not want to let on.

After a while the bedding had dried to the point where Rosa could make their beds. Paul said that he would stay up all night and tend to the fire so that it wouldn't get too cold.

The girls crawled into their bed; Katitzi had the puppy with her. Suddenly she sat up.

– Lena, Lena, we have to name the puppy.

– Tomorrow, Lena yawned. I'm tired. Tomorrow: I'm too tired to think right now.

– You have to, Lena. You can't fall asleep until he's been given a beautiful name.

– Oh, you're hopeless, Katitzi. So what do you want to call him?

– If I knew, then why would I ask you, huh?

– Call him Blackie, Lena said sleepily.

– Don't you know he's white? So his name can't be Blackie, can it? Don't you have any better ideas?

– Hey, don't you think that he wags his tail a lot?

– Yes, what about it?

– Well, I mean it looks like he swings his tail.

Katitzi didn't understand at all: she thought Lena was being difficult.

– Hey, Katitzi, let's call him Swing. That's a great name, don't you think?

– Swing. Swing: yes, that sounds pretty good. His name is Swing. And she fell asleep.

Party in Camp

The kind old woman had given Katitzi's father permission to stay on her land for several months, and he had also secured permission from the police to put up his carnival. It was late in the fall and the days were growing shorter. Papa Taikon had strung lights along the electrical wiring above so that the entire camp was illuminated. The lights were multi-colored and the whole place looked very festive.

– Today we're going to have a real *patjiv*, Katitzi's father said.

– Lena, what did Papa say?

– Didn't you hear? He said we're going to have a party.

– What he just now said, patjiv, what is that?

– I just told you, but you don't seem to understand anything. I mean, you've been with *gadjé*, so I guess that's why. But I feel like you've been home long enough that you should have learned Romani again.

– Hey, can I ask you something, Lena? Have we had a party since I came home? Tell me.

– No, we haven't.

– So there, how am I supposed to know what patjiv means when I've never heard of it before? Besides, why are we having a party? Is it somebody's birthday?

– No, silly, we don't celebrate that kind of thing.

– We never get birthday presents the way I did with the circus people? It was from them that I got that beautiful doll I never get to play with, I got that when I turned seven.

– No, we don't get that kind of thing here: we spend our money on healthy things, like food.

– You don't think the circus people fed me, then? I can tell you that we got the best food that can be had. Pork chops, as many as we wanted, and cookies and pastries on weekdays!

– Right, but here we don't eat pork chops day in and day out, because then what are you supposed to eat when it's a party, huh? But you don't understand that kind of thing, because you're too little, Lena said, a bit offended.

– Well, aren't you stuck-up. You seem to think you know everything there is to know, just because you're three years older than I am. But I can tell you that you've never lived with any circus people, and you've never played with any elephants. I bet you've never even seen an elephant, and you know what, have you ever had dolls who can eat real food?

– No, my goodness, you're out of your mind. Dolls who can eat: Are you crazy? Maybe you caught a cold when we slept in those damp blankets? Let's take your temperature: Rosa has that kind of thingamajig you use to see if people have a fever: wait and I'll call her, Lena said, actually looking a bit worried.

– Be quiet, stupid, and I'll tell you how it was. My dolls really could eat. Every day, I gave them food. I had a little table and then I had two little chairs that only fit me, and in my room I used a china set that was for the dolls.

– You had your own room? You never told me that. Why did you have your own room? Were you too much trouble to have you sleep in the same room as the others? Lena asked, hopefully.

– No, fancy people do things like that, even if you don't get it. And you're supposed to be old and know everything. In any case, we were talking about my dolls. When I ate, they ate too.

– But did you sit at the same table, you and the dolls?

– Don't you understand anything? Katitzi was beginning to run out of patience, but she went on:

– We, the circus people and I, ate in the dining room, and the

dolls in my room. When the circus mother cleared the table and did the dishes, I did the same thing for my children.

– Your children, don't tell me that you had kids, too.

– Come on, you understand that I meant my dolls, but I called them my children. But Lena, why are we having a party if it isn't anybody's birthday?

Lena didn't answer immediately, she was lost in thought. Katitzi must have had it awfully nice, with her own room, dolls, furniture and whatever else she had, Lena couldn't remember all of it—Katitzi told her so many things. But this business with the dolls eating the food, she thought that must have been made up. But it wasn't Katitzi making things up: the circus mother must have taken the food away when Katitzi wasn't looking. She thought for a minute if she should tell Katitzi the truth about the food and the dolls, but she decided to not say anything. Instead, she replied to Katitzi's question.

– You know, don't you, that Papa has a bunch of brothers and sisters, but mostly brothers, and now his oldest brother is coming to visit. The uncle who passed by here early this morning told us, and that's why Papa is having a party, because he hasn't seen his brother in awfully long.

– Can we be here then, do you think?

– Of course we can, and we are going to wear our fancy clothes. Our cousins are coming, too: we have lots of cousins, Lena said.

– Really? How many?

– Well, a couple hundred, I think it is.

– Are you insane: a couple hundred? That's an awful lot of people. When we had a couple hundred people in the circus tent, it was full of people. We can't have that many cousins. You're lying, aren't you, Lena?

– No, I'm not, we have lots of cousins. It might not be several hundred, but it's a hundred. I'm super sure, I promise.

– Are they all coming? Katitzi looked puzzled. But where will they sleep?

– They're not all coming, just Papa's older brother and his children. I don't know how many he has, but I think it's ten. But they're not going to sleep in here: they're bringing their own tents.

– But Lena, the lady can't be at the party: she was complaining so much about her migraine this morning.

– Wait, and you'll see something funny. The headache will disappear as if by magic in time for the party, don't worry about that.

– I'm not a bit worried, I was just thinking.

– Please don't think too much. And if you absolutely have to think then try to figure out where we'll find enough firewood, because today we need lots, Lena said.

– We need more than usual?

– Yes, as a matter of fact we do, because Papa is roasting a whole pig.

– What's that? Katitzi asked and looked questioning.

– You take a whole pig, and you stick a long pole through it, and then Papa puts up a rack that he hangs the pig on and lights a fire underneath it.

– Is it alive? Katitzi asked, looking horrified.

– You must be the most ridiculous child I've ever met. Of course it isn't, silly. Yes, you burn a fire underneath it and turn it for several hours until it's cooked through. It's the most delicious thing ever, Lena said.

– It can't be as delicious as pork chops, can it?

– Oh yes, it's just as delicious as pork chops. It tastes the same, but you may not know that pork chops come from pigs.

– They do? Hey, this is going to be delicious, because I'm so tired of the soup we get most of the time. Lena, should we ask the kind old woman if she has any wood we can take?

The two sisters headed off. After a bit, they returned with an armful of wood, with the promise that they could come get more if they needed to.

In the meantime, preparations for the party were underway and Papa Taikon was getting ready to roast the pig. Rosa was bak-

ing lots of bread: it looked like loads of fun. She mixed flour and water and salt, then she flattened the dough into large rounds and fried them directly on the wood stove. Katitzi looked at Rosa with amazement and said that she didn't think the bread was edible. Rosa let her taste and asked: Well, will it do?

– Yes, Katitzi said, it'll do. It's very good: Can I have one more piece, please?

– Split a piece with Lena, but then that's it, because you can't fill up on bread.

In the afternoon, when almost all the food was done, a large group with lots of people arrived. Katitzi's father embraced a man with a long white beard. They hugged for a very long time and it almost looked like they were crying.

Lena explained to Katitzi that they were happy to see each other again and that it had been several years since they had last been together. She also told her that there was a war out in the world and that all Roma were afraid that they wouldn't be allowed to stay in Sweden. But that was something that Katitzi couldn't understand, so Lena thought it was pointless to try to explain more.

– Today we should be happy and eat to our hearts' content and sing and dance, Papa Taikon said. He served food to all the guests and told them to have a seat at the large table he had set up in the middle of the camp. The kind woman had loaned him the table. She was also invited and sat together with the others and enjoyed the roasted pig. She wanted Rosa's recipe for the bread, she thought it was so delicious. The woman said, those of us who bake our bread in the oven probably put too much sugar in it.

When everyone had eaten and was full, Papa Taikon started to play the violin and Paul joined him on the accordion. Katitzi got up to dance for everyone. At first, she was terribly shy, so many people were watching, but after a while she forgot about them and danced as if she was by herself. When she was done, everyone applauded and her cousins shouted at her and wanted to know where she had learned how to dance to beautifully, but Lena was

the only one who understood what they were saying, since they spoke only Romani.

– I don't understand what you're saying, Katitzi said.

– What's wrong with you, one of the cousins said, you don't know our language? What kind of a Roma are you?

– Well, aren't you stuck-up, Katizi said. But I'll tell you, I've been out in the world. That's why I've forgotten Romani, but I'll learn it soon again. Can you dance so that everyone claps their hands, huh?

– No, I can't, the cousin said and looked a little bit defeated.

– So there, then what can you do, if you don't mind me asking? I mean, more than speak Romani, because that's nothing to brag about: you speak that at home all the time. And besides, I don't think you've been out in the world, have you?

The cousin started to think that Katitzi was a bit stuck-up, so she remained silent for a while to think of something to put Katitzi in her place.

– I can tell fortunes, can you?

– What's that? Katitzi said. Is that another word in Romani that I don't understand? she asked Lena.

– No, Lena replied. Telling fortunes, that's when you can see into the future, but I can't do it, either. But Rosa is really good at fortune-telling, everybody says so.

– But I wasn't asking if Rosa can tell fortunes, because everyone who's big knows how to do it. I meant if us children can tell fortunes, then that's something special, the cousin continued.

– What do you do when you tell fortunes? Katitzi said, who didn't understand a thing.

– Give me your hand and I'll show you.

Katitzi extended her hand to the cousin. She looked at it closely and said:

– You will grow very old and marry a rich man.

– Is that fortune-telling? Katitzi said. How can you know if I'm going to get old or if I'm going to get married? Besides, I'm never getting married.

– Yes, you will, I can see it in your palm. It says so, clearly, that you're going to marry rich, with a man who has lots of horses, and then you're going to have lots of children.

– How many, if you don't mind my asking, and when will I have them?

– Don't bother me when I'm telling your fortune: be quiet and listen instead. You will have your children when you're married, of course, and then you will make a long journey across a large body of water. But now I'm not going to tell your fortune anymore. I'm so tired now and have to rest, this is tiring, the cousin said.

– Do you want to give me your hand? If it isn't too tiring, of course. I think I know how to tell fortunes now. You will marry a man who has a lot of money and you will make a journey, let's say over a small body of water, Katitzi said. Do you think it seems hard to learn how to tell fortunes? Lena, I think this cousin is making things up: I don't think she can tell fortunes. But someone who can tell fortunes, that's Rosa.

– You will never become a fortune-teller, that's for sure, the cousin said. But you'll certainly become a good dancer.

Katitzi Wants to Go to School

The day following the party, Papa Taikon's brother left and everything returned to normal. The children helped Papa Taikon set up the carnival, since it had to be done by Saturday. Katitzi and Lena had met some children in the village and they had asked why Katitzi and Lena didn't go to school like other children. One day—it was a Wednesday—the girls approached their father and said:

– Please, Papa, can't we also go to school like other children? We want to learn how to read and write. Please, Papa. We saw all the children in the schoolyard and they were playing hopscotch and jumping rope and having so much fun.

– Weren't you going to learn how to read and write: wasn't that why you wanted to go to school? You can play hopscotch and jump rope right here at home, can't you?

– Papa, that's not what we meant. We just mean that it would be fun to be with other children and get to know them, Lena said.

– Oh, I understand, I was just joking. Let's go meet with the principal and talk to him and you'll see that you can start going to school. Seeing as we're going to stay here for several months, I think it should be fine.

– Should we get dressed up? Katitzi asked.

– Yes, get ready and make sure that you are clean. That's very

important. You can be poor, but you can't be dirty. Tell Rosa to help you, and you, Katitzi, make sure that your hair is neatly combed.

Katitzi and Lena rushed over to Rosa, who was sitting and practicing the drums. She did a frenzied drum roll, and for a minute, the girls forgot about school and stood and listened to Rosa. There was no one who knew how to do as many things as Rosa did, they thought. Bake bread, do laundry, and above all play the drums. Then they remembered:

– Rosa! Rosa! We're going to start school, they said beaming.

– Really, you are, and who said that you could? Rosa replied, and did not seem in the least impressed.

– Papa, of course, who else? We are going to stay here for several months. That's what Papa said, and then we can go to school.

– All right, let's hope it works out for you, that you really get to go to school, Rosa answered.

Katitzi stomped her foot. She was mad at Rosa, for the first time since she had returned home.

– Of course it will be fine, Katitzi said. You're stupid. Papa has said that we can go, and Papa decides everything, doesn't he?

– Of course Papa decides, at least here at home, but maybe not everything. But come along now and I'll get you ready. Maybe it will work out, Rosa said.

Katitzi and Lena were dressed in their finest clothes. Papa Taikon took the girls in the car and drove them down to the school which stood right in the middle of the village. It was a large red building and the schoolyard was full of playing children They had recess. Almost all the children stopped what they were doing and watched Katitzi and Lena, who clutched their father's hands.

– Papa, why are they staring at us like that? Katitzi asked.

– Go ahead and let them stare, they just don't recognize you, then they have to stare, Papa Taikon replied, and continued, you two please remember not to talk when we meet with the principal.

Katitzi thought to herself that she and Lena almost never spoke

unless they were spoken to when adults were around. In fact, she thought it was unfair, since adults got to talk all the time. And they almost never listened to children, except to Rosa, of course, but she wasn't exactly like other children.

At first the girls and their father walked up many flights of stairs, then down several hallways. Finally, they arrived at a hallway where there were different names on each door. Papa didn't know which door he should knock on, since he did not know how to read. He was at a loss for a while, until a man walked by.

– Excuse me, would you happen to know where one can find the principal?

– Yes, it's the third door on the left, the man replied and hurried off.

Papa Taikon carefully knocked on the door. When no one opened he knocked more firmly. After a minute, a lady emerged. At first, she regarded them with surprise that then turned into dismay, and asked: Who are you here to see?

– We are looking for the principal: Is he here?

– Have you made an appointment with Principal Blom?

– No, we haven't, but I thought that I could speak with him anyway. It's about my girls: they are going to start school here.

– One minute and I will see if Principal Blom is available to speak with you. But I can already tell you that he is very busy. The lady pursed her lips and shut the door with a bang. After a while she returned and said that it would be all right if they came into the waiting area and that they could have a seat and wait, then the principal would see them.

The girls did not quite recognize their father: he didn't seem quite as gruff as usual, no, he actually appeared to be nervous. Katitzi thought that he looked the way she herself did when she had been up to something that she knew was a bad idea.

It took forever before the door opened, Katitzi thought, but the principal finally came out. He was short and stout and wore glasses which looked far too small for his nose and face. He examined

them very carefully, first Papa Taikon and then the two girls. He did not appear satisfied with what was before him.

– So, how can I help you? I'm sorry I had you wait so long, but running a school takes a lot of work. Oh, I forgot to introduce myself. My name is Principal Blom.

– Johan Taikon, the girls' father said and bowed politely. The girls curtsied.

– These are my girls. The little one is Katitzi, she is eight years old, and this here is Lena, she is ten years old.

– And what can I do for you, then? Principal Blom asked.

– Well, it's about enrolling. We are going to live here for a while and then I thought that the girls should take this opportunity to learn how to read and write.

– Where have the girls previously gone to school? the principal inquired.

– They haven't gone to school: we have never been allowed to stay in one place long enough, that's why it has been impossible to send them to school. But this time I think it should be fine, Papa Taikon replied.

– Yes, I would really like to help you, but unfortunately I can't. I don't say this to be cruel, because I would truly enjoy having your children here. But, unfortunately, I can't.

Katitzi stiffened. What did he mean? Cruelty, enjoy, unfortunately? Was he saying that they couldn't go to school there?

Papa Taikon regarded the principal for a long while, then said:

– Would you mind please telling me why they cannot attend your school?

The principal fidgeted awkwardly as his face turned bright red.

– Mister Taikon, I don't think it's appropriate to discuss so that the girls can hear. Perhaps it is better if they stay in the waiting area while we adults talk this over.

– Not at all. This concerns the girls and they should hear why they aren't allowed to go to school: you should be the one to explain it to them.

At this point, Papa Taikon had stood up. He stood before the principal, feet firmly planted, and there was no longer any trace of nervousness.

– I cannot, no matter how much I want to, let the children attend my school. You see, I would have so much trouble with the other children's parents. I can tell you that they would take their children out of school if I admitted Mister Taikon's children.

– And how would you know? You've never had any gypsy children in this school, have you? Let me ask you an earnest question: Do you think it's right to deny them an education? Do you do the same thing to other children, as well? Now Papa Taikon was furious.

– We are not going to continue this conversation. As things stand, I simply cannot accept your children. But perhaps it will work out in another municipality you stay in. Now you will have to excuse me, Mister Taikon, but I have no more time to talk. I have a great deal to take care of. Yes, you surely understand how busy I am, Principal Blom said.

– We will be on our way, but I am very dissatisfied with this conversation. Come now, children, Papa Taikon said.

Katitzi and Lena were on the verge of tears, and remained completely silent. Their father did not utter a word, either, and only looked dejected. When they reentered the schoolyard the students were on their way home. One boy said, loud and clear so that his friends could hear: Look: they're gypsies, they don't have to go to school. Makes you wish you were a gypsy.

Katitzi became so mad that she wanted to rush up to the boy and give him a royal slap in the face. She thought he was stupid for not understanding that they really wanted to go to school but were not allowed to.

– Did you hear what he said, Lena?

– Of course I did. Do you think I'm deaf?

– But why did he say that? He must not know that the fat principal doesn't want us at the school. That boy: He doesn't know anything, does he?

KATITZI 315

– Katitzi, try to be as happy as you can. That boy has surely never seen the world the way you have. Maybe things aren't so easy for him, either.

– You just wait until I'm big, Katitzi said.

The girls' father said nothing, and only muttered something to himself about educated people and their prejudices.

Miss Britta Comes to Camp

When the girls returned to the camp, Katitzi ran up to Rosa, who, as usual, was doing the laundry.

– Rosa, Rosa, they didn't let us go to school. Katitzi threw herself into Rosa's arms and wept.

– Rosa, why couldn't we go to school there? Tell me, Rosa, why?

– Calm down a bit. Wait, and let me dry my hands first: they're covered in soapy water. All right, so why don't you tell me what they said at the school, more calmly this time.

Katitzi attempted to tell her what she had heard the principal say to Papa Taikon, and Lena filled in what she left out.

– I see, Rosa said, they were afraid to have Roma children at the school. Well, that doesn't come as a surprise.

Katitzi looked at Rosa for a long while. It was as though she understood something for the very first time.

– Rosa, do you not know how to read, either?

– No, I cannot read, either. I went to school once, for a month. You were still very little. But I never had the time to learn how to read or write. Paul has never gone to school for more than a month, either.

– Rosa, did they not want you in the school, either? But you are so kind and well-behaved. You're never dirty and you never do anything that the teacher could complain about, Katitzi said. She seemed genuinely amazed: to think that they would deny her sister Rosa.

– People are crazy, Katitzi said. But maybe they haven't seen the world, either.

Angry voices could be heard from inside the trailer. Well, in truth, it was really just a single voice: the girls' father. The other voice belonged to the lady, and it was mostly whining.

Papa Taikon's voice could be heard, loud and clear:

– When is this misery going to end, how much longer will people treat us this way? We can't stay anywhere, and the children can't go to school. We can't get any ration cards so that we can buy food like everybody else. What have we done wrong?

– Please don't speak so loudly. You have to think about my head, I have such a terrible migraine. Oh, I lead such a miserable life, I just regret ever getting involved with you. My poor head, the lady's wailing continued.

Katitzi and Lena looked at each other and now could not keep from laughing.

– Yesterday at the party, there was no mention of any migraine, right, but that's life.

– What are you thinking about, Katitzi? Lena asked.

– I am thinking that I would like to visit the farms and tell all the mothers that we want to go to school. And then they would go visit that principal and tell him that if we can't go to school, well then they will take their children from that stupid principal and his school. Can't you just imagine his face then?

He would probably get red like that again, and then he would say: Mister Taikon's children will begin this very instant. Don't you think so, Lena?

– No, I don't really think anything anymore. I think that all people are cruel.

– Are they? Katitzi said. But aren't we people, then? Is Rosa, for example, cruel? Can you tell me that, stupid?

– We don't count. Look, that lady is coming over this way. She's so beautiful, Lena said.

And the woman approaching them truly was beautiful: she had

long blonde braids that were pinned up like a crown on her head. At first, she approached Papa Taikon, who now stood outside the trailer. She talked to him for a long while, and gradually he came to look pleased, so the lady clearly did not have anything unpleasant to speak with him about.

After a minute, she came up to the girls.

– Hello, how do you do? Are you Katitzi and Lena?

– Yes, that's us, the girls replied, wondering what was going on.

– My name is Miss Britta and I am a teacher at the school.

– Ugh, Katitzi said, having forgotten that you should not speak until spoken to.

The teacher regarded Katitzi and kindly replied:

– I understand that you and Lena are very sad that you did not get permission to go to school, but that is what I have come to talk to you about.

– Will we get to go there now and learn how to read and write? Will Rosa also get to go to school?

– Calm down, Katitzi, and listen to what the lady has to say, Rosa told her.

– Well, this is what I'm thinking: since it seems impossible to get the principal to agree to let you go to school during regular hours—I mean, that you would get to go there with the others—I'm thinking that you will come to me when the other children have gone home. Only if you want to, of course. And I will try to teach you to read and write. I think it's terrible that children should grow up to be illiterate: my teacher's conscience forbids it.

– What is iterate? Lena asked.

– Not iterate, but i l l i t e r a t e, Lena, Miss Britta said, and continued, a person who is illiterate cannot read and write, and we have very few people like that here in Sweden. Really, the only people who are illiterate here are gypsies, and now I understand that it is not their choice.

Katitzi looked at Miss Britta, whom she was not the least bit afraid of, and asked:

– Then maybe you can tell us why that principal didn't want us in school?

– Katitzi, you're not supposed to call the teacher "you." You should call her Miss Britta, Rosa said.

– Well, but maybe she can still tell us why we can't go to that school together with the other children. Or does me calling her "you" make that impossible?

– Miss Britta or "you": it doesn't matter to me. You can say whatever you want to me, Katitzi, but unfortunately I don't have a good answer to your question. I would imagine that the principal and the others know nothing about gypsies and that's why they don't want them in school.

– You, I mean, Miss Britta, then they shouldn't be so mean to us. If they knew that we were mean and cruel, then they could run us out of the school. But they don't know, they don't know anything, so there.

– You're absolutely right, Katitzi, but the problem is that people are afraid of what they don't know. They think that gypsies are more dishonest than others, and they also think that gypsies don't

want to stay in one place, and that they don't want to go to school. When I was a child, I can tell you, they even thought that gypsies stole children from people in the village. They said that they took blonde children, Miss Britta told them.

– Why? What would they do with them?

– Katitzi, never mind that, Rosa said. People come up with so much rubbish. And you know what I think they believe, too? Well, that gypsies are a little bit exciting, too. And when it's exciting, there are also some tall tales involved.

– My goodness, that's so silly, Katitzi said.

– Miss Britta, when can the girls start going to school with you? Rosa wondered.

– If it's up to me, they can start tomorrow. But remember that they cannot come until after four o'clock, so that we don't have any trouble with the principal.

– Absolutely, I'll make sure that they are there at the right time, and thank you, Miss Britta, truly, for wanting to help us.

– Oh, don't mention it, I'm just happy if I can be of some help. One hour a day isn't much, but it's better than nothing, Miss Britta said, waving goodbye.

– Miss Britta! Katitzi shouted. We don't steal children.

– I know, I know, Miss Britta shouted back.

Driven Away

For two weeks, Katitzi and Lena walked to school every day. They certainly thought it was a little bit sad that they couldn't play with the other children, but it was still fun to learn about all the letters. Miss Britta was the kindest person they had ever met. Katitzi said that she had met one other person who was as kind, namely, Miss Kvist at the orphanage, but Lena said that didn't count, because Lena had not met her. Miss Britta had arranged so that they every day received a bowl of rose hip soup and two crisp bread sandwiches with cheese. Today they were very happy, since they had learned how to spell "Mama is kind."

– I can spell much better than you can, Lena said.

– You're so stuck-up, of course you can spell better than me. You're older than me, Katitzi said.

– Didn't you hear what Miss said when you said that I was older than you? It's called older than I am.

– I don't give a damn what it's called, because you still know what I mean: you're just making a big deal. You're old, or aren't you?

– Yes, I may very well be older than you are, but that has nothing to do with it, because I haven't gone to school, either. And besides, I'll have you know that little children have an easier time learning, Lena said.

– You really nailed it now, didn't you. I'm not a little child. If you're mean, I'm going to tell Rosa. Next week I'm going to be able

to spell better than you, even if you are older. And hey, I won't say older than I am even though I know that's what it's called. Because I will say whatever I want, so there.

The girls bickered almost all the way home, but they didn't actually have a falling out.

When they arrived at the camp there were greeted by a terrible commotion: some men were arguing with their father and Paul. The men wanted to fight and Papa Taikon was attempting to reason with them. One of the men entered the tent where Rosa stood frying some pork. Rosa was afraid, but ignored the man. Then he approached her and threw his arms around her. She felt his arms around her waist and became so furious that she immediately turned around and walloped him in the head with the frying pan. The pork went flying. Rosa thought it looked so ridiculous that she couldn't keep a straight face and laughed out loud, but she immediately fell silent, as the man looked at her with a menacing expression on his face.

– You're going to pay for this, he said, and exited the tent.

In the meantime, Papa Taikon had tried to calm down the other men, and they promised to leave. At that moment the man who'd had a frying pan hurled at him emerged from the tent, telling the others that they should clean out the gypsies.

Katitzi didn't understood what he meant, but he looked so angry that she understood that trouble was brewing.

– We're going to drive them out of here, they can't stay even a minute longer. Come on, let's go get the police, he said.

– The woman who owns this land has promised us that we can stay for two months, Papa Taikon said. So you can't drive us away, not you or the police.

– Well, we'll see about that. This isn't the old lady's land, and we know her sons. They probably don't want gypsy trash on their property.

– But why haven't the sons already said anything? Papa Taikon wondered.

– Because they work in the forest and have no idea that you're here. But we are going to let them know, so you better just pack up your stuff and get lost.

Katitzi felt like there was a large lump of ice in her stomach. Not again: not now when everything had started to settle down. Miss Britta had said that she was going to speak with the authorities, or whatever it was called, in Stockholm, so that they could start school for real.

Please God, help us so that we can stay. I promise to never be bad, as long as we can stay here.

– Lena, are they really going to drive us away? Katitzi asked.

– I don't know. It seemed as though Lena could not hear what Katitzi was saying, as though she were suddenly numb.

– You must understand, right, you have to know. The lady who lives up there is so kind. She promised that we can stay, and you can't break a promise. Katitzi was ready to burst into tears.

– If it's up to her, we can stay here our whole lives, but you heard what those mean men said. They said that her sons don't like gypsies, Lena responded.

– Just wait until I'm big, you'll see, Katitzi said. Her eyes were bright.

– Then what are you going to do? Lena calmly replied.

– What I'm going to do? Well, I'll tell you. I'm going to go to the king and tell him that people are cruel to us, that we aren't allowed to live anywhere, and that they don't want us to go to school. Oh, he'll be so mad then. He'll be so mad that he'll stomp his foot on the ground, Katitzi said, stomping with all her might.

Toward nightfall, the men returned. They had brought the woman who rented the land to Papa Taikon. The old woman's sons were also there, and they looked furious.

– You had better just pack up and get out of here. We don't want any gypsies here on our land.

– But we have her permission, Papa Taikon insisted, pointing at the old woman whose face betrayed her sadness at the situation. Or don't we, he asked, and looked at her.

– If it's up to me, you can stay as long as you want, but my boys don't want you here. And it's their land, even if I thought I also had some say. I am their mother, but today I am ashamed of them, she said.

Katitzi and Lena started to cry. The little children did not know what was going on, but chimed in with tears of their own.

– Tears won't help you here. Make sure to pack up and leave—now. If you don't hurry up, we'll help you.

– How long do we have? Papa Taikon asked.

– We'll be nice: four hours, but then you have to be gone. Otherwise, we'll get the police.

– All right, all right, we'll move, Papa Taikon sighed.

Now everyone had to hurry, there was no time to lose. Papa instructed Katitzi to return the wash tub they had borrowed for laundry. Lena helped Katitzi lug it back, and not a word was uttered along the way. When they arrived at the farm, they simply left it in the middle of the courtyard. The sisters didn't want to go in: they were afraid of the old woman's sons. But just as they were about to leave, the woman called for them.

– Please, children, stay for a minute so that I can speak with you.

Katitzi and Lena wondered what she had to say.

– Please do not be mad at me. I only want good things for you and I would never dream of driving you away, do you understand that?

– No, at least I don't, Katitzi said. I don't understand a thing. What have we done? Have we been cruel?

– No, certainly not, my dear child. It's just that my sons don't understand: they think that gypsies are mean, that's why they are driving you away. All afternoon I've tried reasoning with them, but their hearts are harder than rock. If only my husband had been alive, things would have been different. My boys would never have dared behave like this.

– You are very kind, ma'am, and so was Miss Kvist. Our teacher is also very kind, but it doesn't matter. Because there is always someone who decides over those who are kind, Katitzi said.

– Children, I have packed these baskets for you. It's fruit and some freshly baked bread for your journey. And please, do not think too harshly of me: it isn't my fault that you have to leave. If only my husband had been alive, the old woman repeated and her eyes filled with tears.

Katitzi and Lena understood that the old woman desperately wanted to help them, but was unable to. Tears rolled down their cheeks as well. Katitzi hugged the old woman, and they bid each other farewell.

Katitzi and Lena returned to the camp, which had been torn down and packed up. What Papa Taikon was unable to take now was neatly arranged so that trucks could return and pick it up later.

Everyone took their place, the lady with the little children in the car, along with Rosa and Paul. Katitzi and Lena got into the trailer.

Katitzi sat completely still, saying nothing for a long while. It felt as though something inside her had shattered. She wanted to cry, but couldn't. She regarded Lena carefully.

– Aren't you sad, Lena?

– Of course I am, but I'm not quite as sad as you are. I'm more used to this: it happens so often that, finally, there are no more

tears to cry. And crying doesn't help, either. You'll get used to it, you'll see.

– Yes, but this time everything seemed so good, and kind Miss Britta was going to teach us how to read and write. That hasn't happened before.

– You know what, Katitzi, maybe we will meet a kind teacher again in the next place, Lena said.

– But that doesn't matter, because if we meet someone who is kind, someone else who is cruel will come and drive us away.

– Katitzi, there are kind people. Think of the kind woman, the one who wanted to help us, and look at these baskets and the delicious things she packed for us.

– That's just because she got rid of us.

– Now you're being unfair: you know that's not true. You could tell that the old woman was kind. Please, Katitzi, I don't think you really know what you're saying. Say that you understand that the old woman didn't give us this only because we were forced to move.

– Well, maybe I know that I'm wrong. The old lady was probably actually kind, but it makes me so sad. I wish I hadn't been born a gypsy.

– Be quiet, Katitzi, you must never say that. Instead, you should be glad that you have it this good. There are many gypsies who are far worse off than we are. They barely have enough food to eat.

– They can't have it that much worse. What do we have that they don't have, besides food, of course?

– They don't have Swing, and I don't think that any of your little cousins have seen the world like you have, Lena said, attempting to cheer up Katitzi.

– No, you're right, they don't have Swing. Katitzi held him close and mumbled, but just wait until I've talked to the king.

The squat red car with the little trailer behind it rolled on into the night, toward unknown journeys.

The Day I Am Free
by Lawen Mohtadi
&
Katitzi
by Katarina Taikon

PUBLISHED BY: Sternberg Press
TRANSLATION: Jennifer Hayashida
PROOFREADING: Ames Gerould
GRAPHIC DESIGN: Sara R. Acedo
PRINTING: ScandBook, Falun, Sweden
ISBN: 978-3-95679-363-9

© 2019 the authors, Sternberg Press, Tensta konsthall

The Day I Am Free was originally published as *Den dag jag blir fri*.
© 2012 Lawen Mohtadi, Natur & Kultur, Stockholm

Katitzi
© 1969 Katarina Taikon
© 2015 Natur & Kultur, Stockholm
Published in agreement with Koja Agency

The translation has been supported by the Swedish Arts Council.

Sternberg Press
Caroline Schneider
Karl-Marx-Allee 78
D-10243 Berlin
www.sternberg-press.com

Tensta konsthall
Taxingegränd 10
Box 4001
163 04 Spånga
Sweden
www.tenstakonsthall.se